FROM SOUL TO SOLE

THE ADIDAS SNEAKERS OF JACQUES CHASSAING

FROM SOUL TO SOLE

THE ADIDAS SNEAKERS OF JACQUES CHASSAING

JACQUES CHASSAING AND JASON COLES
FOREWORD BY PETER MOORE

RIZZOLI
NEW YORK

New York Paris London Milan

CONTENTS

FOREWORD

I first met Jacques Chassaing in December 1989.

My partner, Rob Strasser, and I had been invited to the home of adidas by René Jäggi, who was then the CEO of the company. He wanted us to come out to look the place over and see what we/they might do to turn their business around. As former Nike guys, this was a difficult decision for us but, in the end, we decided to go take a look.

What we found frankly was not a proud brand, but rather a rudderless ship. They had lost their two leaders who had built adidas into the most successful sports brand in the world and were really struggling. That was our morning; in the afternoon, things got better. We were, one by one, being introduced to the meaningful players—the people still working to improve the brand. Out of all the people we met that afternoon, two stood out.

The first one was Bernd Wahler, a young aggressive product guy who knew a lot about product, adidas, and sport, but was awful at company politics.

The second, Jacques Chassaing, was the one true design talent they had at the time. His designs had kicked Nike's butt with the Forum, ZX Series, Run-DMC, etc... and both Rob and I were a bit caught off guard to think just one guy had done all this.

Over thirty years later, I'm still amazed.

With Jacques on board, we decided to jump back into the fire—only this time, we were on the other side. Our first effort was adidas Equipment, a range of shoes and apparel that would represent the best of adidas. Equipment included footwear to cover every category: running to rugby, training to tennis, and even a new one, Adventure.

Jacques, with a little help from myself, designed them all and developed most of them. The timelines were crazy for one shoe, much less fifteen of them, yet he persevered and delivered a fantastic range.

After this experience, I knew a couple of things. The first was Jacques could really design. He really understands the relationship between function, form, and styling. That is very rare and explains to me why his shoes from the past are still popular today. The second thing I learned about Jacques was he's a great team player, willing to try damn near anything, or do damn near anything to help the team.

Yes, it is true, sometimes Jacques can be hard to get to know, but I can tell you one of the smartest things I ever did was to get to know Jacques Chassaing. Today, I consider Jacques one of my closest friends, and we remain regularly in touch.

A word about this book: It is a beautiful representation of Jacques the designer, the results of his genius, and a hint of the character Jacques really is. Enjoy.

Peter Moore
Former Nike and adidas Creative Director

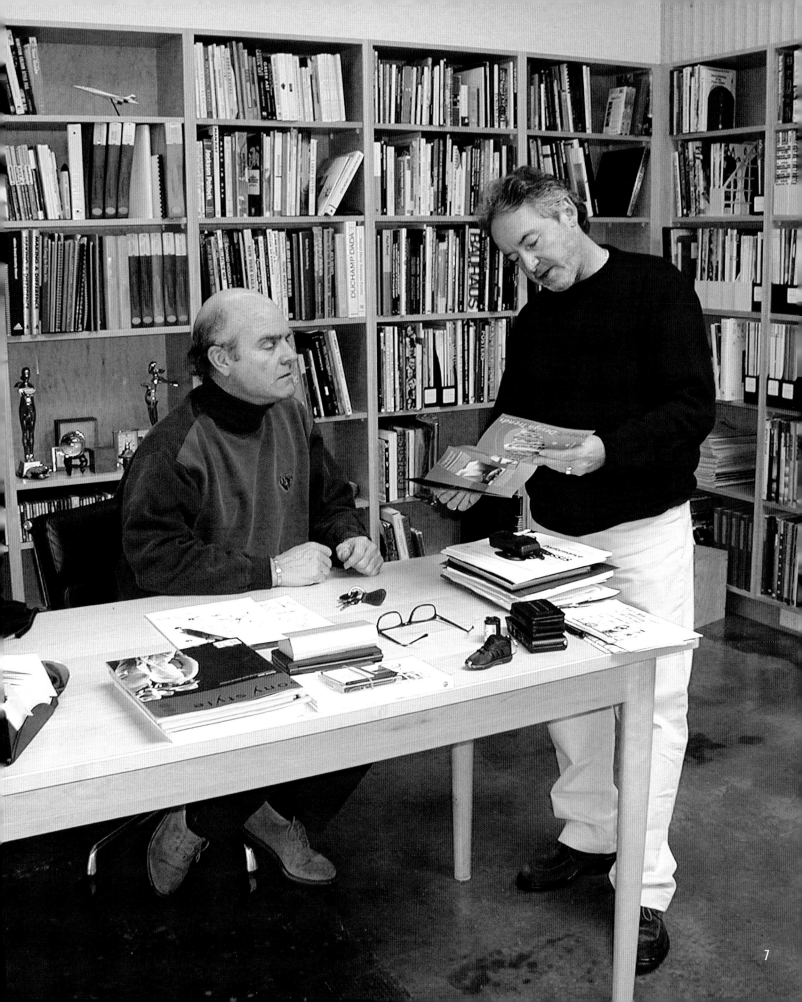

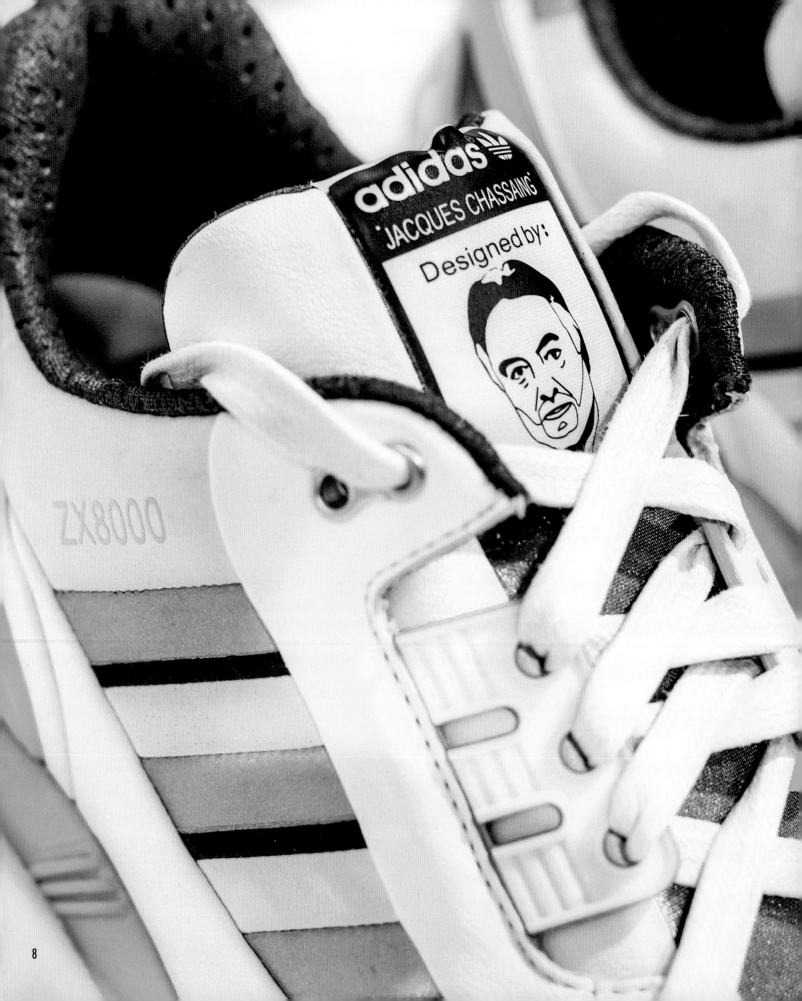

INTRODUCTION

When I first approached Jacques Chassaing about writing a book about his career, his first reaction was, "Why would anyone want to read a book about me?" And that's the thing about Jacques. Despite his creations' being loved by millions and people putting them on their feet for some of the most important moments of their lives—whether it was their first pair of sneakers, their first date, or their first win—he is one of the most modest and self-effacing people I have ever met.

Despite his initial hesitation, after a lot more convincing from me, Jacques finally relented and said, "Ok, let's do it." What you hold in your hands is the result of many hours of interviews and conversations between myself and Jacques and is the self-told story of a person who has put his life and soul into creating sneakers. As far as I am concerned, he is the second greatest sports shoe designer who ever lived. "Only second?" I hear you ask. Yes, because Jacques would never forgive me if I put him ahead of the man who has inspired him throughout his entire career: the founder of adidas, the great Adi Dassler. I also say second because, as I found from speaking to so many of his friends and colleagues, Jacques never seems to have put himself first, always attributing his success to the many people he believes he was so fortunate to have worked with at adidas and Bata.

This book is not a portfolio. As I discovered, Jacques's legacy is far more than just his shoe. If we had tried to cover every single shoe and project Jacques has worked on, this book would be many volumes long. So to save trees, Jacques has selected some of the highlights, and, indeed, even lowlights of his near four decades at adidas.

As I have learned there is no bullshit with Jacques, he is refreshingly honest about everything, so expect a few surprises! Even if you only have a passing interest in sneakers, fear not. This book has been written for anyone who considers themselves a creator and wants to learn something from a person who has been one his entire life.

Writing this book with Jacques has been one of the most fun experiences of my life. I hope you enjoy getting to know him and his life's work as much as I have.

Jason Coles
Co-author

BATA BORN *1971*

It's true to say that if you were to cut me in half, you would probably find Three Stripes running through me. But it's also true that I wouldn't be the person I am if I hadn't started my career at Bata.

I've been a shoe freak for as long as I can remember. From a young age, I had a real love of shoes and shoe design, and was keen to work in a creative atmosphere. There seemed to be a very logical place for me to start my working life: Bata.

Still known today as "shoemaker to the world," from the very beginning when it was founded by the Bat'a family in 1894 in what is now the Czech Republic, Bata was a company that looked after its employees. Working at Bata wasn't just a job, it was a life and an education. If you worked for Bata, you automatically joined a global community as each factory was a world in itself. The one nearest my home in Strasbourg, Bataville in Lorraine, not only provided housing for all the employees but also had its own shops, church, stadium, and gardens.

If you were a new recruit, the policy was that you had to spend one or two months in all the different departments of the company. After one year, you would be assessed as to which one your talents were best suited to. That meant after just one year, I had spent time in Production on the manufacturing line, and in the Costing, Efficiency, Design, Marketing, and Sales departments. After my time in each one, I had to do a report on my work and progress. When the year was over I was told there were three departments I might work well in. Of those, Design was the one in which I felt most at home.

Back then, being a designer wasn't like it is today. You were involved in the entire process. Starting with an idea and then a drawing, you then created your own patterns, cut the materials, and made the samples. You saw each step of the whole thing. But for me, that wasn't enough. I wanted to see what happened after we made the shoe too.

When I asked for a trial in the Sales department, I was put in touch with the Bata sales people in the United Kingdom. Putting me together with one of their top guys, they told me to take some shoes to Marks & Spencer in London. After two trips, I realized that for me, being in sales was a bad idea! I hated the fact that buyers seemed to think they were the kings of the world. And the way they treated salespeople—well, I just knew it wasn't for me! But I didn't regret the experience because it not only gave me an understanding of what the salespeople had to do, but also encouraged me to develop a great admiration for their abilities. It taught me something that would help me during my entire career: humility. I realized there is always someone better than you at your job.

But perhaps the most important thing I learned was to find ways of getting things done. Because at Bata, long before it became our mantra at adidas, I learned that impossible was nothing and never to take "no" as an answer.

MADE IN FRANCE

When I started as a designer at adidas France, my new boss didn't want me to design anything, he wanted me to solve a problem. I soon realized design and problem-solving were one and the same, and that earning my stripes wouldn't be easy.

As much as I enjoyed life at Bata, after ten years I wanted to move on. Making dress shoes had taught me everything about shoemaking, but there was little room for innovation. Sports shoes were a different matter. They were constantly being developed. Being a big sports fan, my ambition had long been to work for the world's greatest sports shoe brand: adidas.

Joining adidas France as a designer was a dream come true. However, as I soon discovered, being an adidas designer was less about creating new shoes, and more about solving problems.

At the time, adidas France made a basketball shoe that was a little like the Top Ten model, but in a kid's size. The problem was they were having a lot of fitting problems in the United States. At the same time, adidas in Germany was also making the same style of shoes and they too had fitting problems. My new boss, Mr. Lorenz Hemmer, the Head of Production, told me that my first task was to fix the problem. There were two styles—a high cut and a low—so I made the patterns myself, checked everything, had the prototypes manufactured,

and then sent them to the States, as did the guys in Germany.

Mr. Hemmer then told me to go to the States to meet our distributor, who would tell us which ones they wanted to go with. When I got to America, I found to my surprise that Mr. Vogler, the Head of Production from Germany, was also there. In the meeting, all the shoes were put on a table and the American guys said, "The German shoes are good, but the French shoes are better!"

Well, Mr. Vogler was not a happy man. I called Mr. Hemmer in the middle of the night and said, "I have to leave now! I can't stay, Mr. Vogler wants to kill me!" After escaping with my life, I went back to France, but not long after was sent to Germany to attend a marketing meeting. I dreaded seeing Mr. Vogler again. But to my complete surprise, he came over to me, shook my hand and said, "Well done. Really good."

Earning the respect of Mr. Vogler, someone who had worked under Adi Dassler himself, meant a huge amount to me and still does. After that, we became great friends and have always remained in touch.

INSPIRATIONS:
STAN SMITH ¹⁹⁷³

When I was working at adidas France, there was never a day when I didn't see a pair of Stan Smiths. Originally designed in the 1960s and first known as the Robert Haillet, it was later renamed when Horst Dassler signed the American world No. 1 tennis player Stan Smith to endorse it.

It had an unavoidable effect on my attitude and work, because to me it was the essence of the perfect sports shoe and a daily reminder of what the adidas brand was all about. Yes, it's a beautiful shoe, but for me it's more than that. Every part and panel of the Stan Smith is there for a specific purpose, not just for aesthetics, and this had a profound influence on my approach to design.

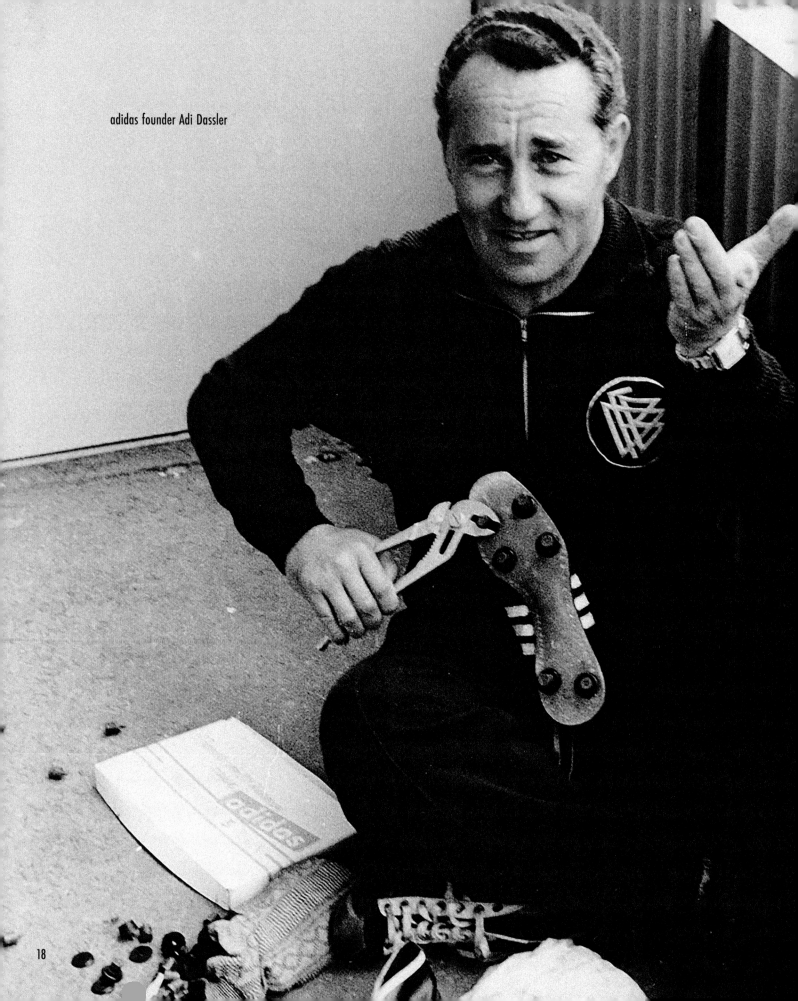

adidas founder Adi Dassler

18

THE CREATOR

Even after forty years working with adidas, I'm still a student of Adi Dassler.

When I first started at adidas, there was no formal process where you were taught about Adi Dassler's values and principles. I learned them from working alongside people who lived them every day, and by experiencing the creation of products which continued to be the essence of all that he believed in.

In my early years at adidas, the 1949 catalogue came to be my bible. It still means everything to me. On the first page is a quote from Adi Dassler; *"Das Beste für den Sportler!"* (Only the best for the athlete!) When I first read it, I felt so inspired. I thought to myself, "Nothing has really changed, it applies as much today as when adidas was first founded."

The more I learned about how Adi Dassler worked, the more I continued to be inspired. I discovered he had a deep interest in the needs of athletes. He spoke to them on a personal level, often inviting them to his home, so that he could understand their needs and problems, and work out how he could help them perform even better. From just a minor change to a heel tab to a completely new design for a shoe, he really thought of everything.

Something that hit home for me as a creator was that although function was Adi's focus, he created solutions

in such a beautiful way, they became an aesthetic feature as well as a technical one. Creating that way is something I've tried to do my entire career, and have tried to instill in the creators I've worked with and taught.

During my time with adidas, the brand was constantly changing, but at its heart, we always tried to keep its original identity and values. Most of the time, our buyers appreciated it; at other times, they didn't. That's life, that's luck. But it was never us who was the judge of that, it was the customer. Whatever the times, Adi Dassler's values have never gone out of fashion because if you give people the best you can, they will always keep coming back.

For me, it was never about chasing Puma, Nike, or Reebok, and doing what they were doing. It was about remaining true to Adi Dassler's original philosophy of making the best product for the athlete, and evolving it to the demands of the day. It's also never been about doing the same thing just because it's a tradition or your heritage, because not all traditions are good ones. But as a creator, if you understand your origins, I believe you will create better things. History should never be a tether, but it can be a spark for what we do today and the inspiration for what we do tomorrow.

INSPIRATIONS:
9,9¹⁹⁶⁰

When I first saw the 9,9, I really fell
in love with it. Perhaps more than any
other shoe, to me it encapsulates adidas
and Adi Dassler's design philosophy
perfectly, because it was designed
purely to make the person who wore it
run faster. From its one piece kangaroo
upper and glovelike fit, to the Three
Stripes that wrap around the foot like a
bandage and the rear "X" piece that
helps to grip the heel, every feature
on the shoe exists only to increase
performance, giving it a weaponlike
firmness of purpose. When it made its
debut, adidas advertised the 9,9 as
"The track and field shoe of the future."
It was a bold claim but one that proved
to be true, because it influenced running
spike design for decades to come.

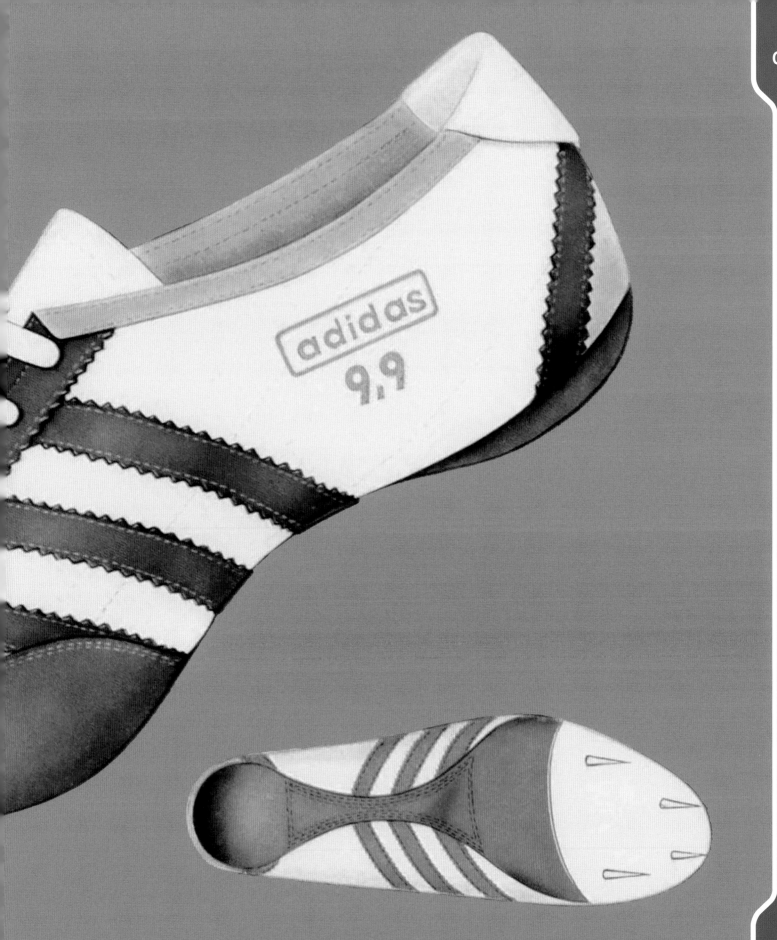

ESSENCE

I believe when you create an object like a sports shoe, apart from performing its function well, it needs to have its own "essence." What is essence? To me, it's instilling a part of your soul and a reflection of your personality and attitude in what you create. It has to come from that part of yourself that is unique to you. It's what I've tried to do my entire career—not always successfully, I admit—but when I have, it's those creations that always resonate most with people.

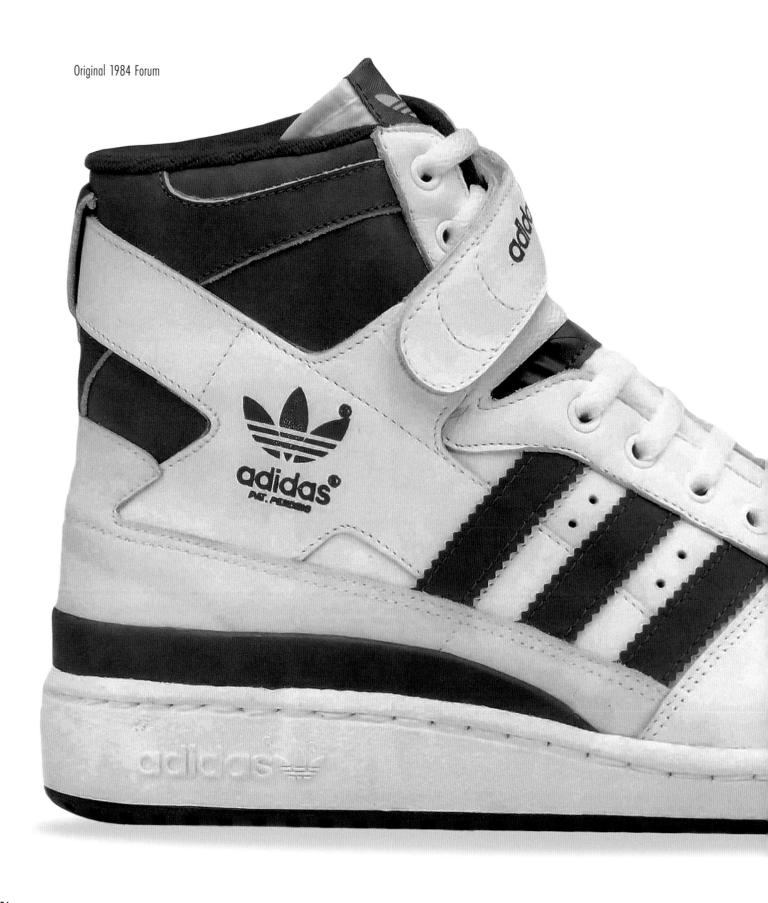

Original 1984 Forum

FORUM *1984*

I always found our most popular shoes weren't born out of a specific brief or a request from marketing; they came almost out of nowhere. The Forum was one of those, because it started as just a gut feeling.

The only thing we knew was we wanted to create a new basketball shoe in time for the 1984 Olympics Games in Los Angeles, but as for a specific brief, there just wasn't one.

I really believe that before you create something new, you need to know where you're coming from in order to get where you're trying to go. This was definitely the case with the Forum.

It's predecessors—the Superstar, Pro Model, and Top Ten, were the premier basketball shoes of their time, and the fact our rivals had either straight copied them or "borrowed" elements of their design meant we weren't alone in thinking that. Their successor needed to carry on that "class of the court" legacy.

Before I put pen to paper, the first thing I did was to look at all the previous adidas basketball shoes to understand their evolution, from the very first one Adi Dassler made in 1949, the "Basketballstiefel," to the very latest, which were the Concord and the Top Ten. The Top Ten was still a fantastic basketball shoe, but as I analyzed what individual

players were doing on court, I realized that, depending on their position, each one had different requirements from their shoes, and that the Top Ten wasn't perfect for all of them.

Again, taking inspiration from Adi Dassler, by talking to the players, I learned that while the Top Ten was great for small forwards and point guards, it wasn't as ideal for centers or power forwards, who were generally larger players and thus needed more support, stability, and shock absorption.

I also noticed that many were strapping their feet before putting their shoes on, which gave me the idea that perhaps we could somehow integrate the strapping into an actual shoe. On the original prototype, we created a kind of stretchable bandage tunnel that replicated the strapping the players used, but built into the shoe. This was developed into an external floating crosspiece that wrapped around the exterior of the shoe, before it was finally integrated into the upper and became the Criss-Cross support system that is still synonymous with the Forum today.

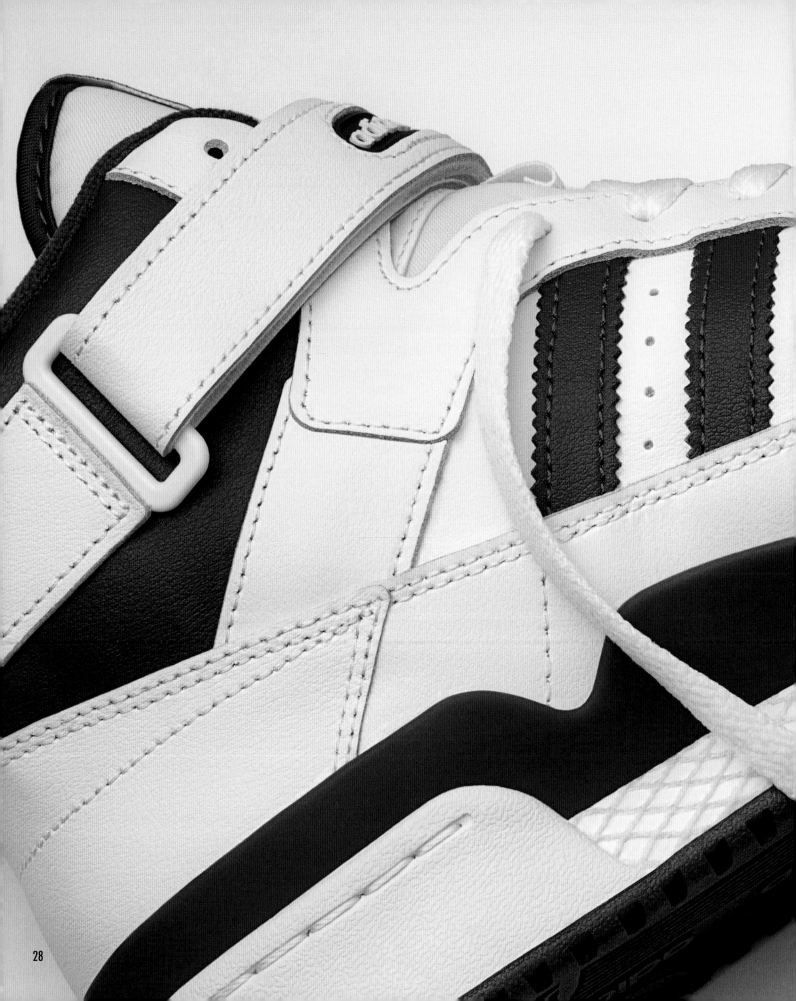

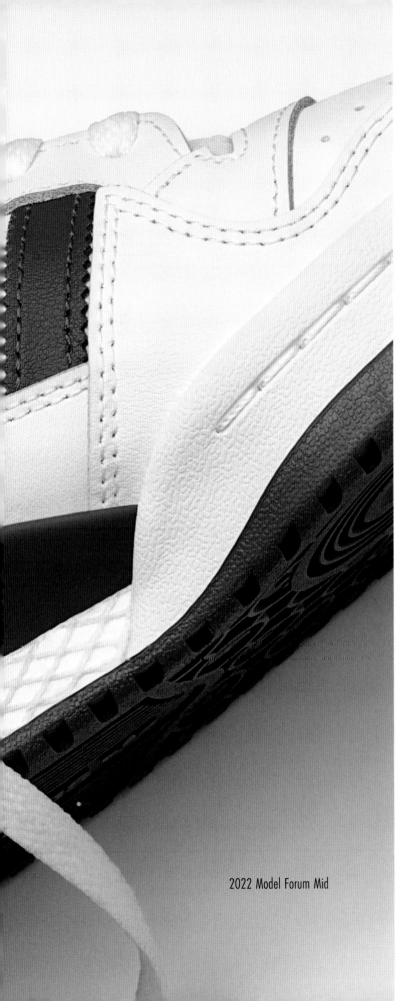

2022 Model Forum Mid

Another thing I discovered from talking to the larger players was that, before putting on their shoes, some of them were putting an orthotic heel cap into the shoe. When I asked why, they told me that it was because when landing they experienced a kind of "bottoming" on impact that pinched the heel, causing blisters, and sending a painful shock to the knees.

Hearing about these kinds of problems led me to think about how we could create a basketball shoe that would be a solution for these players. To address the bottoming, I tried using a regular insole but with a molded rubber piece at the rear to surround the bottom of the heel, prevent pinching, and provide more cushioning. With tennis and basketball having similar dynamics, for the sole unit, we took the shell sole from the Lendl range, which had a motion control unit in the heel, and added a Dellinger Web to reduce distortion of the midsole and to give it better impact cushioning.

When it was still in the prototype stage, we considered calling the new shoe "Prestige," but the marketing guys decided to name it "Forum," after the basketball venue for the 1984 Los Angeles Olympic Games and home arena of the Lakers. When it launched, it sold for $100. People said we were crazy. But many of those same people paid it because the shoe quickly became a status symbol.

INSPIRATIONS:
TOP TEN *1978*

The Top Ten was the flagship basketball shoe when I started at adidas France. Its name came from being developed in consultation with ten of the top NBA players, who gave advice on what they wanted from a basketball shoe. Designed by my colleague Otmar Kaiser, for me, it's a milestone in shoe design. If you look at many of the basketball shoes from all the brands in the '80s, you'll see the inspiration came from the Top Ten. Ideas like perforated toe box, the fore flex on the vamp, the notched eye stay, and padded ankle cuff. They either came from or were perfected on the Top Ten. It was such an advanced shoe for the time that when I came to do the Forum, even though the Top Ten had already been around for a few years, it was still so popular with players that the idea was not to replace it with the Forum but to sit alongside it.

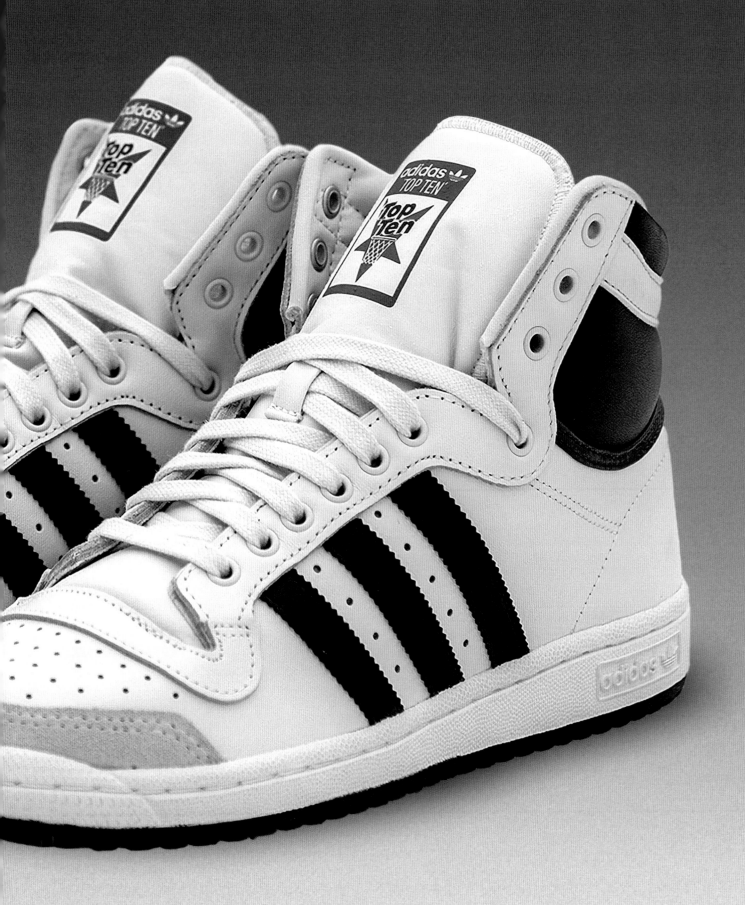

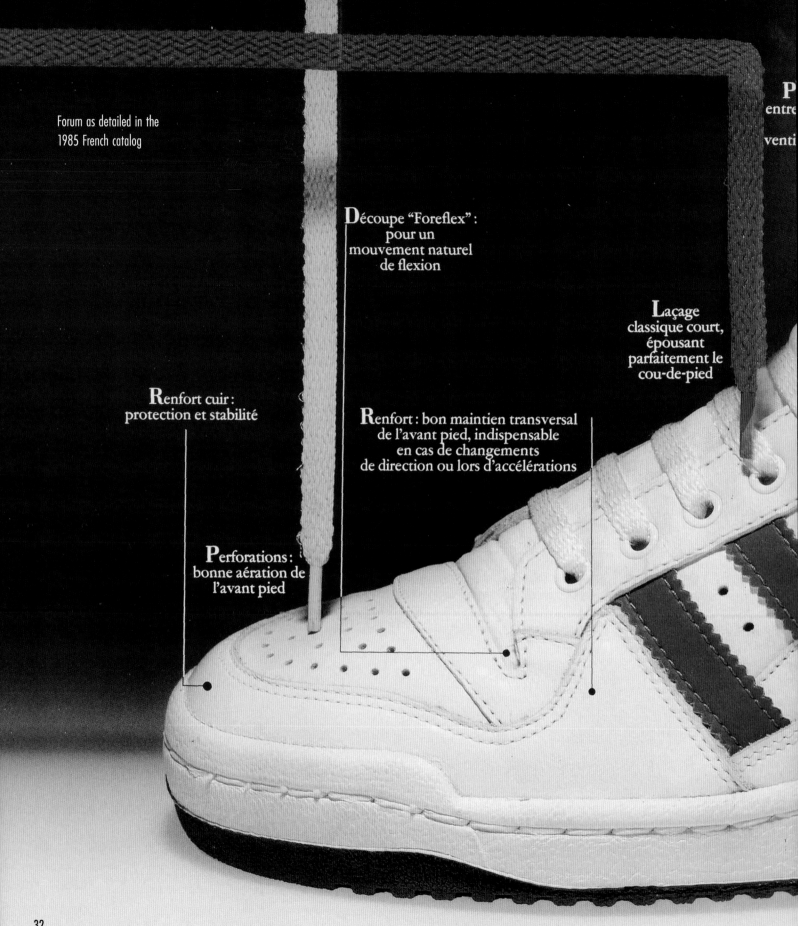

Découpe "Foreflex" :
pour un
mouvement naturel
de flexion

Laçage
classique court,
épousant
parfaitement le
cou-de-pied

Renfort cuir :
protection et stabilité

Renfort : bon maintien transversal
de l'avant pied, indispensable
en cas de changements
de direction ou lors d'accélérations

Perforations :
bonne aération de
l'avant pied

P
entre

venti

Languette
nylon matelassée :
protège
le cou-de-pied
de la pression du
laçage

ons
ndes :

u pied

Haut de tige
matelassé :
confort optimal
de la cheville,
protection du tendon
d'Achille

Système
Crisscross :
maintien optimal
de la cheville

adidas
ME. PERKINS

Stabil heel counter : augmente la stabilité
du talon et le maintien latéral du pied

Semelle cuvette bicolore
en caoutchouc de qualité supérieure
grande résistance à l'abrasion,
très bonne adhérence et stabilité de
l'ensemble - elle ne laisse pas de trace

Découpe
"Flex" du laçage :
flexion aisée
de la cheville

adidas
la marque aux 3 bandes.

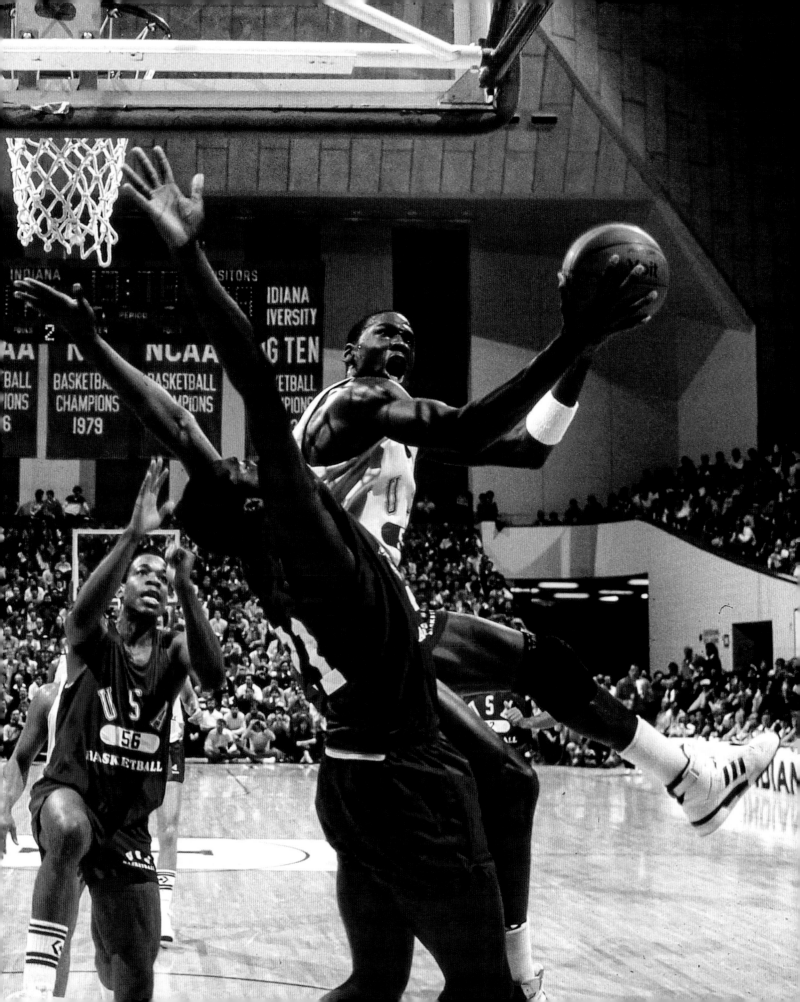

PETER MOORE

It's no secret that before he got together with Nike, Michael Jordan was an adidas fan. As I remember it, back when he wasn't a star yet and still in college at the University of North Carolina, he knew an adidas rep who kept him supplied with adidas gear, and he really liked their shoes and warm-ups. He loved practicing in the Forum, to the point that everything he did was in the them, until game time.

Michael's coach at UNC was Coach Dean Smith. Coach Smith had a reputation for coaching his players like a Drill Sergeant, and his players did exactly as they were told. So when he had Michael put on Converse like the rest of the team, that was probably the only time he wasn't wearing adidas back then. He knew the brand well and wore the Forum during the 1984 Olympic basketball trials, which meant when the time came, all adidas needed to do was to invite him to Germany, and I'm pretty sure he would've signed. He's been very open about the fact that is was just a matter of them making an offer. But as we know, Michael and adidas didn't happen, which was great for me, because it meant I got to work with him at Nike!

When Michael joined us, I knew that he had a thing for the Forum, and he told me he wanted the same court feel in his Nike shoe. So when I sat down to design the Air Jordan, the one piece "belt" that starts at the heel and arcs up to the top of the high-top and incorporates the upper lace throughs, that was inspired by the "X" strap of the Forum. So even before I knew him, I always credited Jacques Chassaing with helping design the Air Jordan 1.

When I later joined adidas, one of the first questions I asked was why they had passed on Jordan. They told me that they had no idea what they would have done with him. They already had Kareem Abdul-Jabbar, the greatest player in the NBA, so why did they need to sign a rookie they didn't know anything about? I have to admit, thinking back to my Nike days and the success we had with Michael, I thought, "Thank God!"

Although fate meant Jacques never got to make shoes for Jordan, having worked with both of them, I can tell you they would have been one hell of a tough team to beat.

PETER MOORE
*Former Nike and adidas Creative
Director, designer of the Air Jordan 1*

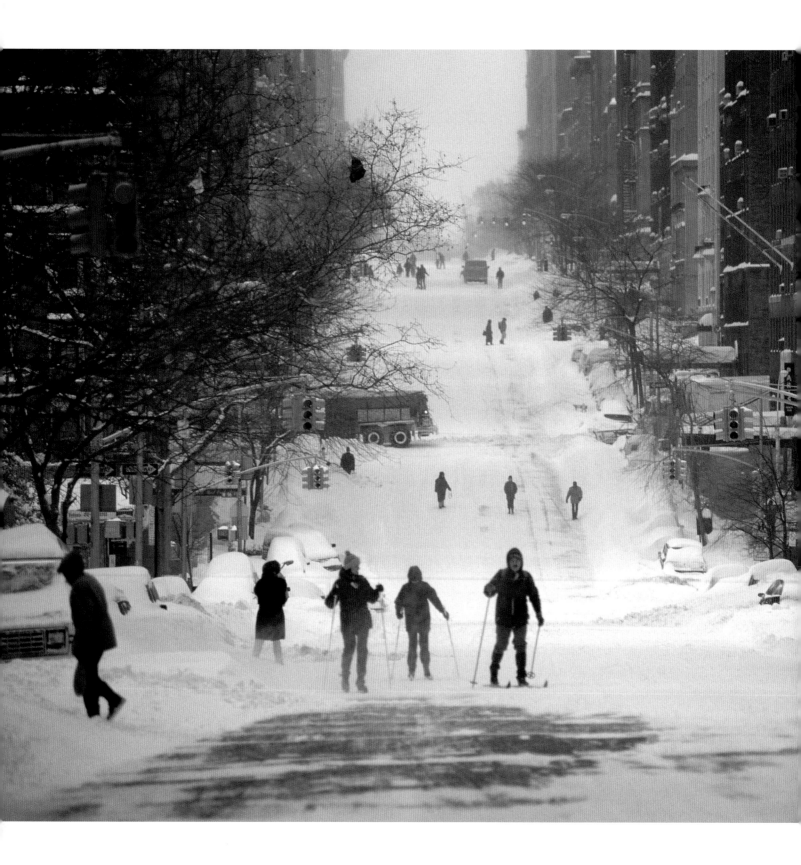

THE BLIZZARD

I have lots of stories associated with the creation of the Forum, but this is one I'll never forget. Having been in Chicago for a distributors meeting, with our new basketball sneaker in mind, I decided to make a stopover at JFK on the way back to Paris to meet a former basketball coach who was now one of our New York sales reps. The plan was to get as much insight as I could on the US game, and to brainstorm and exchange ideas on the new basketball shoe.

As I left Chicago, a snowstorm had been forecast over New York, but I never imagined how bad it would be. After reaching JFK, I met Coach de Angelis, an experienced basketball coach, and we began sharing ideas for the new basketball shoe. But just as the creative juices started flowing, an emergency announcement notified everyone that the airport was closing due to an approaching blizzard. Keen to get home before the roads were blocked, Coach de Angelis left.

With my flight canceled and all my belongings in the hold, I was stranded. Luckily for me, Air France handed out food vouchers, but it wasn't the case for many other passengers. The situation got tense, with fights breaking out and the police called to break them up. Thankfully, things calmed down, but that night, the airport became a refugee camp, with a sea of people sleeping wherever they could.

Having little else to do, I began thinking about my discussions with the distributors on the design for the new basketball shoe, and what Coach de Angelis had told me about the latest developments in the playing of the game. It wouldn't be true to say the Forum was born in that airport lounge, but it certainly began to take shape there.

In the morning, although the blizzard had stopped, New York was buried in deep snow. With the airport still closed shut, Air France managed to get me to a hotel in Midtown Manhattan, the Roosevelt. Effectively stranded in New York, I decided to make the best of being in the city and ventured out. As I walked though the snow bound streets, thoughts of what the Forum could be filled my head with only the amazing sight of people cross-country skiing down 5th Avenue distracting me!

The following morning, I got word that JFK would reopen. With only a few taxis running, the ever-enterprising cabbies were charging crazy money, so I joined a group of students taking the same flight back to Paris. I finally reported back to my unimpressed boss three days late, but with the genesis of the Forum in my head. I can't honestly say the Forum was born in New York, but it seems somehow apt that the city that would fall in love with it would play a part in its conception.

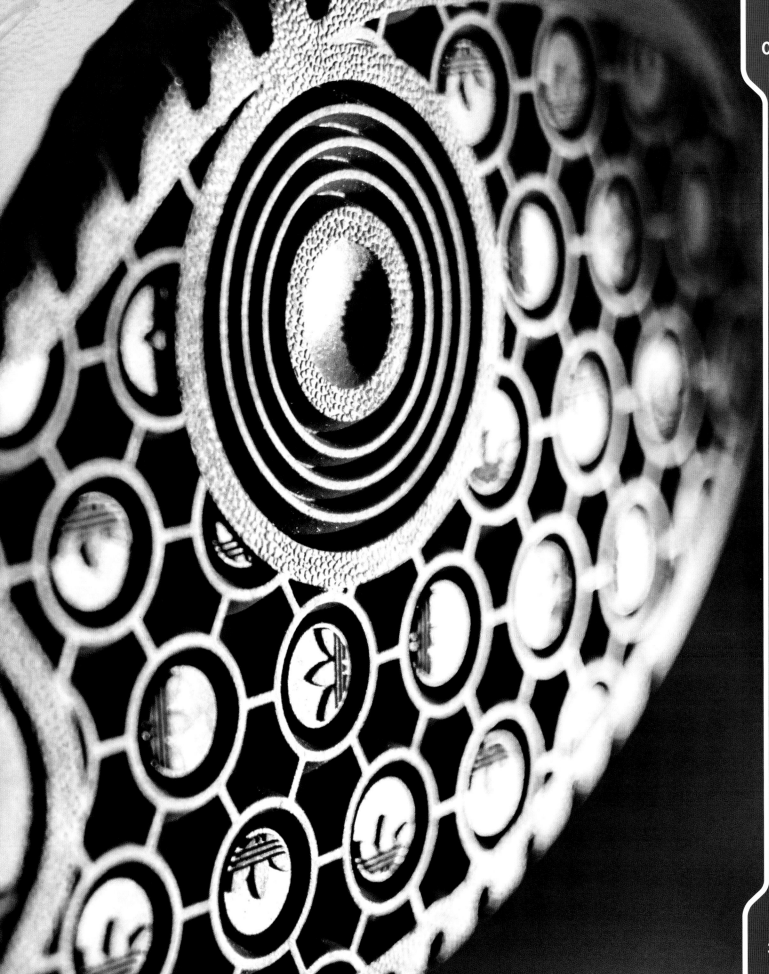

JEREMY SCOTT "MONEY" FORUM ²⁰⁰²

I've seen the Forum become a canvas for many cool collaborations, and one of my favorites is Jeremy Scott's "Money" Forum. He covered the shoe in $100 bills that had his face on them instead of Benjamin Franklin, and had only 100 pairs made. It was a really cool reference to the original price tag of the shoe and the exclusivity it had when we first launched it.

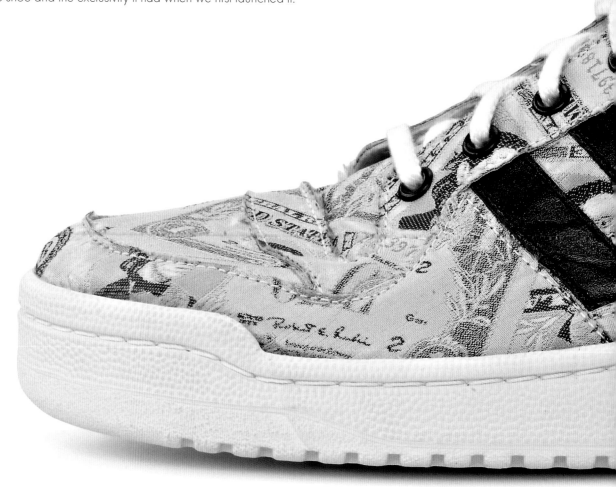

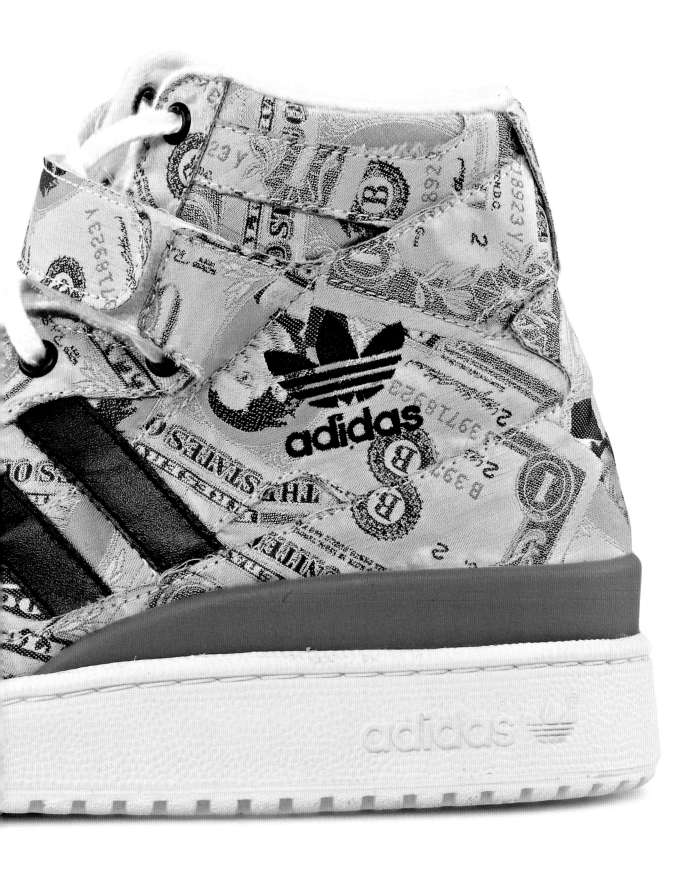

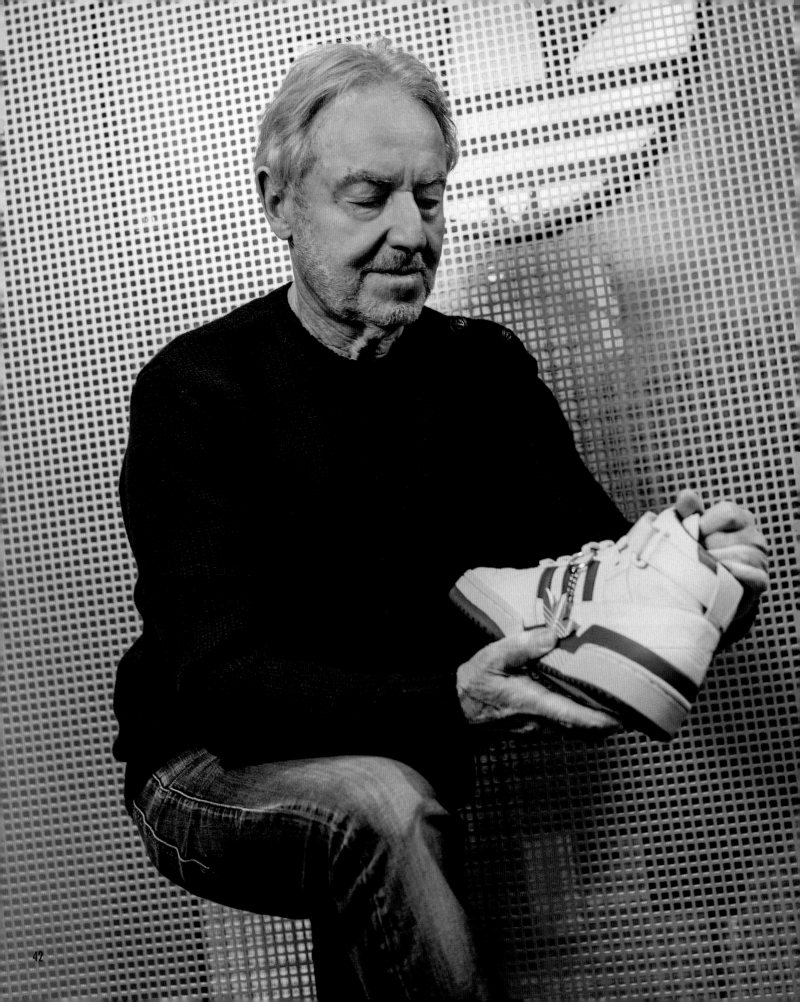

Sometimes people ask what would I do differently if were designing the Forum again today?

You know what? I wouldn't change a thing.

I admire many of Jacques Chassaing's designs, but the one that means the most to me is the Forum because it's indelibly associated with my love for hip-hop culture. In '80s and '90s Britain, basketball just wasn't a massive sport, so you were far more likely to see Forums on people into hip-hop than you were on a basketball player.

Because you could play football in them, most people in the UK gravitated towards running shoes, but hip-hop's connection with balling stoked a fascination in me for the basketball shoes that hip-hop artists were wearing. I would check out what the rappers and B-boys were wearing in magazines and videos, although many of them would be wearing Superstars, Suedes, etc. the guys I followed such as Public Enemy and Tuff Crew etc. were wearing Forums.

The first hip-hop artist I saw rocking them was Jam Master Jay. People automatically associate Run-DMC with the Superstar because it was synonymous to their style. So while Run and Darryl McDaniels stayed true to that look Jay was the one breaking protocol and wearing Forums and other adidas models, because he was the most stylish of the three and probably the closest to the look of the streets. The other notable guy who rocked Forums was Flavor Flav of Public Enemy. I was feeling the way he wore them open–with the tongue prominent, laces loose and strap undone, just like in the seminal "Fight the Power" video. I'm pretty sure PE and the whole '98 Posse are wearing Forums, Rivalries, and Conductors in that video. So it was Chassaings all the way for those guys.

It doesn't usually get talked about much, but aside from basketball, an even bigger influence on hip-hop fashion were drug dealers. As they were up to their eyes in cash, they always bought expensive stuff, not just to look good but also it was almost a form of money laundering. Instead of just stashing away their nefariously gotten gains, they would rock it. That's why they had the fur coats, the Double Goose jackets, the gold teeth, and the gold chains. The Forum being the first $100 basketball sneaker meant they just had to have the ultimate status symbol for their feet. Because these guys were the most stylish people on the street, when the rappers and B-Boys came along, they wanted the same gear.

One of the things I loved about the Forum and why it was so popular as street fashion, was its aggressive silhouette. It made a statement with its sharp wedge profile, short toe box, high eye stays and the criss-cross strap and looked proper B-Boy, proper street, so it became a mission for me to obtain a pair. Living in Aylesbury, an expansion town just outside of London, the local market just didn't cut it for more discerning fashion choices, so I'd head into London as the stores there had more upfront choices, but at that time I couldn't find Forums for love nor money. The one time I found a beautiful white and burgundy pair in a Footlocker in Birmingham, they didn't have my size and I was gutted. Despite it being the shoe I wanted more than any other, it eluded me for years, even though during trips abroad I would often spend a good portion of my shopping time trying to hunt down a pair of those bad boys.

People rightly heap praise on the Superstar as one of the first basketball shoes to make the transition from courtwear to streetwear, but you have to remember it was an already an old shoe by the time that happened, so it didn't impact the look of future shoes in the revolutionary manner of the Forum. It was the Forum's silhouette that became the archetypal basketball sneaker, influencing the style of not just later adidas basketball shoes, but all the other brands throughout the '80s and early '90s. It set the levels so high it's still a pinnacle in not just hip-hop and basketball sneaker history, but sneaker history full stop.

To me and many others, it remains one of the most beautiful sneakers of all time, not just because of its striking aesthetics but because it was designed to perform at the highest level. There's a compelling reason it was Michael Jordan's favorite basketball sneaker before Nike came along. Features that look like they're just there for appearances, like the Dellinger web or the foreflex notch, and the criss-cross strap system are there for performance reasons, not just aesthetics, but Jacques Chassaing managed to incorporate those design elements in such a serendipitous fashion, it conquered the streets as well as the courts. There are only a handful of sports footwear designers who have achieved that, which is why, for me, he is without question one of the greatests!

KISH KASH
Sneaker collector, DJ, podcaster and cultural archivist
@kishkash1

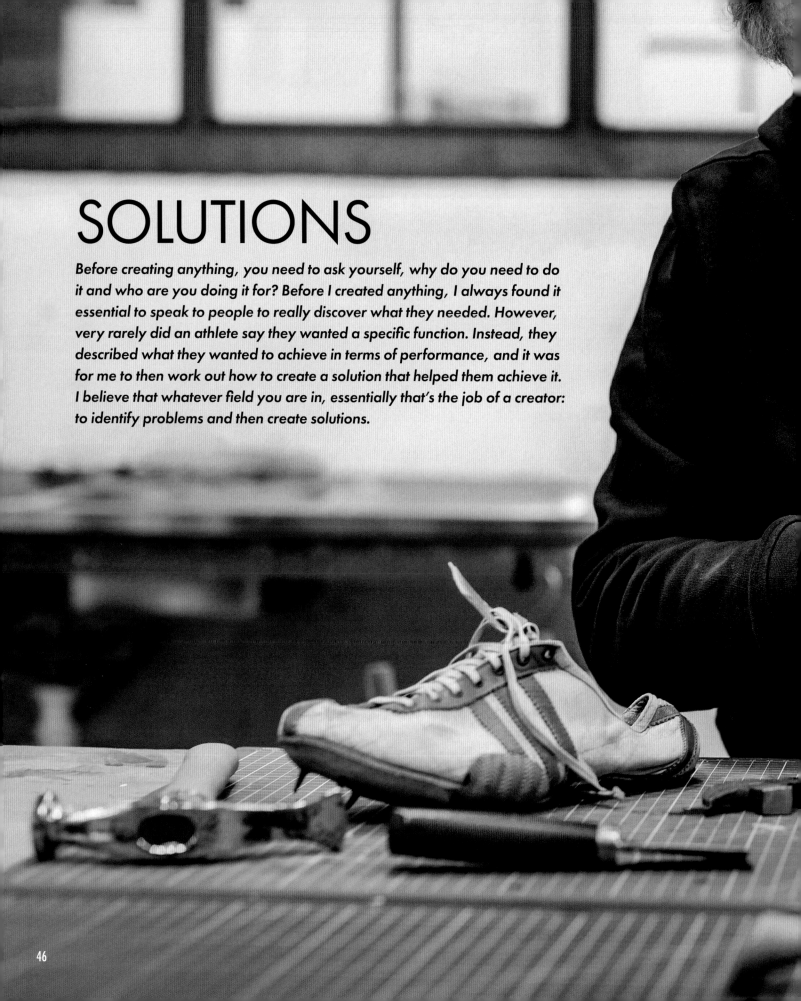

SOLUTIONS

Before creating anything, you need to ask yourself, why do you need to do it and who are you doing it for? Before I created anything, I always found it essential to speak to people to really discover what they needed. However, very rarely did an athlete say they wanted a specific function. Instead, they described what they wanted to achieve in terms of performance, and it was for me to then work out how to create a solution that helped them achieve it. I believe that whatever field you are in, essentially that's the job of a creator: to identify problems and then create solutions.

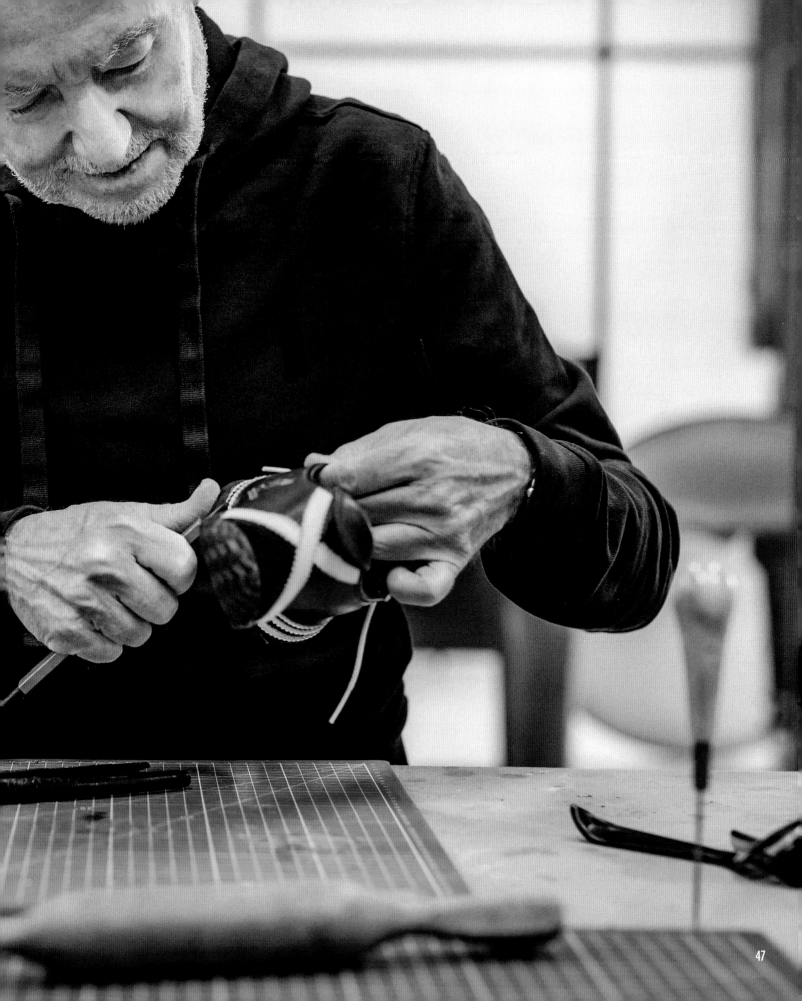

ZX500 ¹⁹⁸⁴

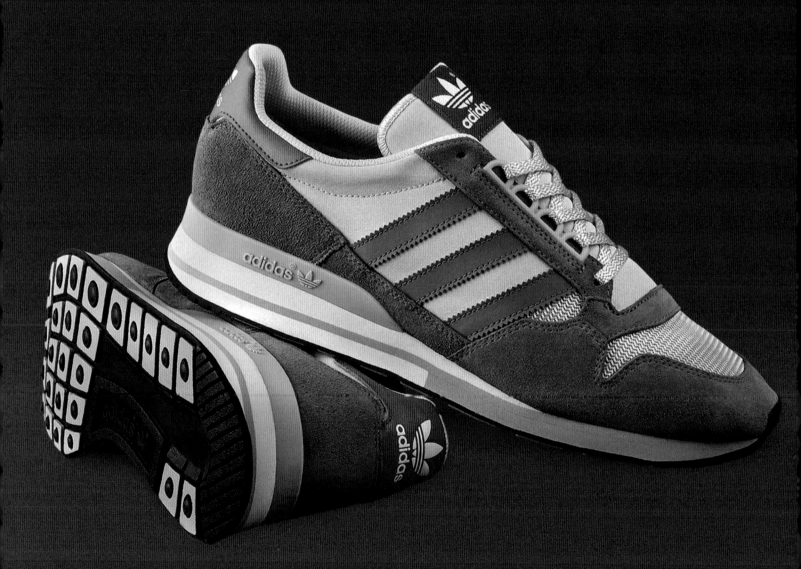

THE BIRTH OF ZX

The idea of ZX was really born out of a kind of frustration.

When we needed to design a new running shoe for the 1984 collection, I looked at the previous years' catalogs and what our rivals were offering, and realized it was a confusing marketplace for runners. If you walked into a sporting goods store, you were faced with a bewildering choice of shoes, and it was hard to find any kind of structure in terms of product positioning that addressed the needs of individuals.

Runners come in different shapes and sizes and run in all kinds of environments, so a "one shoe fits all" approach doesn't really work. The idea was for a customer to be able to go into a store, and, depending on their body type and running style, easily understand which was the best shoe for him or her. Rather than just buying a pair of shoes based on how they looked or what color they were, a runner could buy the model best suited for their individual needs. That was the essence of ZX.

The ZX 500 was the genesis of the range. I felt we should start with a support shoe, which went against the grain at the time, because when the US sales guys would come over,

they would show us shoes from our rivals and prod the soles, saying, "Soft! Soft! Soft!." It was a trend at the time for running shoes to be like a mattress, but that isn't necessarily great for your feet because, in the long term, soft shoes cause you to run less naturally. My aim was to allow people to run as naturally as they would barefoot but with comfort. That meant providing stability, not softness, and it became the driving idea behind the ZX 500.

What made it special at the time was that it was designed around the concept of motion control. An extended heel piece stabilized and supported the foot so that it landed in a neutral position and didn't roll inwards and cause potential injury. On the medial (inner) side, it also acted as an arch cookie to support the arch and instep of the foot.

The midsole was very pioneering, being constructed from separate pieces of EVA, creating different zones of support. At the heel, it featured multiple EVA layers with differing densities that reduced shock in stages and acted like a dispersion plate. On the medial side, the EVA pieces were harder to stop over-pronation or roll. Some pronation

is natural, but by making the EVA harder on the inner side, the shoe could control it.

Although it was a fresh approach to creating a running shoe, we didn't want or need to completely reinvent everything. Features such as the ghillie speed lacing system that Adi Dassler created still worked well, so we evolved it rather than trying to reinvent it. It was the same with the outsole, which was an evolution of the one previously used on the Zelda running shoe. It has what look like studs or plugs that provide traction on loose surfaces, like mud or sand, but are hollow, so that they can compress and create suction, providing grip on hard surfaces. The beauty of it was that one design provided benefits on two very different types of terrain.

When the ZX 500 was tested by the German consumer testing agency Stiftung Warentest, it got the top review, which was the first time for an adidas France shoe. I still have the cover of the newspaper! But something that made me even happier was when *Paris Match* did a feature on the actor Richard Chamberlain, and there he was with a pair of ZX 500s!

ZX 500

Du punch et de l'équilibre.

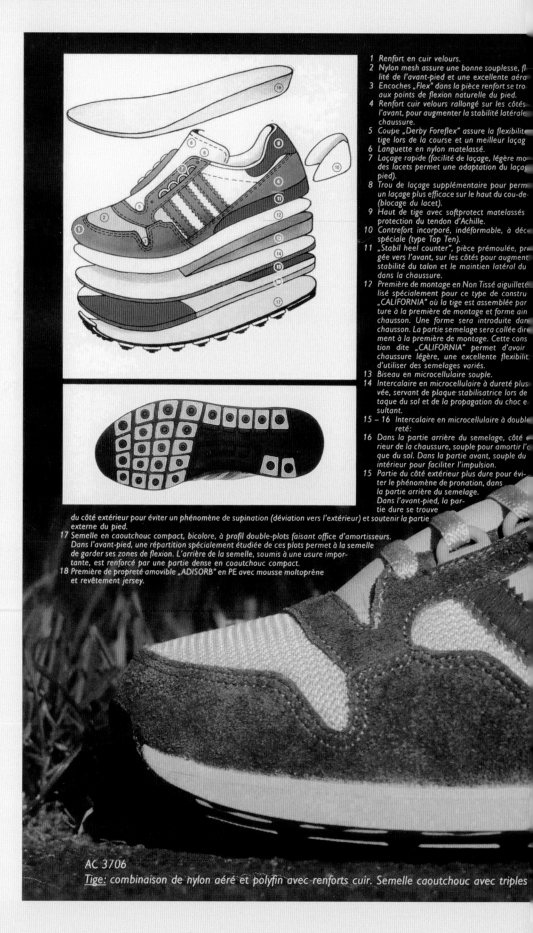

1 Renfort en cuir velours.
2 Nylon mesh assure une bonne souplesse, fl
lité de l'avant-pied et une excellente aéra
3 Encoches „Flex" dans la pièce renfort se tro
aux points de flexion naturelle du pied.
4 Renfort cuir velours rallongé sur les côtés
l'avant, pour augmenter la stabilité latérale
chaussure.
5 Coupe „Derby Foreflex" assure la flexibilit
tige lors de la course et un meilleur laçag
6 Languette en nylon matelassé.
7 Laçage rapide (facilité de laçage, légère mo
des lacets permet une adaptation du laça
pied).
8 Trou de laçage supplémentaire pour perm
un laçage plus efficace sur le haut du cou-de
(blocage du lacet).
9 Haut de tige avec softprotect matelassés
protection du tendon d'Achille.
10 Contrefort incorporé, indéformable, à déc
spéciale (type Top Ten).
11 „Stabil heel counter", pièce prémoulée, pr
gée vers l'avant, sur les côtés pour augment
stabilité du talon et le maintien latéral du
dans la chaussure.
12 Première de montage en Non Tissé aiguilleté
lisé spécialement pour ce type de constru
„CALIFORNIA" où la tige est assemblée par
ture à la première de montage et forme ain
chausson. Une forme sera introduite dan
chausson. La partie semelage sera collée dir
ment à la première de montage. Cette cons
tion dite „CALIFORNIA" permet d'avoir
chaussure légère, une excellente flexibilit
d'utiliser des semelages variés.
13 Biseau en microcellulaire souple.
14 Intercalaire en microcellulaire à dureté plus
vée, servant de plaque stabilisatrice lors de
taque du sol et de la propagation du choc e
sultant.
15 – 16 Intercalaire en microcellulaire à double
reté:
16 Dans la partie arrière du semelage, côté
rieur de la chaussure, souple pour amortir l'
que du sol. Dans la partie avant, souple du
intérieur pour faciliter l'impulsion.
15 Partie du côté extérieur plus dure pour évi-
ter le phénomène de pronation, dans
la partie arrière du semelage.
Dans l'avant-pied, la par-
tie dure se trouve

du côté extérieur pour éviter un phénomène de supination (déviation vers l'extérieur) et soutenir la partie
externe du pied.
17 Semelle en caoutchouc compact, bicolore, à profil double-plots faisant office d'amortisseurs.
Dans l'avant-pied, une répartition spécialement étudiée de ces plots permet à la semelle
de garder ses zones de flexion. L'arrière de la semelle, soumis à une usure impor-
tante, est renforcé par une partie dense en caoutchouc compact.
18 Première de propreté amovible „ADISORB" en PE avec mousse moltoprène
et revêtement jersey.

AC 3706
<u>Tige:</u> combinaison de nylon aéré et polyfin avec renforts cuir. Semelle caoutchouc avec triples

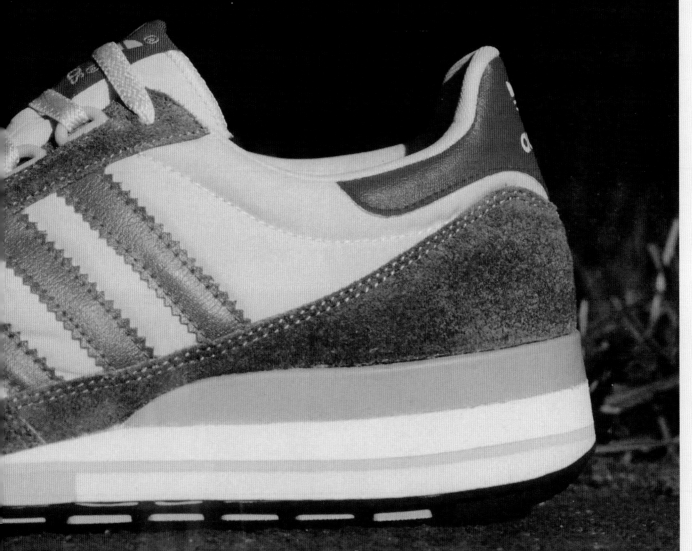

La première fois qu'une chaussure de running protège aussi efficacement les sportifs dans leur course!
Sa grande stabilité, son soutien et son maintien exceptionnels du pied la désignent en priorité à tous les coureurs sujets à une pronation excessive.
Spécialement conçue pour l'entraînement tout terrain, impulsive, souple et ultra confortable, sa semelle à double plots en fait la vedette du running par sa bonne adhérence au sol et ses qualités d'amortissement des chocs.

amortisseurs. Intercalaires et biseaux en microcellulaire bi-densité, contrefort arrière de stabilisation. <u>Avantages:</u> stabilité, confort.

INSPIRATIONS:

ZELDA ¹⁹⁸²

The Zelda was one of the first premium adidas running shoes positioned at the apex of where performance met lifestyle. Even though it wasn't a "serious" running shoe in the mold of the later ZX series, some of its features inspired the design of the first ZX shoes, such as the unique hollow stud outsole design that gave it fantastic traction on multiple surfaces and would be used again on the ZX 500.

Perhaps the highlight of the shoe was that it was made from soft leather, or what is better known now as garment leather, which gave it a unique feel on foot and also meant it was very light. It was very unusual to use such a soft leather on a running shoe at the time. Reebok also used it on the Freestyle, and it was one of the reasons it became such a huge hit.

ZX600 ¹⁹⁸⁵

We created the ZX 600 for runners
who did serious mileage on hard
surfaces like road and pavement.
Because these types of terrain are
very hard and abrasive, we used two
different compounds of rubber on the
outsole. The toe and heel areas were
made using compact rubber because
this is where you have the most wear,
especially on hard surfaces, whereas
the rest of the outsole was made from
expanded rubber, which is softer and
gives you more shock absorption.
The midsole was an adaptation of the
idea used in the ZX 500 of having
different densities of material to
improve stability, with the core made
of polyurethane and the toe and heel
zonal inserts made of EVA.

ZX 710 *1987*

The ZX 710 was an evolution of the top of the range ZX 700, which was designed as an all-terrain shoe with an off-road profile. Our focus with this shoe was lightness. Many runners at this time were really crazy about weight, to the point the first thing they wanted to know was how much the shoes weighed, rather than what its comfort and benefits were. With this in mind, the midsole was made from polyethylene, a very light polymer usually used in packaging, and wrapped in a Dellinger Web. The rear of the shoe sat in a lightweight molded heel shell to provide stability and support. We tried something a bit different on the outsole for the 710. We created a curved line that followed the flow of pressure from the heel to the big toe and used a red colored insert to indicate the flex zone of the shoe and green to highlight the landing zone on the heel.

INSPIRATIONS:
OREGON *1981*

The Oregon was one of the first adidas shoes to pioneer the Dellinger Web that we used on ZX 710 and several other ZX series shoes. Both the name of the shoe and the web came thanks to its inventor, Bill Dellinger, Head Coach of the famous University of Oregon track and field team, and an Olympic 5,000 meter medallist. The web was a polyamide netting that was glued to the sides and bottom of the midsole, but left free to move on the top, giving it a kind of trampoline effect and dispersing shock across the entire sole. Some thought it was just an aesthetic feature, but, in fact, it had a real performance benefit and was used on many adidas shoes in the '80s. I liked using the Dellinger Web on my shoes because it was an example of a visible technology and gave a shoe a unique look and visual link to others in the adidas family.

I heard the name Jacques Chassaing for the first time in 2008. The adidas AZX series with various 3- and 4-digit ZX models hit the stores and, as a highlight, there was an ultralimited pair with the likeness of Jacques and Markus Thaler. This sparked my interest, so I started to research.

As a collector, it was always important to me not only to own the shoes, but also to gather as much information as possible. As a part of adidas France, Jacques worked on the very models that would become my favorites years later. I was amazed at how many adidas shoes Jacques was involved with as a designer: running, basketball, tennis, everywhere he incorporated his experience.

The ZX 500 from 1984 is one of my all-time favorites and Jacques designed that model from the design draft up to the finished product. In 2012, I got to design my own version of the ZX 500 as part of the "Your Story" campaign, a dream come true! Sometime later, I was asked to sign a pair for Jacques because he liked my version so much, which was an indescribable feeling and a great honor for me.

For a book project I did together with the illustrator Peter O'Toole, I visited the adidas archive for a few days in 2014. I was researching some interesting information for the models in the book, which of course, included some models that Jacques had his hand in. But the highlight was that I was able to spend a couple of hours with Jacques in person and talk with him about the different models. He had some interesting background info on the shoes and I really enjoyed listening to him while diligently taking notes. A lot of that info was absolutely valuable and went into the book.

I have continued to follow Jacques's work over the years and was glad that such a legendary designer from adidas was there to assist younger colleagues. His knowledge and personality is incredibly important to adidas, and I hope he continues to share that with his colleagues for a long time.

A few years later, I finally turned my hobby into a profession and started working for the Berlin sneaker store Overkill. Among my first projects, there was one in particular, which is one of the biggest and most important in the history of the store so far. adidas had decided to continue the story of the ZX series and create a model that was the missing link between ZX and Equipment, the ZX 10,000 C, which was brought to life with great support from Jacques. A new model—but one that clearly features the ZX DNA.

We at Overkill got to celebrate the launch of the model with our collaboration and rented a huge venue for the occasion. Our guest of honor was Jacques Chassaing. Many ZX fans had their boxes signed, joint photos were taken and, of course, talks about adidas ZX were held. I am very happy that I had the opportunity to meet Jacques personally several times and nerd out about adidas shoes.

ZX 800 ¹⁹⁸⁶

In French, we have a term, *surenchère*, that in English means "one-upmanship." It's a description that comes to mind with the ZX 800 because it's a perfect example of what was going on in the sports shoe industry at the time, which was a fight with our rivals over who could bring the most innovations to a running shoe. We never received a trophy, but maybe we should have because we really packed the ZX 800 full of new ideas and technology.

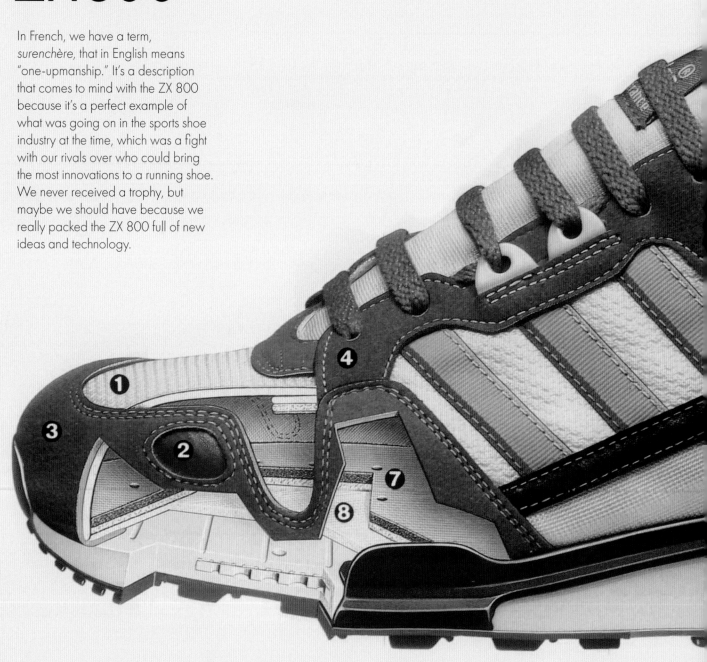

Technical cutaway drawing from the 1985 catalog detailing the ZX 800's numerous technical innovations

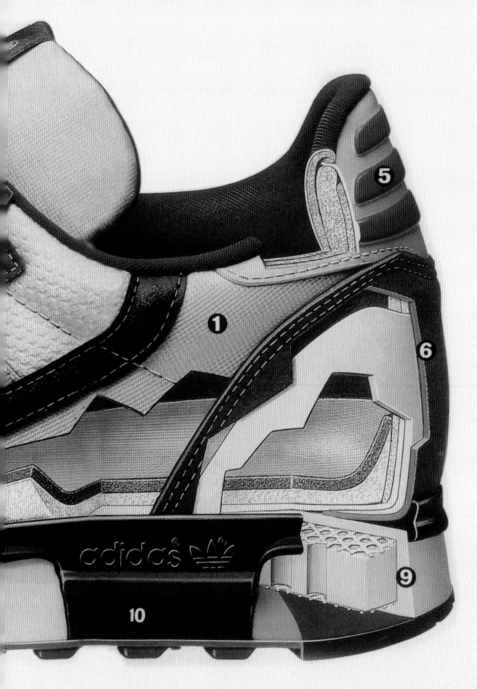

1 Combined polyester mesh on foam and metallic polypag nylon upper for ventilation and lightness

2 Reflective trim

3 Synthetic velour front reinforcement for support and protection of the foot

4 Double lacing system guaranteeing better transverse support of the forefoot and a good hold of the upper

5 Two-tone Softprotect quilted "flex": Achilles tendon protection

6 Synthetic velour reinforcement with buttress incorporated for heel support and directional control of the shoe

7 Removable insole with ventilation holes

8 Moccasin construction for forefoot flexibility and lightness

9 Low density polyurethane midsole with stabilizing inserts and Web mesh reducing the shock by dispersion and energy return

10 Compact pre-cast part called RSD, providing directional rear and side hold:
- inner side: controls pronation in ground attack phase
- outer side: controls supination in pulse phase

INSPIRATIONS:

NITE JOGGER ¹⁹⁷⁶

A shoe I was head over heels about was the Nite Jogger. What I love about it was that, from a visual point of view, it's not so different from other classic adidas training shoes, but it's the things you can't see that make it special for me. The first is that it was made from Cangoran, a synthetic material that was designed to replicate the properties of kangaroo leather, namely strength and lightness. At the time, kangaroo leather was banned in many places like California, so as adidas advertised, Cangoran was "One less worry for 20 million kangaroos."

The other feature, which gave the shoe its name, was that the heel tab had a phosphorescent coating that glowed in the dark and a reflective coating on the Three Stripes and tongue that lit up when car headlights and street lamps shone on them. It was a really cool idea that made them a safety device as well as sporting equipment that we used on many of the ZX models to enhance nighttime visibility.

ZX930 *1988*

The ZX 930 was the last of the hundred series, but it probably gave me the most headaches. Maybe that's why it was the last! If you look at the outsole, you can see it was split between the forefoot and rear foot. It was a year before we launched Torsion, which was based around the same idea of separating the sole into two parts, so I had a lot of hesitation from my colleagues who said I shouldn't do it because it was heading in the same direction as Torsion. But I basically didn't listen and resisted changing it because I wanted to mimic the rotation that happens in the foot in the shoe's outsole. So it wasn't Torsion, but almost.

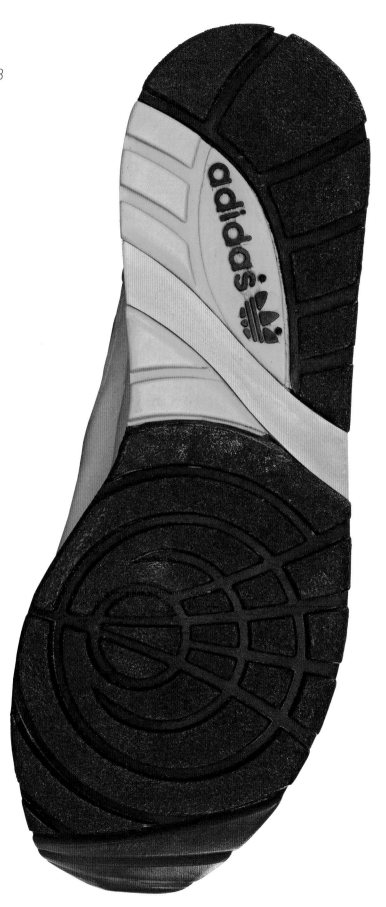

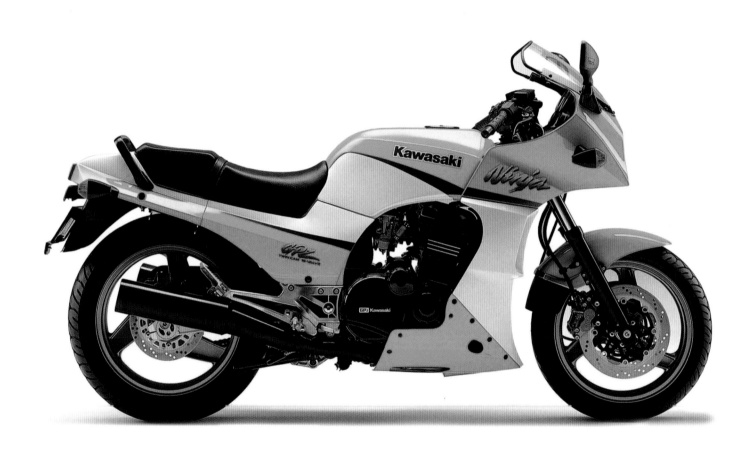

WHY ZX?

Even today, people still ask me where the name ZX comes from. When it was launched, people thought it had some sort of biomechanical or mathematical connection, or something to do with the Z and X axis on a chart, but it was actually inspired by the Kawasaki ZX900A motorcycle (GPZ900R in Europe). The adidas France marketing guys thought ZX sounded sexy and fun, so we went with it. In 2021, adidas celebrated the link with a special edition Kawasaki ZX 8000.

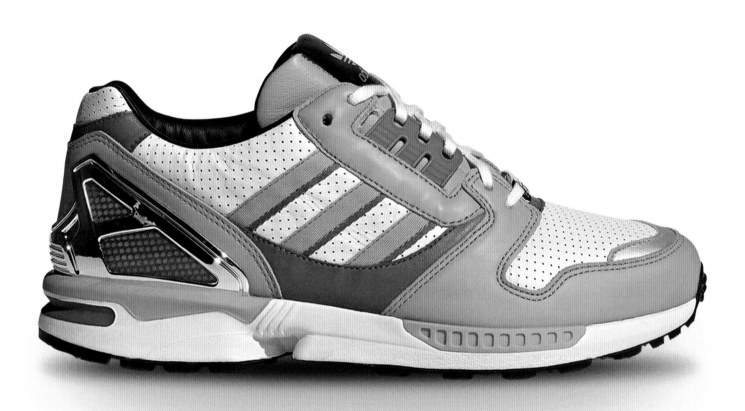

ROBERT McCARTEN

Mention the name Jacques Chassaing to me and it stirs up lots of great memories. I remember the first time I saw the early ZX models. Until the mid '80s, the runners in the shops we went to were classics such as Oregon, TRX, and Marathon TR. Then there were the rarer, almost mythical runners like Waterproof and Zelda, two models I only ever saw decades after release. (I'm glad to say that I now have a pair of each in the collection.) Then the ZX range started to appear. As fresh as they looked, they seemed semifamiliar, having elements of the great runners we already knew, such as the webbed midsole of the Oregon on the ZX 380 and the ghillie lacing system of the New York on the ZX 500. Today I have a huge collection of both vintage and modern trainers, but one pair I refuse to add is a reissue ZX 500. It's such an important shoe, it's an original French pair or nothing!

In 1985, the legendary ZX 600 was launched, a shoe that had everything. Although similar in color to its predecessor the ZX 250, the ZX 600 was built to last, with a dual-density midsole, heel counter, the finest polypag mesh and a killer colorway. A real premium shoe, and I had never seen anything like them before. I still remember holding one in a sports shop, and they seemed almost futuristic. Premium shoes came at a premium price though, and I'm sure they retailed at around £65. Well out of my league as a young lad with a Saturday job!

Another memory is of my friend Graham, who lived a few houses up the road. He was four years older than me and in full time work. He'd often have a new tracksuit or jacket, and when he opened the door that day it was the first time I saw the beautiful ZX 710. A stunning pair of runners with a colorway, like the ZX 600 they had everything going on, but were also poles apart. Another proper premium runner, everything about them was excellent, the colors, the shape, the materials, they just looked so good. I've always been interested in all the little functions and elements of a shoe, and I used to look at them and wonder why there was criss-cross stitching on

the midsole, the plastic rings the laces went through, the reflective strips, the branding logos and the plastic guards on the heels. It was the technical things that done it for me. Looking back, Jacques Chassaing and his team were creating the worlds best running shoes at adidas France in the 1980s. The evolution from the 3-digit ZX range ending in the excellent ZX 930, to the 4-digit ZX Torsion range was jaw dropping. It seemed to happen so fast, but even more impressive was that they were very different to what we had seen previously, a whole new technology. Not only did they have ground breaking sole units, they came in an array of colors, from bold aqua blue to pastel green, reflective panels, soft cell cushioning, and premium materials too. Running shoes had never been so good.

As a 16 year old high school leaver in 1989, the house music scene in the UK—especially the North West—was peaking, and the local night club, The Quadrant Park, was packed with over 2000 people every week. With no dress code and an all-night license, comfortable trainers were a must. The 4-digit ZXs were the answer. The contrasting colors lent themselves to the clothing of that era. Some lads wore flared jeans, tie-dye hooded tops with suede shoes, and a big middle part, but for us it was Torsion, teamed with an adidas velour tracksuit and a Berghaus jacket and crew cut. Anything else just wasn't good enough.

For me, the ultimate ZX Torsion model is the ZX 8000. I remember five of us getting the train into Liverpool city center one sunny Saturday afternoon, each of us wearing brand new ZX 8000. They were mind-blowing, and they still are. I hear stories from lads my age saying it was about finding trainers that no one else had, but for us, it was about having the very best, together. It was a statement, I suppose. Although Jacques and his team had set out to create an ideal investment for the serious runner, we would wear Torsion for dancing through the night, going to the match, and shopping in town. The perfect storm for everyone...

ROBERT McCARTEN
adidas collector, history expert and advisor
@a_distant_ship_smoke

When Ivan Lendl won the
1984 final at Roland Garros,
I remember going absolutely
crazy. It was such a special
feeling to see him win in
France wearing my shoes.

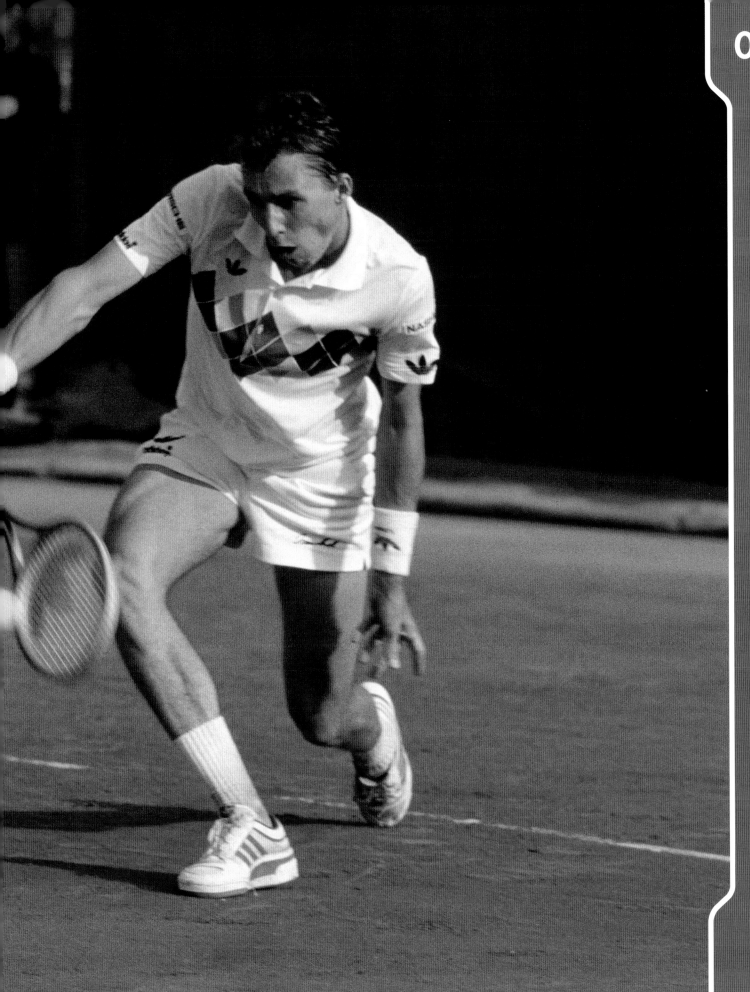

1984 - IVAN LENDL

LENDL COMPETITION ¹⁹⁸⁴

My first tennis shoe. My first winner.

In tennis, you used to focus on clay court or hard-court shoes, but with the Lendl Competition, I wanted to design just one shoe that would work on both surfaces. When you look at the outsole, you can see there are two styles of herringbone pattern. Usually for clay courts, the herringbones are thin so that they can dig in and grip the surface, but for hard courts, you need a wider pattern for the best grip. The width also provides better dispersion of impact on hard courts. So I combined the thin herringbones from the Superstar, and the wider ones from the Nastase to create a mixed profile that plays well on both surfaces.

Wimbledon was different though. For lawn courts, we created a profile made up of tiny dimples that gripped the grass. Each year before The Championships, you had to submit your shoes to the tournament committee to check the shoes complied with their rules and didn't damage the courts. But after the shoe was approved, Ivan Lendl asked us to put two raised parallel "walls" on the medial side of the toe area to give him more grip. We told him it wouldn't be approved by Wimbledon, but he was sure that they wouldn't notice once the tournament began, so we added them. He was right; they didn't notice!

Rather than making it a full leather shoe, for better breathability, we went with a mix of both leather and nylon mesh. Like the ZX 500, I used ghillie speed lacing, which at that time was a real adidas signature feature.

Lendl really loved this shoe. He felt it was "his" shoe, not just because his name was on it but because he said he felt so good in it. One thing he especially liked was that the motion control unit in the shoe's heel gave it a pretty wide surface, which made him feel really planted when receiving his opponent's service.

When we began creating Torsion tennis shoes, I went to see him before a tournament with prototypes to get his impressions. He tried them on in his hotel room, then he turned to me and said, "No. Keep them. I'll stay with the Comp." The fondness he had for the shoe was clear. When he left adidas to join Mizuno, they made what appeared to be a very close copy of it. We had a similar situation with Steffi Graf. She grew up with the adidas Grand Slam, so the shoe meant a lot to her in terms of confidence, even though it was by then an older model. So, when we created a Steffi Graf collection for her, although they were made to look like the new model, she mostly competed in Grand Slams.

The Lendl Competition shoes that Ivan
Lendl wore to win Roland Garros in 1984

LENDL SUPREME *1985*

1 Asymmetrical leather reinforcement to support the foot during lateral movements

2 Soft leather low upper with perforations front and side for aeration

3 Lacing with flex cutouts and additional lace holes in the upper for improved hold

4 Flexing notch

5 Padded tongue

6 Comfort lining

7 Softprotect "flex" quilting: Achilles tendon protection

8 Rear and side leather reinforcement with in-built buttress to protect the heel during movement

9 Removable sock liner

10 Polyurethane midsole with stabilizing inserts, guaranteeing comfort, lightness, and good shock absorption

11 In-built "Stabilo" unit in the sole increasing stability and directional control of the shoe

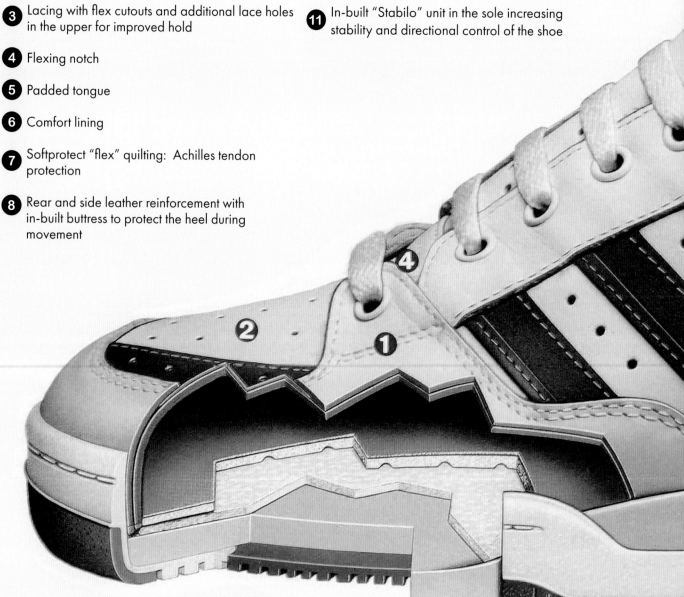

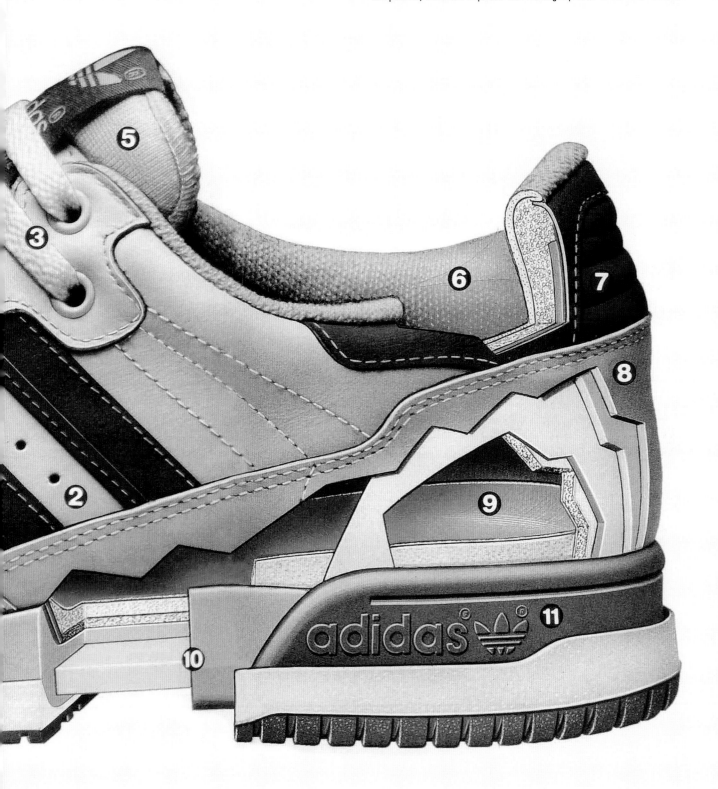

Illustration from the 1986 adidas France catalog. Although Lendl didn't wear it in competition, the Lendl Supreme was the flagship shoe of the Lendl collection.

1986 - RUN-DMC COLLECTION

RUN-DMC

When three rappers from New York started wearing Superstars and adidas tracksuits, we realized something new was happening with the brand on the streets.

People often ask me, "When do you think sneaker culture was born?" The truth is I really don't know. I don't think you can say there was just one single moment, like a moon landing, but speaking for myself, it was Run-DMC who made me realize that there was something happening.

We were always very focused on sport and performance at adidas but, of course, we knew people loved to wear sportswear day-to-day too. Up to that point, it had always been about comfort. When Run-DMC first appeared on our radar, we realized that something was changing. Wearing sportswear on the street wasn't just about comfort; it was about identity.

Even though it wasn't worn by the top players any more, we knew the Superstar was still popular in the United States, especially with young black guys in cities where street basketball and the NBA were popular. They had seen their favorite basketball players wearing Superstars in the past and wanted to wear them too. In the '70s, when the Superstar was a pro-level shoe, that wasn't so easy. It would have been rare for someone who wasn't a player to own a pair because you couldn't buy them from just any sporting goods store. You needed to

know someone who knew someone. If you could get and afford a pair, they were a kind of status symbol.

By the '80s, the Superstar was no longer our premium basketball shoe, so it was less expensive than the Top Ten and Forum and was also more easily available, but it still had prestige as a street shoe, which is why it appealed to Run-DMC. Because they wore Superstars and tracksuits on the street, they also wanted to wear them on stage. It was a statement about who they were and where they came from.

We first heard about Run-DMC from a great guy called Angelo Anastasio. Angelo was a former soccer player with the New York Cosmos who had been taken on to look after entertainment promotions. He was perfect for the job because he seemed to know everyone in Hollywood and managed to get lots of movie stars wearing adidas. Once he got us to make some customized motorcycle boots for Sylvester Stallone. He was a real charmer, a bit like an Italian-American Don Johnson from "Miami Vice," and even drove a Ferrari with "ADIDAS1" on the license plate!

Angelo first met Run-DMC when he went to a concert. After the show

London

A

MADE IN ENGLAND

LON 101
(886 070-7)
ZPMSC 10974

From the
Album
"RAISING
HELL"

Original Sound
Recording
Made by
Profile
Records Inc.

℗ 1986
Profile
Records Inc.
Licensed to
London Records
Ltd.for the U.K.

Copyright
Control/
MCPS

45

MY ADIDAS
(J.Simmons/D.McDaniels/R.Rubin)

RUN-D.M.C.
Produced by Russell Simmons and
Rick Rubin for Rush
Productions

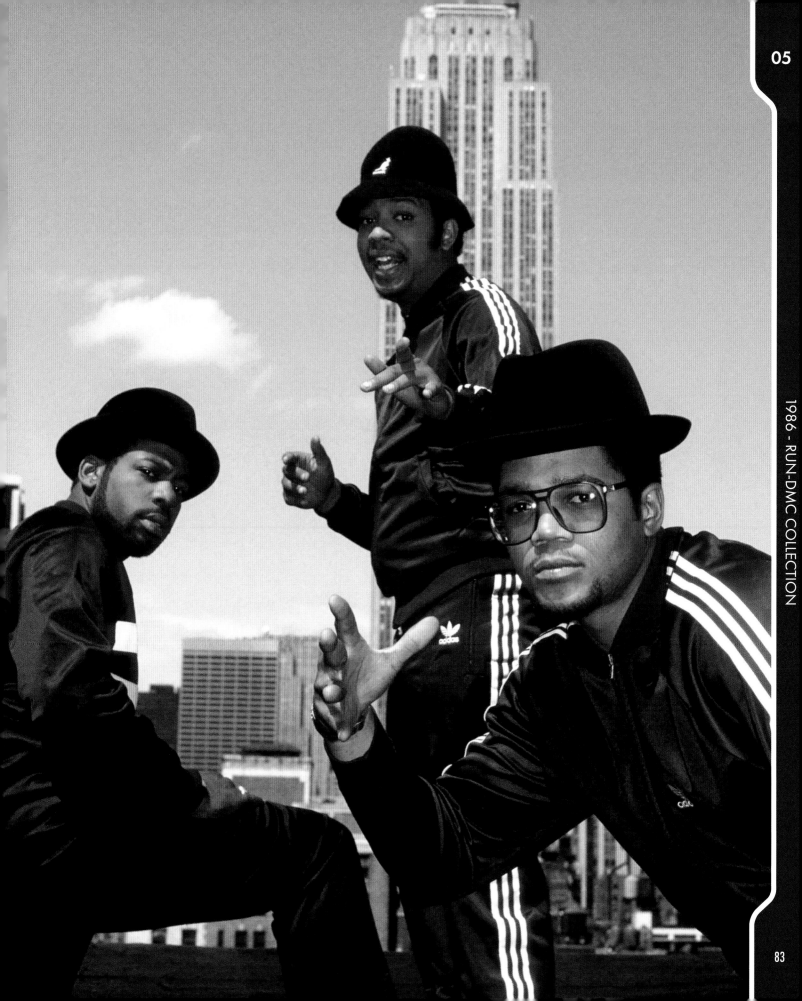

he saw them break dancing outside the venue wearing adidas top to toe and introduced himself. They weren't stars yet, but he stayed in touch with them. When they became famous, he made sure they had plenty of adidas product. After they built up a huge following, their fans all started wearing Superstars and adidas tracksuits too—something that wasn't exactly unusual because fans of athletes did the same, but the difference was that we weren't paying Run-DMC anything.

It wasn't like that for long though. After they had a big hit with "My Adidas," they really wanted an endorsement deal so they invited Angelo to a show. When they sang the song, they asked all the fans to hold up their sneakers, and Angelo saw a sea of Superstars. After more lobbying from the band and their manager, Angelo spoke to Horst Dassler about doing an endorsement deal and brought him to one of their shows. I don't think Horst really got it until he went to that show, but afterward he approved a deal for $1 million which was a huge amount of money at the time. When you look at it now, it seems almost visionary, but back then some thought it was crazy because we had never done a deal like that outside of sport.

As part of the deal, we produced a Run-DMC collection. Usually when we designed shoes, we did so with a very specific and focused performance goal. What I loved about working on the Run-DMC collection was that we could have some fun and do something a bit more crazy than we usually would.

Because they were so synonymous with the Superstar, we used it as the starting point for the Ultrastar. The idea was to keep it more or less true to how the band wore it, so we gave it an elasticated tongue to make it easier to wear without laces, or to slip on easily if you did keep them on. At the back, we supersized the heel tab and gave it a massive Trefoil with a lined "grille" effect. We also made the eyestay longer and gave it a "notch" for better comfort.

Along with the Ultrastar was the "Cadillac Line," three shoes named after the group's favorite cars: Eldorado, Fleetwood, and Brougham. Eldorado was a super hi-top with a huge padded tongue and concertina-style upper side panels, as was the Fleetwood, which had the same construction but with reptile skin effect leather. The Brougham was a low top version of the Eldorado. All three blended influences from the Top Ten, Forum, Rivalry, and Metro Attitude to create a collection that had clear basketball influences but were at home on the street.

Along with a great clothing line and marketing campaign, the Run-DMC collection was groundbreaking for both adidas and the sneaker industry. At first, many thought it was strange for us to do a non-sport collaboration, but as sport and street fashion were becoming more and more symbiotic, hip-hop represented the center-point and showcase of that relationship. Looking back on that time and how sneakers and hip-hop continue to be inseparable today, I'm proud to have been there at the start of it all.

Run-DMC collection from the 1988 adidas USA catalog

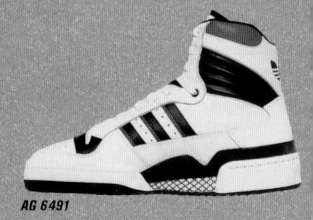

AG 6491

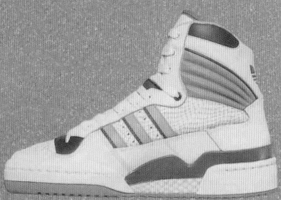

AG 6518

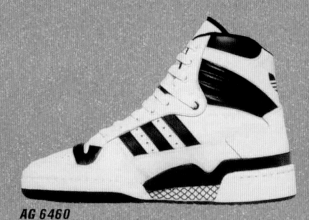

AG 6460

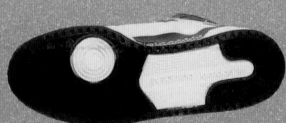

Fleetwood **Sizes: 6-13,14**

Uppers: Premium grade full-grain reptile-impression leather with nylon lining. Thickly padded, extra-wide polyurethane tongue with Adi "Foot Rap" elastic tongue straps. Notched Achilles heel. Pre-molded rubber ankle flex zones. Compact rubber Stabilo Heel Support System with pre-molded thermoplastic counter. Removable inlay sole with terry lining.
Midsole/Shell Sole: Microcellular midsole covered by the Web System. ¾ rubber shell sole with multi-disk profile and serrated edges for fast cutting.

Eldorado **Sizes: 6-13, 14**

Uppers: Full-grain leather with reinforced nylon lining. Upper features same technical innovations for support, stability, and cushioning as the men's *Fleetwood.*
Midsole/Shell Sole: Microcellular EVA midsole covered by the Web System. ¾ rubber shell sole with multi-disk profile and serrated edges for fast cutting.

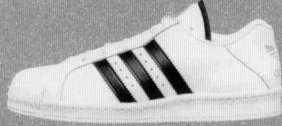

AG 6185

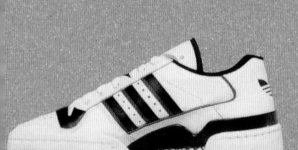

AG 6525

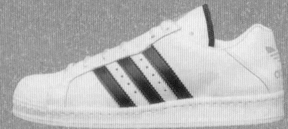

AG 6587

AG 6532

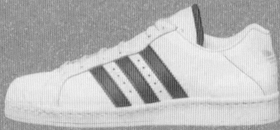

AG 6453

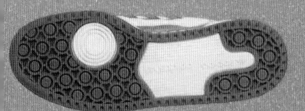

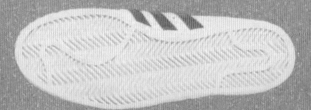

Brougham
Sizes: 6-13, 14

Uppers: Full-grain leather with reinforced nylon lining. Both upper and bottom construction feature same technical innovations as the men's *Eldorado,* but in low cut styling. *Midsole/Shell Sole:* Same as *Eldorado.* Covered by the Web System.

Ultrastar
Sizes: 5-13, 14

Uppers: Full-grain leather with rubber shell toe. Extra-wide, thick, polyurethane tongue features Adi "Foot Rap." Elastic tongue straps. Pre-molded thermoplastic heel counter. Notched Achilles heel, chrome-leather sock liner with arch support. *Shell Sole:* One-color stitched and bonded shell sole with herringbone profile.

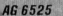

Humility... If I were asked to think of an individual from the sportswear industry who personifies that word, the answer would be Jacques Chassaing. His work comes from what I personally believe to be the golden age of sportswear before the internet, the hype, the influencers, and the fashionistas moved in. It was an era where imagination and creativity drove underclass youths—from Toxteth to the Bronx to Trench Town—in their re-purposing of performance sportswear for its aesthetic and stylistic value. Many of the products that Jacques designed were major catalysts in that adoption. This reinvention laid the foundations for sportswear being woven into the very fabric of popular culture and, in turn, becoming an essential reference for high fashion decades later.

There is an internal mantra inside adidas that states that "no individual is bigger than the brand." This is perhaps why the name of Jacques Chassaing—a man who arguably changed the face of athletic footwear (on more than one occasion) is not nearly as well known as his work warrants. No doubt Jacques would also want me to credit those colleagues he worked amongst in these achievements. Many within modern sneaker culture may not know who he is but anyone with even a passing interest in vintage adidas footwear is certain to be familiar with a number of his designs.

Jacques is unassuming. He remains an understated design genius, and perhaps that's the way he likes it. Who needs accolades when your work is intrinsic to the styling of some of the most important subcultures of the late twentieth century? Jacques has designed iconic footwear decade in and decade out, but my personal favorite era has to be the Eighties—his work owned it. The look of the pioneering years of hip-hop culture—back when it truly was rebel music—has the Chassaing signature written right through it. Yes, the Chris Severn-designed adidas Superstar holds its position as the definitive hip-hop shoe but alongside those icons are Jacques' adidas basketball designs. Designs that graced many an album sleeve from the Ultramagnetic M.C.s to the Beastie Boys. His designs formed the bedrock of the product selected for the sportswear industry's first non-athletic endorsement deal between Run-DMC and adidas.

I joined adidas in the late '90s at the tail end of what I consider to be the "golden age" and have been blessed to meet (and in some cases work with) a number of the people who I considered to be the unsung pioneers in an industry that has massively impacted my life. Of all those individuals Jacques is the one designer who I am probably most in awe of. This was the man who led the design on both of the original ZX series—my favorite footwear range of all time and an absolute staple for both northern football casuals and London rude boys.

They say never meet your heroes as they will only disappoint you—that was not my experience with Jacques. His attitude and integrity is exemplary and he personifies what I believe to be the adidas way—well mannered, dignified, and very honest. In spite of the praise he gets he maintains his objectivity and does not speak highly of everything he has produced. After a conversation with him in London about the original brief for the adidas Power Phase and Continental 80, I was inspired to design the Burnden SPZL. When the time came to reveal the Burnden SPZL on my personal Instagram, Jacques graciously sent a simple message to my personal Instagram commending the work. His comment cut straight through all the noise of the social media opinions that come with any new release. It was the greatest accolade the Spezial team could receive about them. I often look at the work that Jacques has been involved in for inspiration and reference in the product creation of Spezial because it is without doubt some of the very best of all time.

Jacques and the teams with whom he has worked over the years have repeatedly set the bar.

GARY ASPDEN
adidas Spezial curator, collector, historian, and brand consultant
@gary.aspden

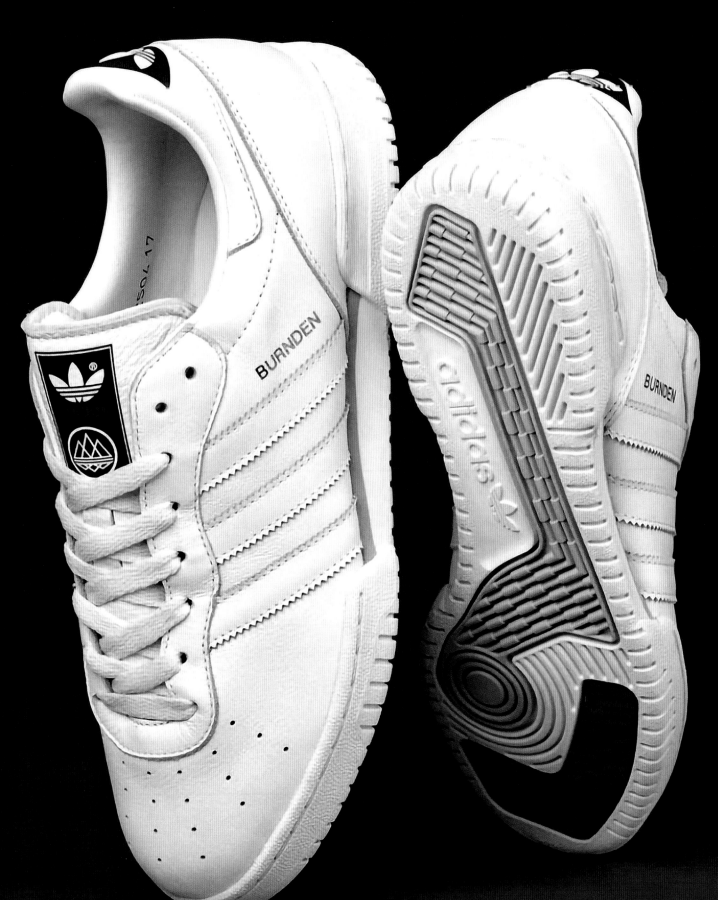

THE SECRET

Something that has always been fascinating to me is why certain shoes come to be considered classics, whereas others are never seen again. It's something that you can't easily explain. I call it "The Secret" —the emotional, almost subconscious connection that certain shoes build with people. For a creator, as much as you try, it's not something that you can build into a product because it's not about construction, form, or function. It's more about what happens around the shoe in fashion, culture, or society that creates this connection with people's lives and makes them fall in love with it. And that's something that you as a creator have no control over, which makes it both scary and wonderful.

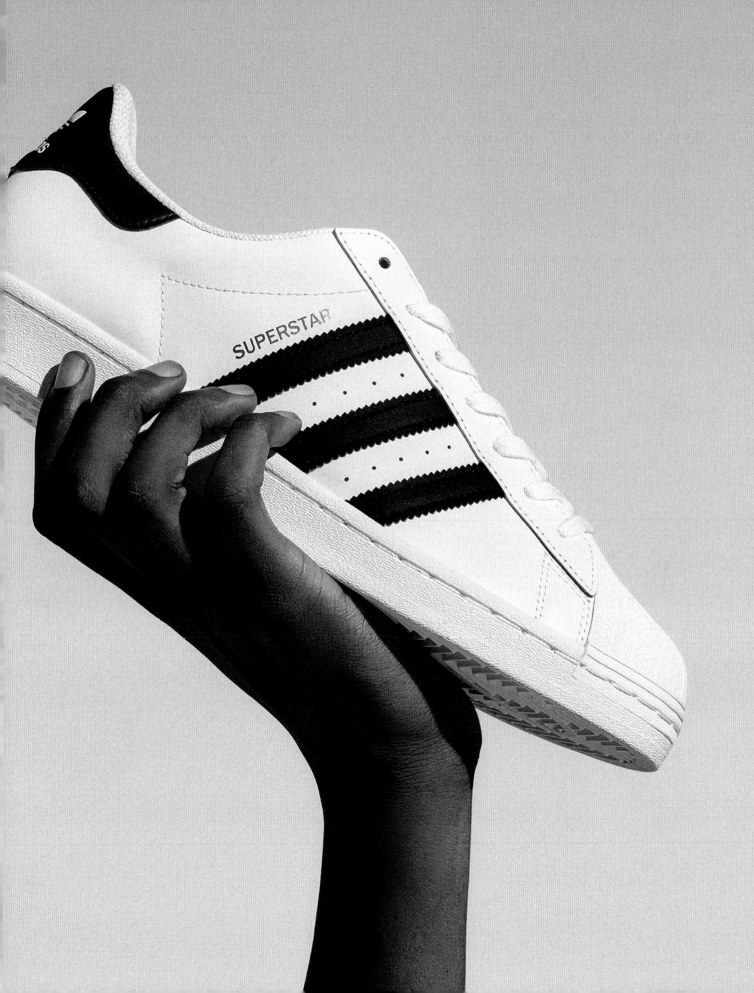

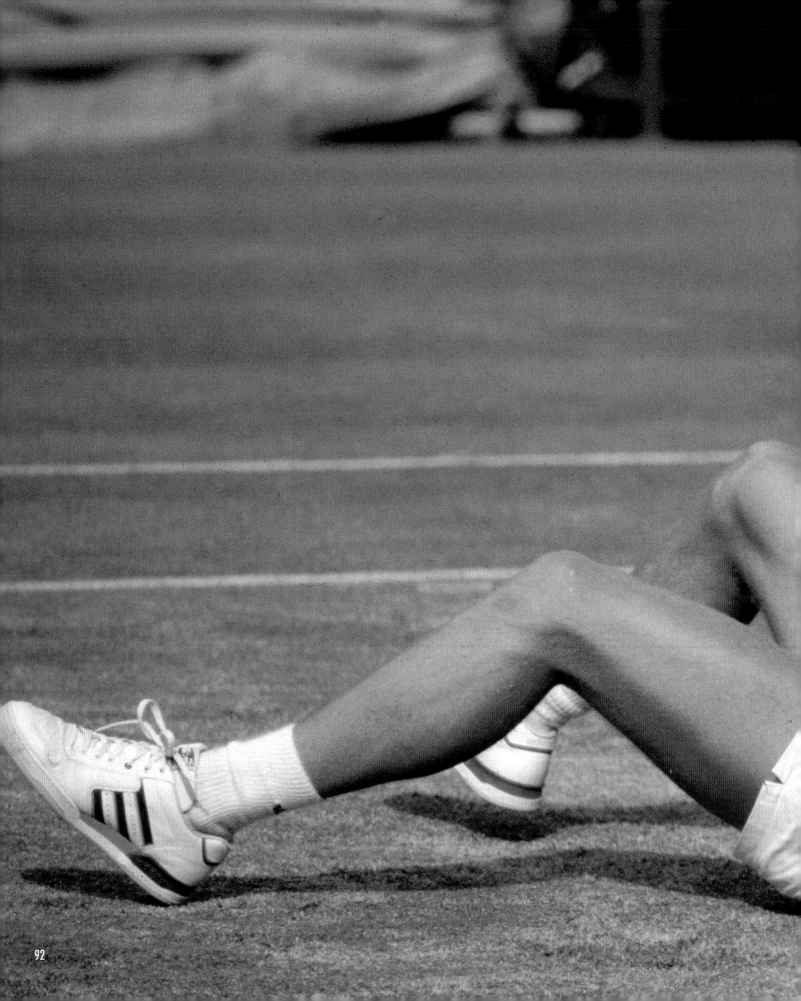

1986 - STEFAN EDBERG

STEFAN EDBERG ¹⁹⁸⁶

In the early '80s, tennis shoes still owed much of their design to the classic styles that had been worn since the '30s. It was time for a change.

Until the '80s, tennis shoe design had remained very simple and traditional for decades but, with the Edberg, we wanted to do something different, by bringing the more technical look we had brought to running to tennis.

One of the most apparent examples of this was the eye stay styling, which was very unusual for a tennis shoe. Featuring an extension from the toe cap with a single eyelet, the idea was to provide superior lateral support to the sides of the foot, with the "floating" eyelet allowing a gap in the main eye stay that gave the shoe more flexibility over the bridge of the foot—something which was especially important during the serve. It became a kind of signature Edberg feature, and we later used a similar design on the Instinct basketball shoe.

The influence from running can be seen in the "notch" where the ankle cuff meets the heel tab. This helped to give the Achilles tendon a lot more freedom of movement, and was also a new look for tennis, giving it a more ZX look at the rear.

Something I must admit is that I think I was having a bad day when I designed the outsole. The idea was to define the best placement for different grip profiles. In tennis, you need to be able to slide with control, but you also need to stop quickly. So we attempted to combine the two with strategically placed areas in the profile that would allow this, with Stan Smith–style nubs in some areas and Lendl–style herringbone in others. Looking at it now, it was a mess and something we shouldn't have done, but you can only learn from mistakes.

Thankfully, the sole isn't what people remember about this shoe; it's the colorway. Previously, color had been used minimally on tennis shoes, but we wanted to have a bit more fun and be a bit louder, so we worked with the apparel team to create a look that reflected the Edberg clothing collection. Although the green and yellow became known as the Wimbledon colorway, Wimbledon was probably the only place it wasn't popular. After Edberg wore the shoe to win there in 1988, all the brands started to bring more color to their shoes, and the All England Club quickly tightened up its all-white uniform code.

Stefan Edberg tennis shoe as shown in the 1987 adidas Germany catalog

The adidas Edberg that Stefan Edberg wore to win
Wimbledon in 1988. They were specially modified
with dimpled Lendl Supreme sole units designed
for grass courts.

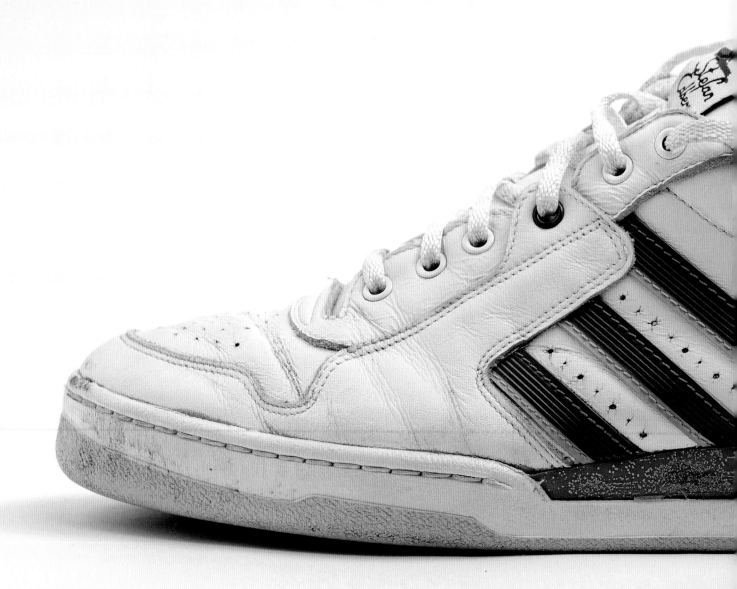

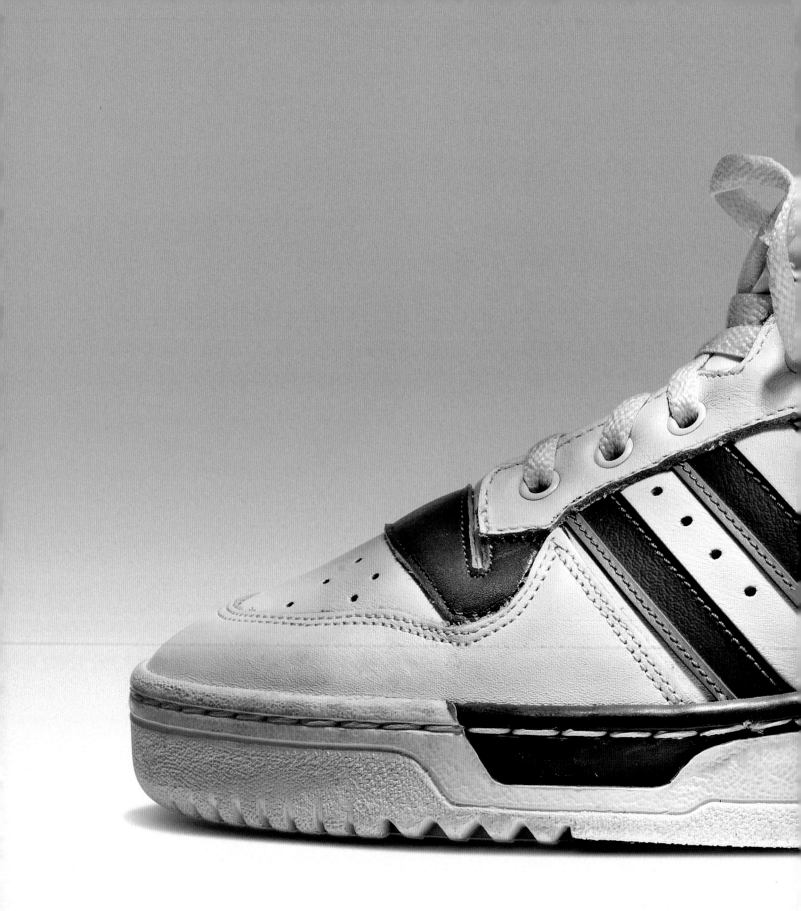

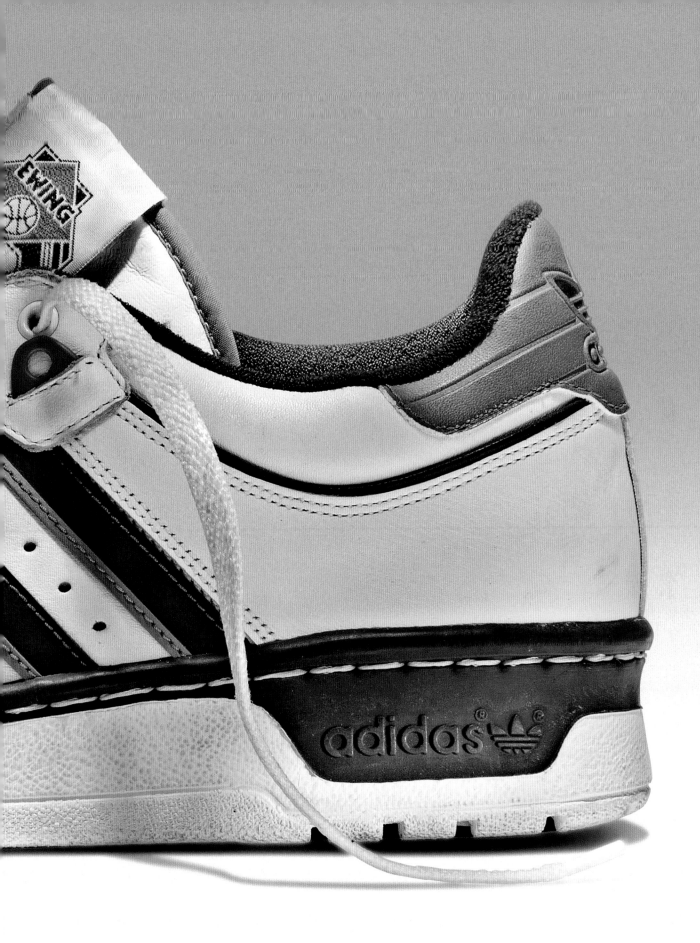

CONDUCTOR ¹⁹⁸⁶

The Best of the best for the Beast of the East

When we created the Conductor, we designed it to replace the Forum as our "crème de la crème" basketball sneaker and to be the flagship shoe of our new Ewing Collection. Patrick Ewing was adidas's big NBA star at the time, and the idea was that he wouldn't have just one signature shoe but a whole range, with the top of the range Conductor being the shoe he wore on court.

Like the model it took over from, it was a very technical shoe, designed for performance and featuring several new innovations. One of the new ideas was the tongue design. On the Forum we had the strap, but on the Conductor we used a different approach to enhance stability. Usually, the tongue of a shoe is only attached to the vamp and is only there to cover the top of the foot and prevent the laces from rubbing against it. However, on the Conductor, we made the tongue and the quarter on one side a single piece—the idea being that it wrapped around the foot to provide more stability.

Another new idea was the "floating" upper eye stay. On the Top Ten and Forum, the eye stay had been one piece from the vamp to the top of the throat, which could cause pinching at the front of the collar. By splitting it, attaching the upper part

to the collar, and putting the lower eye stay on an extension piece, it allowed far more freedom of movement.

One of my favorite stories related to the Conductor actually has little to do with the shoe but plenty to do with Patrick Ewing. He was one of the biggest stars in the NBA during the '80s and, for a while, looked as promising as Michael Jordan. He had been drafted by the New York Knicks in 1985 to a ten-year $32 million contract—a huge amount for those days—and named Rookie of the Year.

When he came to visit us at adidas France, it was a big thing. While he was there, we wanted to take his feet measurements and have our orthopedist look at them so that we could make special made-to-measure shoes for him to play in.

Other than the exterior, athlete models often bear little resemblance to the ones in the store, especially with basketball players, because they often have enormous feet and need customized foot-beds and sizes that you won't find in Footlocker.

I asked Patrick if we could take his measurements, and he was happy to oblige. He had big feet, but not a crazy size like Fernando Romay for whom we made US 17.5-sized Forums, so I wasn't expecting to be surprised. But when he took his shoes off, I definitely got a surprise. It wasn't the size of his feet, though; it was the holes in his socks! The millionaire superstar of the NBA had holes in socks, just like I had!

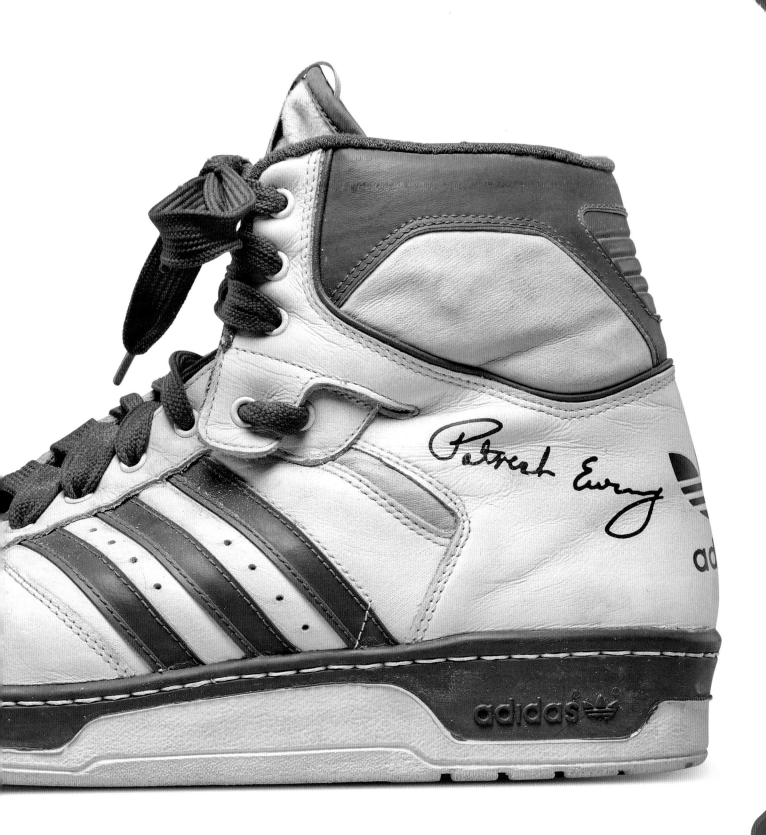

When I started playing organized basketball in 1982 at the age of thirteen, I had never heard of Jacques Chassaing and had no idea about how he would affect my life. It would also take another three decades before I became aware of this and realized how much my understanding of basketball shoe aesthetics was shaped by Jacques Chassaing's designs. This is the story.

My love for basketball was sparked in a small-town club in Germany. The club offered everything it took to get a teenager my age interested in the sport. In a carefree time without digital media and social networks, all my free time was focused on shooting hoops. But in my club, it was not just about competition and improving performance but also about conveying an attitude to life with friendship and team spirit, music and clothes—a complete lifestyle.

This led to almost all of my everyday life revolving around basketball. I even read a monthly newspaper called *Basketball* (at that time the official organ of the German Basketball Association) from the first to the last page. Besides studying results and statistics, I was also able to get an impression of the basketball boots that the German and European top basketball players wore on the field and which, of course, would also make me good enough at some point in my future so I would be in this newspaper.

The shoe that I perceived most frequently in *Basketball* in those days was clearly the adidas Conductor, which instantly made it the object of my desire. A year of hard persuasion finally led to the fact that I was allowed to call the most expensive shoe on the market at the time, 299 DM, my own. I basically wore the Conductor day and night until it fell completely apart a few years later. However, my pain was real when I realized that my mother had got rid of it without checking back with me.

With the rise of the eBay a few years later, time travel shopping became possible for me and took me back to my carefree teenage days. During this time, my passion for the Conductor reignited. The internet also taught me that a whole host of other fantastic basketball silhouettes with the Three Stripes had hit the market in the '80s, most notably the adidas Rivalry, which, like the Conductor, was part of the Patrick Ewing collection. My passion turned into love

and in addition to collecting these shoes, I began to deal intensively with their history.

During my research, I learned that Jacques Chassaing was responsible for the Conductor and the Rivalry. Of course, I knew at the time that Jacques was a sneaker designer with a global reputation, but I mainly associated him with the adidas ZX line. Of course, I knew he had developed the adidas Forum in 1984, and that was when I realized he was the driving force behind the paradigm shift in basketball shoe design. This shift away from simple, classically designed basketball shoes, towards playful multilayer designs stuffed with the latest technology to improve comfort, stability, and flexibility, and thus make the game even more attractive, originates from him. The Forum in 1984 and the Conductor in 1986 were game changers. His impact on European basketball in the 1980s was immense, and I believe that this fact in particular has received too little attention in Jacques's resumé to this day.

At an event in early 2019, I then had the opportunity to speak to Jacques Chassaing in person. Despite the fact that Jacques was the evening's more or less guest of honor, he took half an hour for a nerdy conversation with a complete stranger, in which he answered all my questions. I was amazed to find out that many other basketball classics in my collection can be traced back to him and his design team. What will remain in particular memory of the evening, however, is how Jacques, with his modest and reserved manner, never gave me the feeling that my fan questions were too much for him or that the conversation bothered him. He made the evening very special for me.

In hindsight, I like to tell myself that our conversation was a welcome change for Jacques, who for once didn't have to talk about his role in the development of adidas running shoes history. And it was a conversation that made me realize the great influence Jacques has had on my life for more than three decades. Without his designs, my life would have been different. I would never have gotten so many great opportunities and never met so many great people. Thank you, grand seigneur.

ERNIE BECKMANN

1. Perforated full-grain leather upper

2. "Ankle Harness System" (AHS) supports the ankle in a secure way, without restricting the natural movement of the basketball player

3. Flex zone at the ankle

4. Stabilizer band ensures fit lacing and good support

5. Padded tongue in polyurethane

6. Light and flexible 3/4 bi-density cupsole. Sole profile favoring multidirectional traction

7. Lightweight "adilite" EVA midsole

8. Polyurethane insert under the heel

9. Polyurethane insert under the metatarsals

10. Shock wave dispersing web

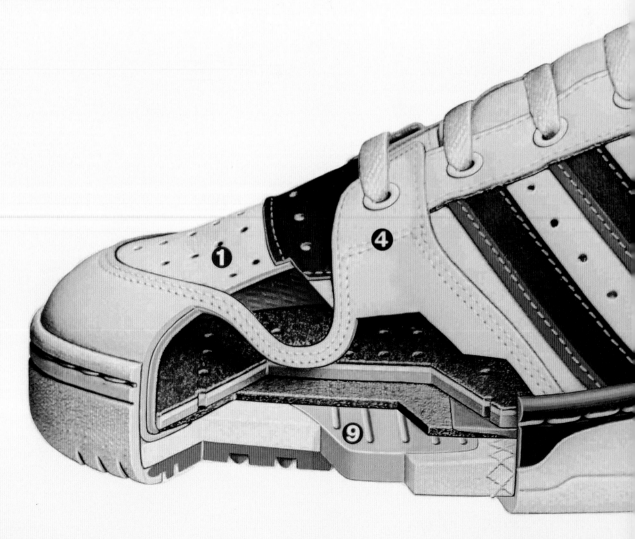

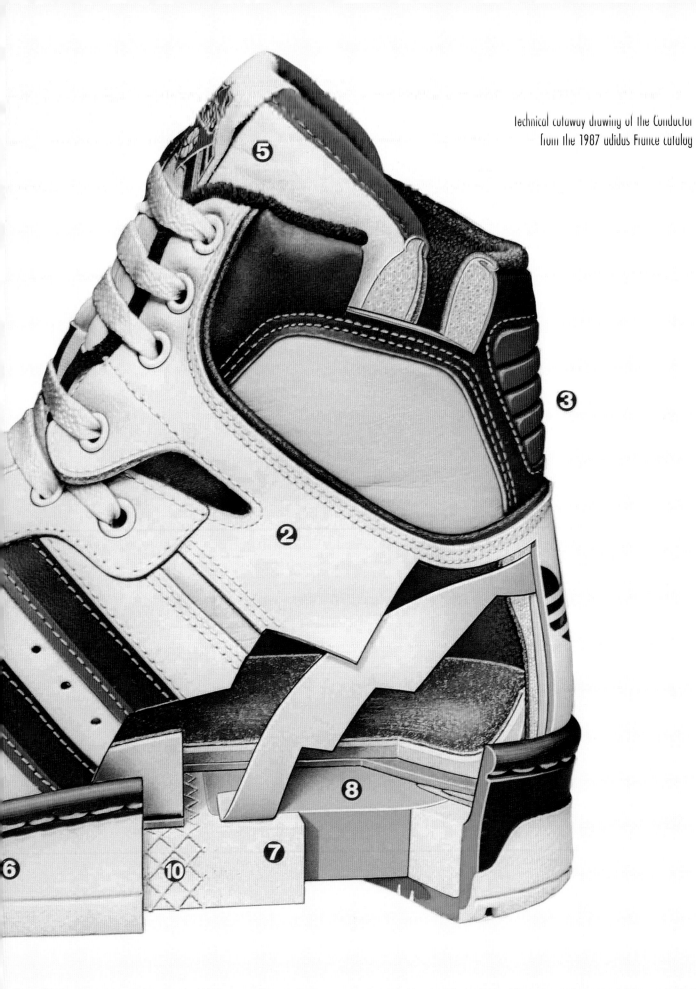

Technical cutaway drawing of the Conductor
from the 1987 adidas France catalog

RIVALRY ¹⁹⁸⁶

The younger, more popular brother in the Ewing Collection

The "little brother" of the Conductor, the Rivalry was a very similar shoe but was the mid-range shoe in the Ewing collection, so it wasn't as technical and had less performance features. Still, it had all of its bigger brother's style.

Both the Rivalry and the Conductor shared the same sole unit, which was designed to bring some of the features of our running shoes to basketball. The look of the midsole, which we gave a two color profile was inspired by the ZX 800. It brought a new look to a basketball shoe but made me pretty unpopular with the guys who made the mold, as it was a nightmare to produce! The single ghillie eye stay on the low-top also brought an influence from the ZX 800, allowing you to strengthen the lacing and fine tune the heel fit. The design of the outsole was what I call a "mosaic," made up of lots of small concave irregular pieces.

As often happens in collections, while the Conductor was the headline shoe and grabbed attention thanks to Patrick Ewing wearing it on court, the Rivalry's similarity, availability in a low-cut, and more affordable price made it the shoe that was more popular. It's great to see that people still love it today.

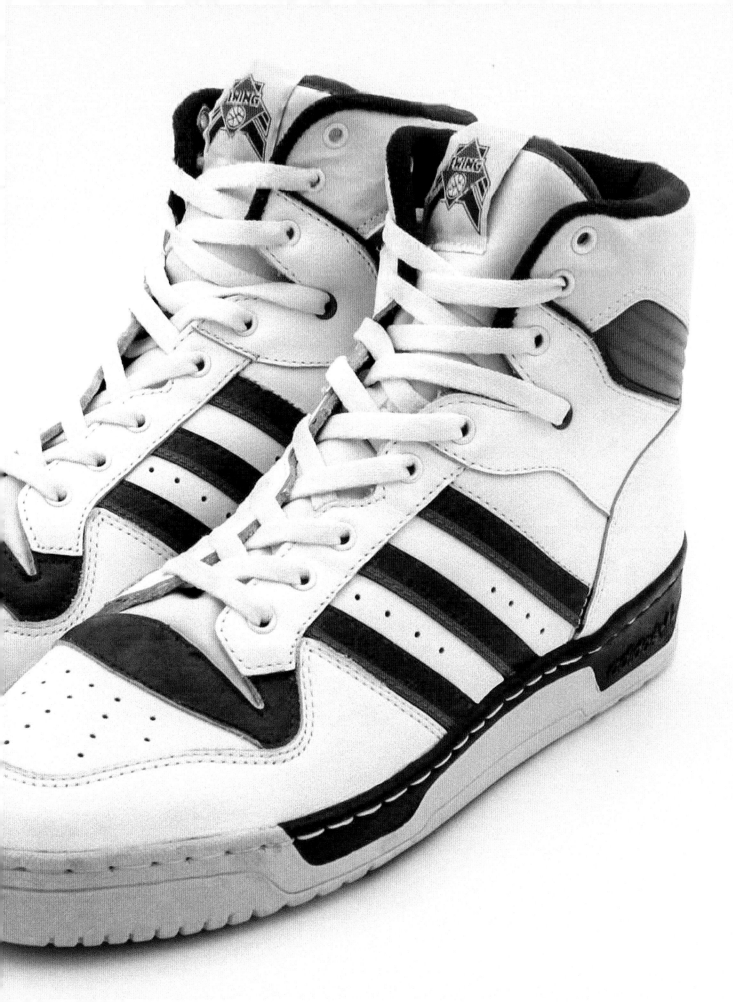

THE ADIDAS RIVALRY: A BERLIN LOVE STORY

JULIA SCHOIERER

As a German brand, adidas has always had a great standing in the country, but the Ewing collection has a special status in the capital. You can get a first glimpse of this in one of the most famous press pictures of the 20th century by Lionel Cironneau; Berlin celebrating the fall of the wall on November 12, 1989, at Potsdamer Platz, with a group of teenagers sitting on top of it. The photo depicts a quite accurate cross section of the shoe styles worn in 1989, and the adidas Conductor holds one of the most prominent positions (even three years after its original release).

That's because in Berlin, if you played basketball and had a deeper appreciation for sneaker in the late '80s until the mid-'90s, chances were pretty high you owned a pair from the infamous Ewing duo—that is, the Conductor and Rivalry. The signature tongue label very quickly became a sought-after detail to define a certain scene. The Attitude Hi and Lo in Knicks colours would follow with a Ewing logo in 1988, but this model gained most recognition for it's materials and colour combinations when the Metro and therefore faux snakeskin was added to the model.

As a kid, I did not know that the Three Stripes were associated with the exclusivity of products from Europe/overseas by tastemakers in New York and across the States. But suddenly, a brand everyone in Germany had gotten so used to, as it had a constant omnipresence over generations, appeared in an incredible new light. It was a red, white, and blue light, the American touch in advertisements and the media that we all looked and aspired to as teenagers in the '80s and '90s. The NBA was a welcome catalyst for whoever could afford pay-TV and craved a first look at the upcoming models.

When first released in 1986, it was pretty clear the Ewing collection was created not only for the court. Colourful shoes were slowly establishing individualism in the NBA with nonmarking soles and player endorsements. On the well known "Unstoppable" advertisement, depicting

Patrick Ewing the air traffic controller on top of New York, the products description states, "Pro look, street look, yard look."

In pre-internet times, trends and styles often took a few years to migrate to Europe (especially before the iron curtain fell), and they had a much longer lifespan to grow diversely throughout various subcultures. But that street and yard look was brought almost instantly to many scenes in Europe with album covers like Erik B & Rakim's *Paid in Full*, Anthrax's *I'm the Man*, Stetsasonic's *On Fire* or even New Kids on the Block's *Hangin' Tough*. Not to forget the extensive influence Run-DMC (and the Beastie Boys) had by representing the Ewing collection in almost every public and media appearance and on their European tours. They were changing the footwear game with player endorsements to a street wear game with artists collaborations.

Although the Conductor was supposed to be the star of the Ewing collection with its high performance make-up and way more technical and aggressive design, the Rivalry became a grail for connoisseurs of Generation X from the end of the '80s until the mid-'90s. An impressive demonstration of how celebrities and the media can transport a product from the sports world into subcultures,

The Rivarly's many colorways and team stripes edition made room for more individual choices, and their price was not nearly as steep as the Conductor's, which was the most expensive shoe on the market at the time (299 DM [US $170] compared to the Rivalry with 199 DM [US $115]). Although Patrick Ewing sported the Conductor in almost every adidas print ad, the Rivalry were worn more on the streets also due to some simple practical reasons like being much faster to slip into and lace up. It's popularity was fuelled by the American culture we witnessed in the media during the '80s. By the '90s, Europe had responded to the model and embedded it into their own culture.

1985 - EWING COLLECTION

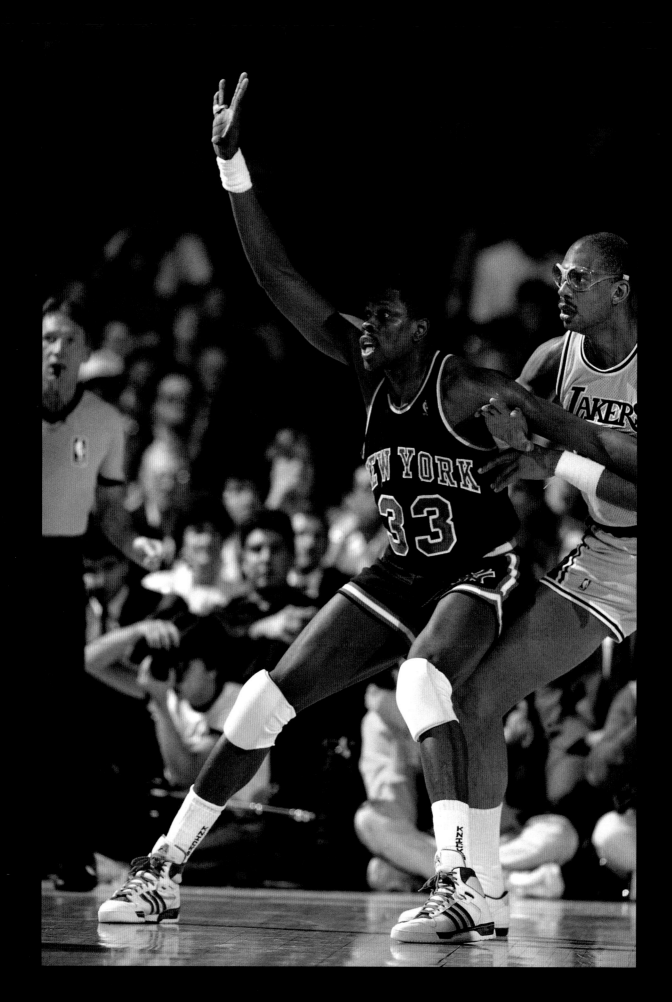

Unfortunately the variety of colors that released in Germany were much more limited than in the USA. Only the Knicks, red-white and gray-white Rivalry, as well as the Knicks, gray-white and (in Berlin, so called "American") blue-white colorway of the Conductor were available on the West German market. Many colorways released in the States were only made available in former West Berlin through people with connections and knowledge, who brought them from overseas with regular trips and many duffle bags. It was a mystery to me why the shop owners of stores like Street Life/Mad Flavor, Downstairs or Enterprise had to "import" Superstars with snakeskin stripes and Rivalrys in team stripe colors to fill their shelves with these exclusive beauties.

I was used to buying my swooshed sneakers in the United States mostly because I had relatives there, my family and I went to visit pretty frequently, but I did not understand how a German shoe brand could sell certain models only on the American market. The exclusivity was driving every sneakerhead in Berlin crazy and built up a legendary status for these models.

Luckily, people like Azad, Oliver Ortgies, or Niklas Beckert had the vision, craving, or whatever motivated them to bring all those gems back to Berlin and be the gateway to American fashion (as paradox as this may sound talking about a German brand) to a growing scene of sneaker aficionados in the capital.

I was too young to live the first hype of the Ewings in the '80s; my love for them sparked in the '90s, when I watched my older sister's friends sport them. Toward the mid-'90s they were mostly worn by connoisseurs and people from the hip-hop scene as a status symbol.

But the groundwork for the Rivalry's popularity in Berlin was laid by graffiti crews from the north like AGS to cliques like the "Yugo Stars" (who also brought quite a nice batch of the Three Stripes back each time they visited their second home) protagonists like ARUNSKI, ELVIS, BRILLSKI; and writers like SOME, AMOK, KAOS, ODEM, PHOS4 and MAXIM who elevated the three stripes' status to another level in the Berlin hip-hop communities with their style.

In the early 2000s, adidas brought back a classic many Berliners had been waiting for! The Metro Attitude Hi. Unfortunately, they were mass-produced in every possible colorway and, at the same time, in really low quality. A frustration started to build up, as many hoped for the Rivalry to return next because the models have a nearly identical last and sole.

But our hopes were not fulfilled and the Rivalry never came until some years later when a new opportunity presented itself. In 2012, I was asked to be part of the adidas collectors project, where 5 collectors got the chance to revive a favored model. A collector's dream come true! Usually, I am horrible with big decisions like that, but I heard a calling with this one.

From the beginning I was sure I had to bring back the Rivalry for the Berlin sneakerheads. So I went for a deluxe version of the classic white and gray high-top. Plus I choose snakeskin instead of suede stripes, with a nod to the most sought-after material and ultimate status symbol on adidas back in the '80s and '90s.

As part of the collector's project I also got to meet Jacques Chassaing for the first time in 2013. I had visited the adidas archive numerous times before, nerded out on discrepancies in German and French catalogues, and exchanged models with the team. Going there to sit on a couch with the creator, the inventor of so many of my holy grails and most loved silhouettes, was a first and maybe the greatest perk of collaborating with the Three Stripes. It was a true highlight for the collector's team visiting Herzogenaurach. Of course, we all were a bit starstruck, with about a million questions on our minds. Luckily, Mr. Chassaing was such a pleasure to be around and the goldmine of design knowledge everyone dreamed of. He was patient and almost too charming to be considered a nerd, but I could have listened for hours to all the technical and creative insights he was happily sharing with us. Time was, of course, too short, but talking with him about the design evolution of my favorite basketball silhouettes has become an unforgettable and cherished memory.

JULIA SCHOIERER
Photographer, sneaker collector, blogger
@sneakerqueen

Opposite: Patrick Ewing in Conductors battles with Kareem Abdul-Jabbar

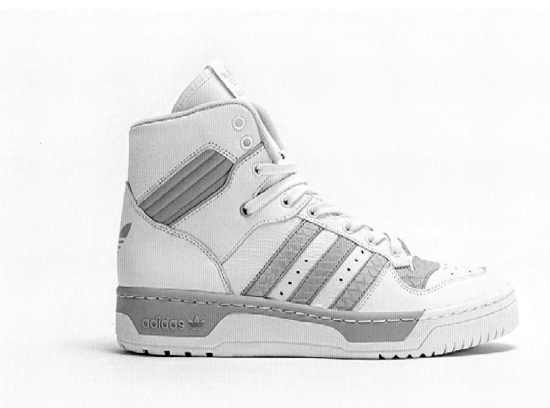

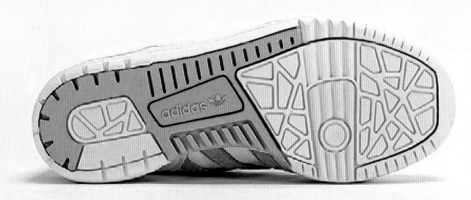

METRO ATTITUDE HI ¹⁹⁸⁶

The shoes that almost started a riot...

The Metro was a version of the Attitude basketball sneaker that was deliberately aimed at the street first and court second. I got the idea for the reptile skin effect when we were visiting a leather supplier in Pirmasens in Germany. Pirmasens was famous as the center of the German shoe industry, so you could often find interesting materials there. The supplier we visited had various examples of reptile skin. I thought it could be a cool idea to use it, so the first samples of the Metro Attitude were made of real snake skin but, of course, we couldn't do that for the production version of the shoe, so we used a pattern embossed on the leather instead.

Later that year, I went with my adidas colleagues Hart Klar and Bob La Lime to the United States for a tour of Footlocker stores in New York, Philadelphia, and Boston. I took bags full of samples of the reptile Metro Attitude and Rivalry because it was around the time when people were starting to go crazy for basketball shoes and I wanted to get feedback from people. In New York, the Footlocker guys said, "Do whatever you like with the samples," so I put them out on display in the store to get people's impressions. Well, all hell broke loose.

The kids were going crazy, pushing each other aside and demanding to buy the shoes. Some of them were even pulling out $100 bills from their wallets, desperate to buy them. The problem was I just had samples, so it was only one side, not a pair. When I had to send them away disappointed, I thought it would cause another riot! I had never seen that kind of crazy reaction over our shoes before. It was the first time I'd seen close up that they weren't just sneakers to people anymore, they were status symbols.

THE BOSS

The man who took adidas France to the world

Many people ask me what was the secret ingredient that we had at adidas France that made it the birthplace of so many of adidas's most loved products. It was really a combination of many things, but if there was something, or perhaps someone, who created the environment for them to happen, it was Horst Dassler.

Horst was the eldest child of Adi and Käthe Dassler. From a young age, he showed signs of possessing the best traits of both of his parents: his father's love for sports and craftsmanship, and his mother's leadership and people skills. From a young age, he saw that a large part of reason for adidas's success was the strong relationships that his parents nurtured with the people that worked for them and the athletes they made shoes for. It had a profound impact on his future effectiveness as a leader.

After attending the renowned shoemaking college in Pirmasens that his father had attended, his parents sent him to the 1956 Olympic Games in Melbourne, where it was often said he first got his taste for the business, making friendships with many of the athletes and ensuring they wore adidas instead of Puma!

In 1959 his parents sent him to run the new adidas factory at Dettwiller in Alsace, France, and adidas

France was born and a new era for the company started. Horst's more worldly outlook, combined with his ambition to make his own mark, meant adidas France quickly became a kind of company within a company, creating its own product ranges and taking a more dynamic and international approach than his parents did in Herzogenaurach.

When I joined adidas France in 1981, I quickly gained a lot of respect for Horst, not just because he was the boss but because he was a guy who really knew about products and took an interest in their development. He had been actively involved in the creation of shoes like the Superstar, Stan Smith, Rod Laver, and Country because he had a keen sense of what people wanted and where the market was going, usually long before any of our competitors did.

I didn't have many one-to-one encounters with Horst, but one I remember fondly was when I was working on the outsole for the latest Penarol football boot. My design used lots of angular "L" shapes and, when he looked at it, he smiled and said, "You must be a fan of Picasso to design something like this!" Naturally, even being only jokingly associated with Picasso, coming from him, I took it as a great compliment.

Another thing I remember about Horst, and which any of my former colleagues will tell you, is how much he cared about his employees. If someone or even their family member was ill, or if they had some sort of personal problem, he always wanted to help, even visiting people in hospital or at home and personally helping if they had problems outside of work. He also didn't see any separation between himself and the staff, often playing football and sports with everyone.

With the dynamic and informal environment that Horst created, it was in many respects no surprise that adidas France became such a creative and successful part of adidas. After the death of his father, when the company suffered from stagnation and greater competition, Horst was called by his mother to return to Herzogenaurach to run the company and put adidas back on the right path. There was sadness when he left adidas France, but we knew it was the right step.

Sadly, Horst never got to bring the success he had in France to the wider company, succumbing to cancer at the age of just fifty-one. Being Horst, he was working from his hospital bed until his very last breath. His passing was mourned deeply throughout adidas and the sporting world, but especially by us in France.

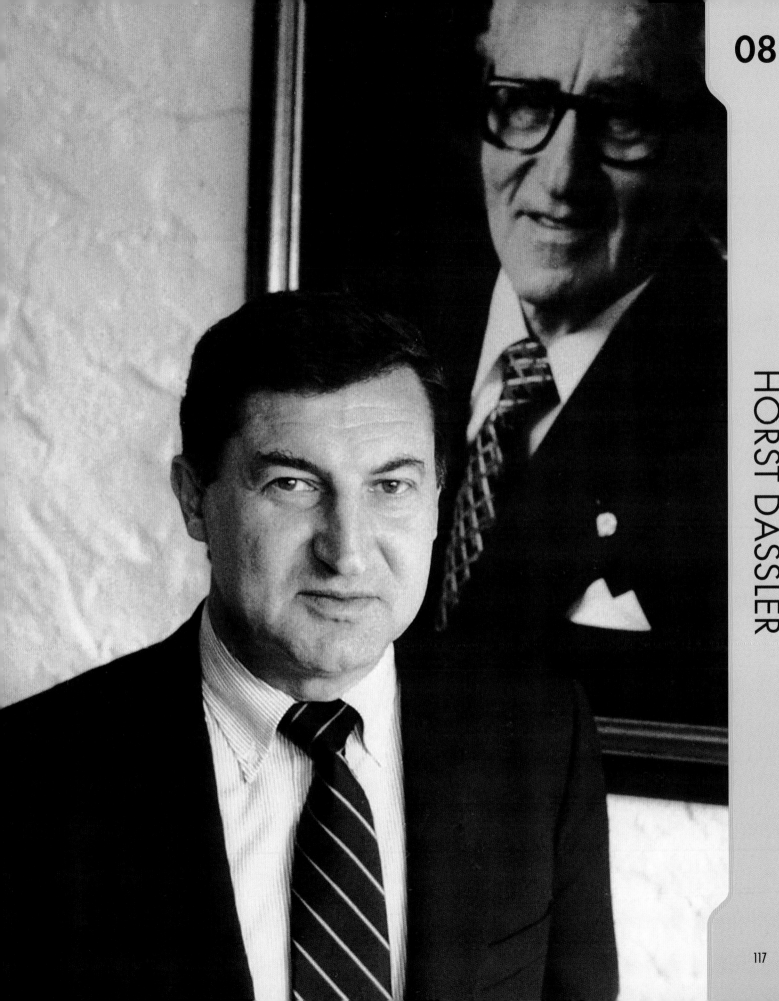

HORST DASSLER

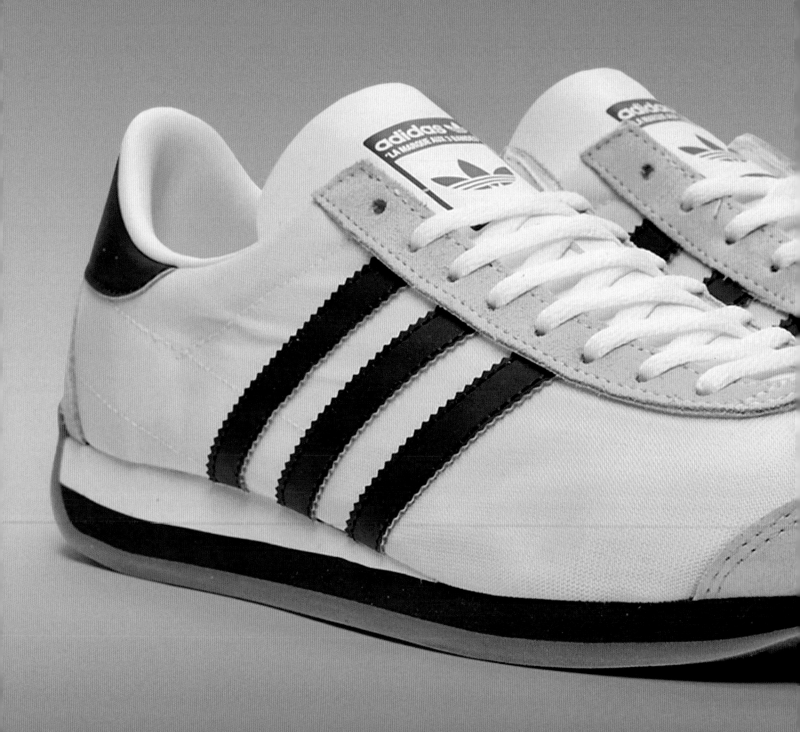

INSPIRATIONS:
COUNTRY *1973*

The Country was a typical adidas France and "Horst" shoe, in that it was developed almost in defiance of adidas Germany. Adi Dassler had always steered away from the soft, mattresslike shoes that were popular in the United States during the running boom, because he believed that in the long term, they weren't good for your feet. But with US distributors pleading for something to compete with shoes like Nike's Cortez, as he often did, Horst Dassler decided to do his own thing and asked the team at adidas France to develop what became the Country, one of the first adidas running shoes aimed squarely at Nike. It's a shoe I fell in love with not because of its softness but because of its shape. The upper has a contoured, raised heel profile similar to a track and field spike, the result of the design of its wedged midsole, which is constructed from the dual density foam and is the source of its softness.

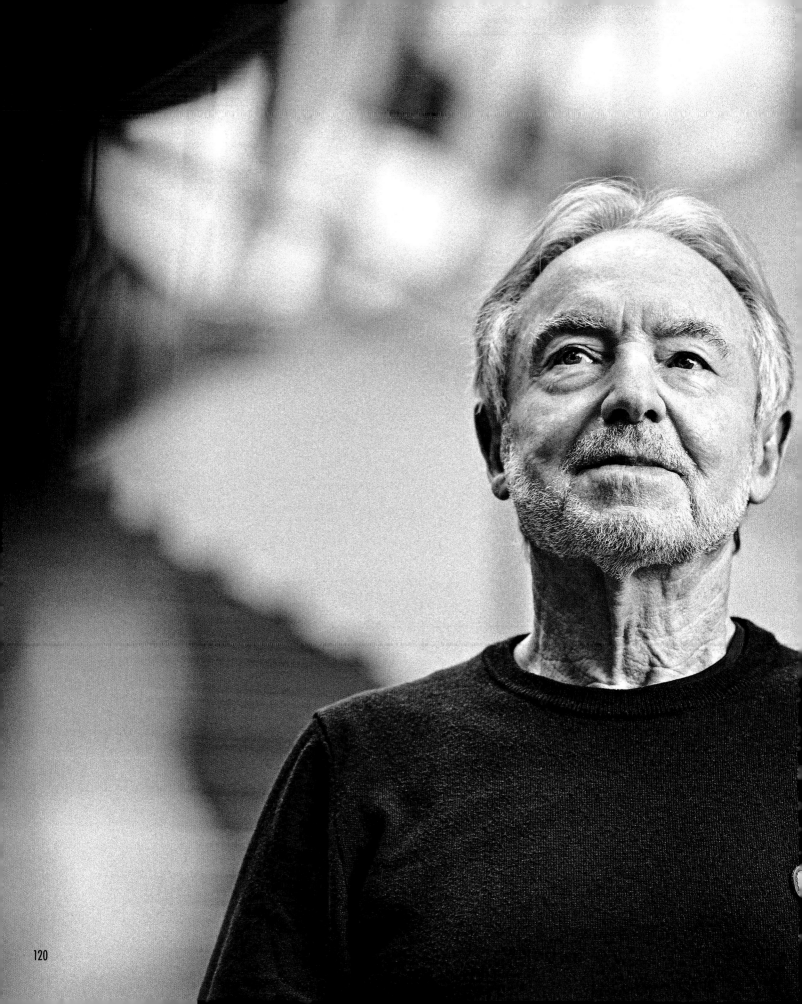

THE COMPETITION

As a creator in a competitive industry, I always tried to respect our rivals. I would keep an eye on their latest shoes and technologies, and go to exhibitions like ISPO, not only to see what they were doing, but also to ask myself if what I was doing was good enough. Often it was, often it wasn't. Sometimes, you fall behind; it's the way the world works. My approach has always been to see it like running the 5,000 meter. You might be behind on one lap, but if you push yourself hard enough, you can close the gap or even pass the leader on the next one. The only difference is that it's a race that never ends, which means you can never stop innovating or learning because if you do, you're never going to lead the race or even challenge for it.

HORST DASSLER

CONTINENTAL *1987*

It was rare that we designed in reaction to what competitors were doing, but this was a "Reebok fighter" from day one.

The Continental was an unusual shoe for adidas because ordinarily, when we created a new shoe or collection, it was us setting the agenda, but the Continental was created as the response to an "emergency."

From out of nowhere, Reebok had been making waves with its aerobics and fitness models that Americans, especially women, were buying in the millions. Reebok was taking a huge chunk of sales from Nike and us. Although we already made shoes in the fitness category, we didn't have an answer to Reebok's runaway success. Desperate to respond, Horst Dassler called us all together and asked us to develop a range of "Reebok fighters," and I found myself needing to create a brand new model in next to no time. In that kind of situation, you don't have the luxury of months of development, so I had to go with my gut.

One reason many of Reebok's shoes were so popular was that they were made from garment leather, a super-soft leather usually only used for clothing and furniture. It was a material we would never usually have used for a performance shoe because it was so thin. I can still remember my former boss, Mr. Hemmer, saying, "Never do a shoe like that. The toes will go through the vamp!" But having Reebok in our sights, we had to put aside his advice and use garment leather. Reebok fans might also spot another feature of the shoe that was common on Reebok models of the time: the logo window.

The Continental was a response in another way too. People were telling us they were bored with seeing full-length Three Stripes on everything, so we cut the length of them on some models, which is why you see a lot of shoes from this time without traditional full-length stripes. On the Continental, we went all the way. It's one of those rare adidas models with no stripes at all–just a twin color line inspired by the Player GS and ZX 800.

When it was released, the Continental was part of a range called the Magic Line, a collection that was "half sport, half fashion." It was launched alongside the Powerphase, which similarly was created as a response to Reebok's Workout model. In truth, although they may have put a dent in Reebok's sales figures, they came too late to mount a serious challenge. The Continental did eventually have its day though, when it became a big hit after it was brought out of the archives as the Continental 80 almost thirty years later.

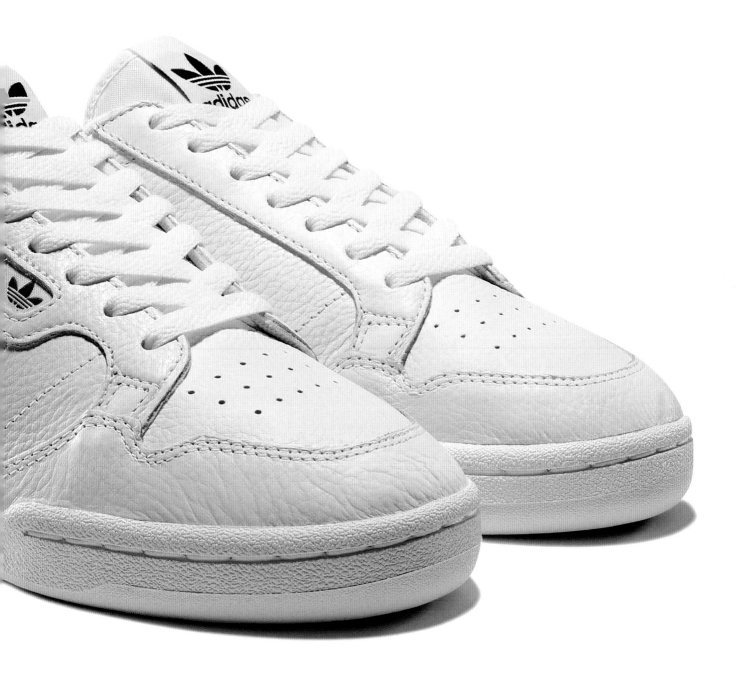

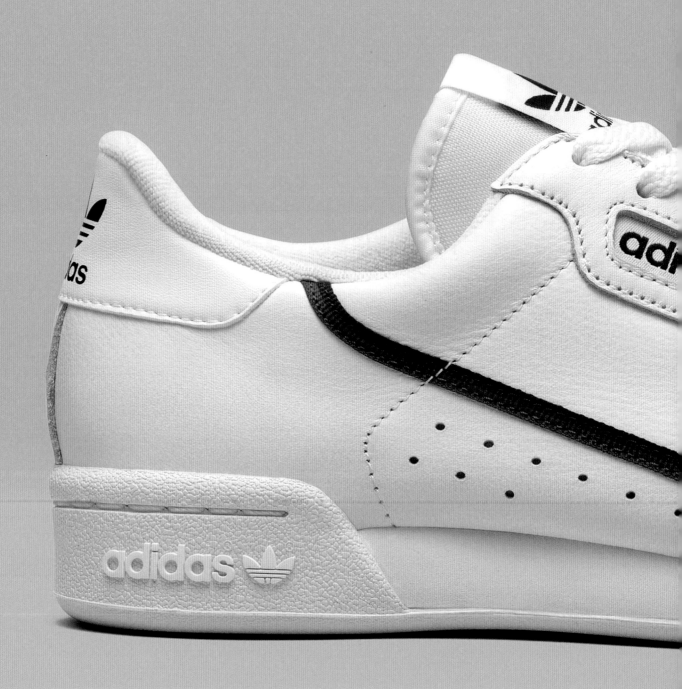

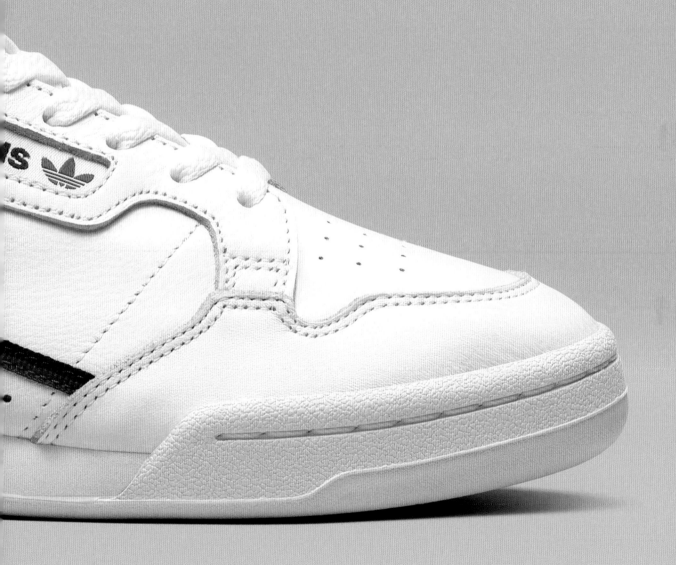

INSPIRATIONS:
ROD
LAVER ¹⁹⁶⁹

Like the Continental, the Rod Laver is unusual for an adidas shoe as it lacks the famous Three Stripes, giving it a similarly clean and simple look. However in the Laver's case, the omission of the stripes was due to the no branding rules that were still prevalent in tennis at the time. Its distinct look also came about as a result of input from the player it was named after.

After being signed by Horst Dassler, Rod Laver was given carte blanche to spec his perfect tennis shoe. Laver was used to playing in canvas shoes and disliked how sweaty his feet got and, when playing on clay, the way the clay dust would stick to his shoes. He asked the designers at adidas France to create a shoe that would solve the two problems. Their answer was nylon mesh. It was highly breathable, very lightweight and also non-stick, meaning it was resistant to dust. The mesh, along with its lack of stripes, gave the Laver a look that was unique—so much so that when the Rod Laver Super was developed, even though the branding rules had been relaxed, the decision was made to keep the classic unstriped look.

STRIPPED

Adidas has always been about so much more than just Three Stripes. Some designers thought that just because you put Three Stripes on something, it makes it an adidas product. It really doesn't. What does is making it the best you can for the athlete and the customer. I believe that, whatever your brand, if you can strip off the logo and people still know who made your product, you're doing it right.

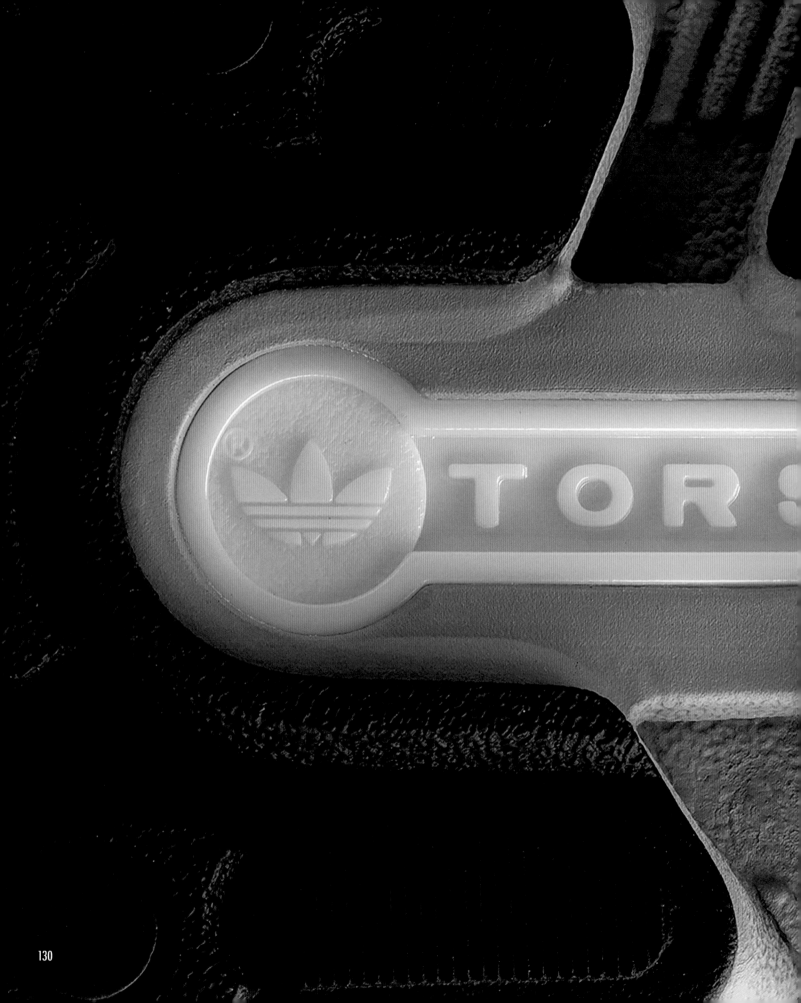

1989 - TORSION

TORSION

One of the first rules of designing performance shoes is that it's essential to have an understanding of what goes on inside them. You have to respect the foot!

I realized early in my career that if you want to make great sports shoes, you need to understand biomechanics. A guy that really influenced my thinking was Swiss expert Dr. Benno Nigg, one of the first people to look at running shoes from a biomechanical perspective.

He explained the differences between pronators and supinators, the optimal heel shape for when the foot lands and, depending on the sport, what was the best thickness for the midsole compared to the height of the shoe. They were ideas

that would all have a big effect on my design thinking and would influence one of the most pioneering technologies we developed at adidas: Torsion.

The origins of Torsion came from the ETH Zürich research institute, where I spent time with a team studying the biomechanical dynamics of sports.

Their research in running showed that when you run barefoot, as your feet land on the ground, there is a natural rotation or twist between the front part of the foot and the rear. From the earliest days of running shoes, the sole had always been a single

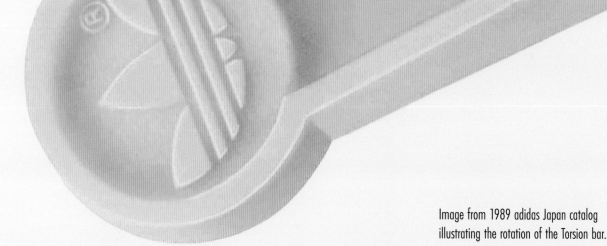

Image from 1989 adidas Japan catalog illustrating the rotation of the Torsion bar.

piece, which didn't allow this, so we realized that to allow this rotation or torsion, we needed to decouple the shoe in order to mimic this natural rotation. By splitting the forefoot and rearfoot and creating notches in the midsole, the foot could move and rotate more naturally. This became the concept behind Torsion.

However, this split created a problem because there is less support in the midfoot. With running, it's the midfoot that experiences much of the strain, so support here

is essential. Our solution was the Torsion bar. In the midfoot of dress shoes, you often find a shank made from metal or wood placed between the outsole and insole that supports the arch of the foot and gives the shoe structure. Similarly, we designed the Torsion bar to be a bridge that supports the midfoot during the step transition from front to the rear, which allows and controls rotation.

At a time when technology was increasingly important to the customer, we felt it was important the Torsion bar was visible, so we deliberately put it on show by not encapsulating it and making it bright yellow. However, as effective as Torsion was as a technology, it

wasn't easy to explain, and we had to spend time with the salespeople to get them to understand it.

This was a problem because the best innovations are always those that are easily understood, but as with many things biomechanical, it isn't immediately obvious. This led us to create a sales kit and point-of-sale installations that showed retailers and buyers how Torsion worked and what its benefits were.

When Torsion was first introduced, like many revolutions, it needed some time before it became a genuine success, but it did become one, and reshaped design at adidas and the way we thought about performance. For people now, Torsion is still the "yellow bone" in the bottom of their shoes, but they don't realize that it's much more than that. Maybe it doesn't matter; they're still buying Torsion shoes today.

ZX THOUSAND SERIES

The idea of the ZX Thousand series was to take everything we learned from the ZX Hundred series and evolve it to offer runners new technologies and even more choice based on the individual needs.

Centered around Torsion, the debut shoes in the range also featured other innovations such as midsoles made from Purolite, a new type of more flexible polyurethane, Soft Cell, a capsule in the heel filled with layers of polystyrene balls that provided improved cushioning; and an external exoskeleton style of heel counter that gave even more support to the rear of the foot and helped prevent pressure and blisters in the heel.

When we run, we all have individual types of roll in our feet when they land, which affects our running efficiency and the wear on the shoe. To allow runners to choose the best shoe for their needs, we structured the collection around three types of shoes: CUSHION for those with neutral roll, where the foot has no foot roll and lands evenly, SUPPORT for those with pronation, where the foot rolls inwardly to the center of the body, and GUIDANCE for those with supination, where the foot rolls to the outside. The midsoles of the shoes were color coordinated with the type of roll they supported. The idea was that when choosing shoes, the retailer would analyze your feet and advise you which shoe was the best for you based on your foot roll and budget.

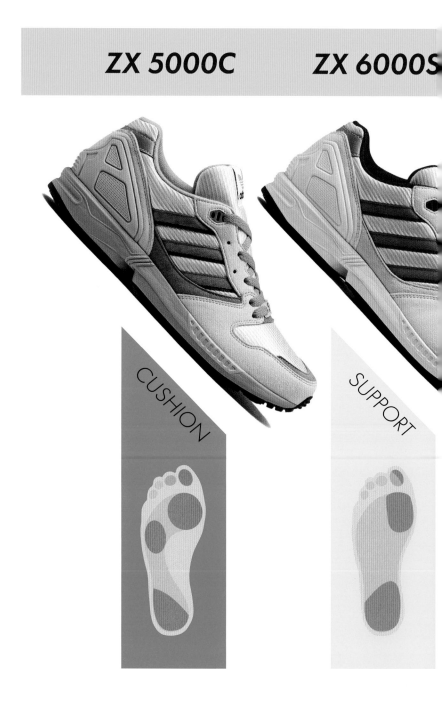

ZX 5000C

ZX 6000S

CUSHION

SUPPORT

ZX 7000G ZX 8000C ZX 9000S

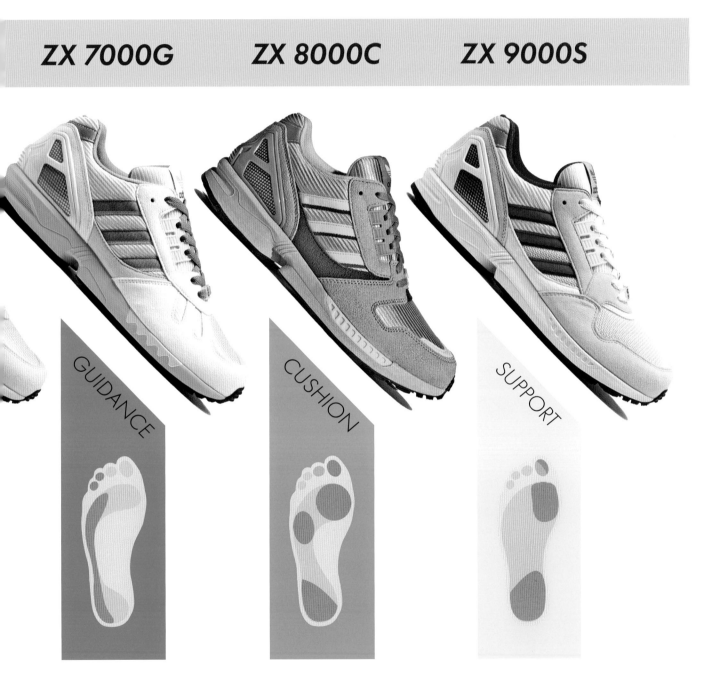

GUIDANCE

CUSHION

SUPPORT

ADRIAN LEEK

I started with adidas in the United States as a marketing guy in 1988, having come from a kids shoe company called Kangaroos, based in St. Louis. Coming to adidas was a dream because I was an athlete, and, most of my career, I ran in Tokyos and trained in SL72s and 76s. I came to Herzo pretty much the day after I started to attend a product meeting, and that was my first interaction with Jacques. As I would later learn, he was the real guru of design at adidas, and he was revered for the work that he did around the idea of form follows function. I also discovered once I got to know him that, in many ways, he was an old school shoemaker at heart, and had been schooled in shoe design at the French Bata factory, where he became a designer.

Typically, when we had new product meetings, in the room there were delegates from France, Scandinavia, the UK, and sometimes Japan, and I was often the guy who came over from the US. We'd all sit in the room and Jacques would present the new products and talk us through them. I can only really describe them as being pieces of art. They were always just so impressive and so incredibly well thought through. In my very first meeting, the products that were being unveiled were the ZX 7,8 and 9000, the first Torsion shoes, and no one had seen those shoes before, so they were revealed as this secret new offer. I remember being amazed at the thought and integrity that had gone in to the product. It was crazy, just on another level.

Seeing these presentations, I was a little awestruck by Jacques at first, but he was so easy to go up to and talk to. Whenever I spoke to him I always realized why I loved being at adidas. I didn't think so much about it as an athlete, but he really made me appreciate the thought process in the product, and his engineering and design background.

When I joined adidas, the company was struggling. There were battles going on as to who would own the company and what direction it was supposed to be going in. I think what happened with Jacques is that, in the midst of this, he found his spiritual partners in Rob Strasser and Peter Moore. When they came along, they totally bought into the whole concept of form follows function and the idea that people should know an adidas product without even seeing the Three Stripes. I think Jacques was the master of that philosophy.

Jacques really was a kind of secret weapon for us. I remember when he did the Edberg shoe around '90 or '91. We showed it to the guys at Footlocker, and I remember them saying, "This is the most beautiful shoe I've ever seen." And that's what Jacques gave to adidas: a perfect marriage of his understanding of what people wanted out of modern footwear, and his ability to channel into it what Adi Dassler's philosophy was for creating products.

The other thing that I always found so impressive about Jacques was his ability to inspire others. We often used to get him in front of the design and marketing teams just to tell stories and inspire another generation of designers. I think designers in general want to reinvent things because that's their nature. But that wasn't Jacques. He wasn't trying to completely reinvent things. He would try and bring function and performance to the product through evolution, and that remained constant throughout his career. Even when he was working on Porsche Design, many years after I had first known him, he was still the same person that I knew from the beginning.

Having been an athlete who wore the shoes and then getting to work with the guy that led me to fall in love with them in the first place, has been one of the pleasures of my life. Jacques is a true genius, and I feel honored to know him.

ADRIAN LEEK
adidas Core Footwear VP

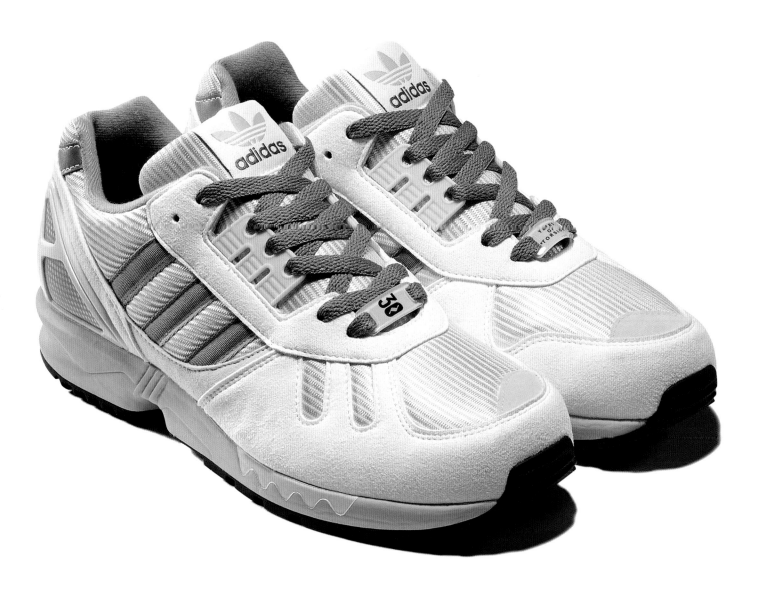

ZX 7000 30th Anniversary Edition

ZX 8000C *1989*

Inspired by an Olympic collection, the ZX 8000's colorway seems to still be turning heads more than thirty years later

When we launched the ZX Thousand series, we wanted it to be even more impactful than the hundred series visually and technically, and the ZX 8000C was probably the best example of this.

In creating the flagship cushion shoe, we wanted it to turn heads, so we looked to the designs that had been done for the 1988 Seoul Olympics collection. For sports shoe brands, the Olympic Games are a real battleground because your products are on show in front of an audience of hundreds of millions, so Olympic collections are often specifically designed to attract the eyeballs of television viewers. With its bright luminous colors, which were all the rage in the late '80s, it was the Seoul collection that inspired the Aqua colorway of the ZX 8000. At the time, people were not used to seeing running shoes with such an attention-seeking color combination, and, on the street and in the stores, they immediately caught people's attention.

The Aqua colorway is still much loved today, and many adidas models have used it as a kind of homage to the ZX 8000. A lot of people have said to me it was a milestone in fashion. If it was, great, but I have to admit that as much as we wanted it to grab attention, the idea was never to create a fashion icon!

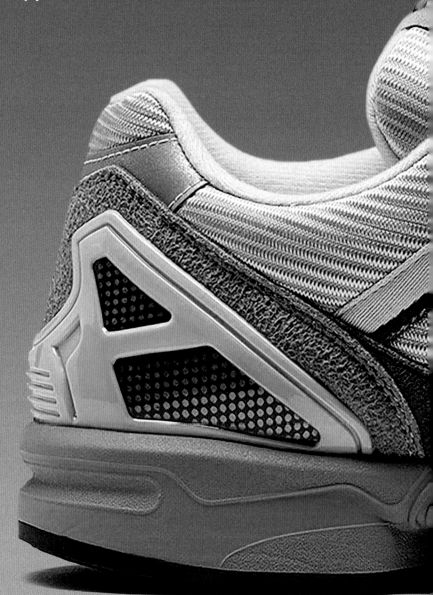

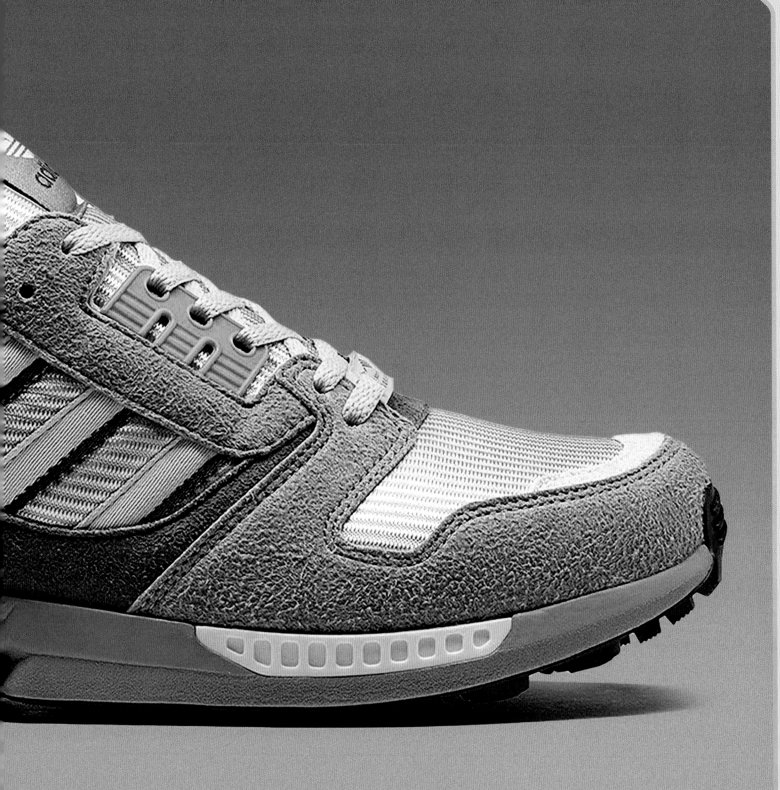

1 Differential-lacing:
For individual, comfortable adjustment.

2 Support element:
(Inside the shoe)
Supports the foot and counteracts overpronation (walking on the inside of the foot).

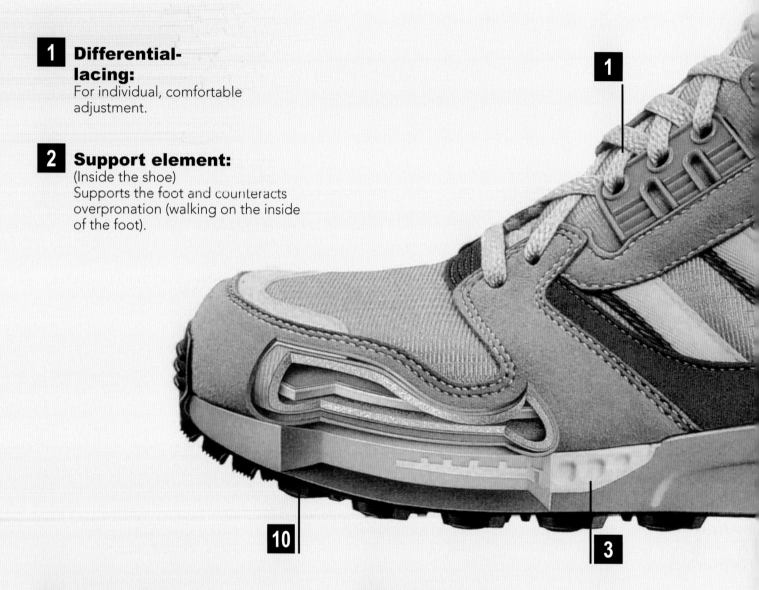

3 Guide element:
(Inside the shoe)
Counteracts oversupination (walking on the outside of the foot).

4 adifit-TORSION-insole:
Exchangeable, with spherical shoulder for back support and foot bed, anti-bacterial, washable.

5 Unity heel:
External heel counter with U-shaped recess at the back; supports the heel without constricting the Achilles tendon.

6 PUROLITE-midsole:
Light, almost fatigue-free material, therefore good cushioning over a long period of time.

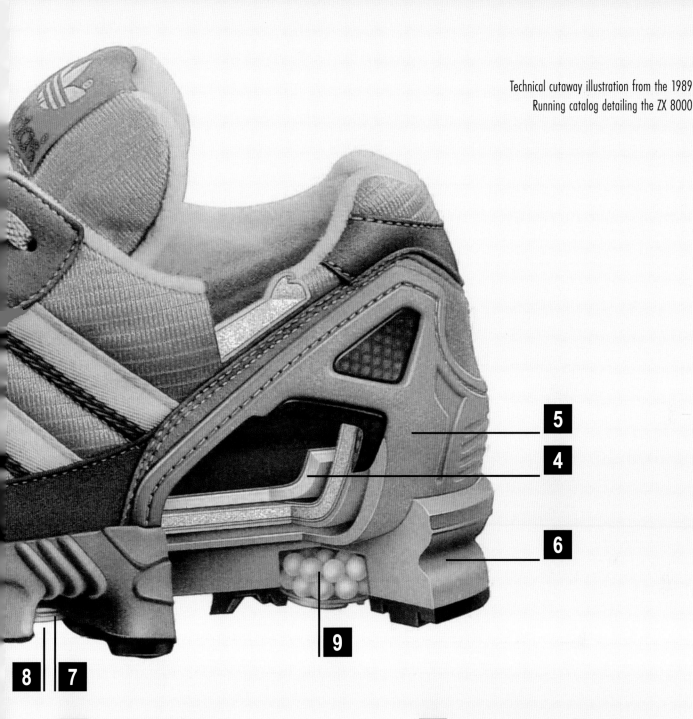

Technical cutaway illustration from the 1989
Running catalog detailing the ZX 8000

7 TORSION-bar:
Protects the foot from rotations.
Diminishes risk of injury.

8 TORSION-notch:
Divides the sole into 2 parts and enables
separate movement of the fore and aft foot. In
this way, the foot in the shoe can safely adapt to
all unevenness in the ground and roll naturally.

9 Soft Cell ball damping:
2 layers of ball rings made of highly elastic
plastic, which slide into one another in an
offset manner and thus exert extraordinary
cushioning on the heel bone.

10 Positraction-outsole:
Divides the sole into 2 parts and enables
separate movement of the fore and aft foot.
In this way, the foot in the shoe can safely
adapt to all unevenness in the ground and
roll naturally.

ZX 9000 30th Anniversary Edition

ALEXANDRE BLUM

Going through the '90s, as a teenager, I was marked by ONE adidas model: the ZX 8000 Aqua. Like everyone else, I called it the "Torsion," from the name of the arch responsible for joining the heel and the forefoot that was on the midsole.

I didn't know much about this model, but I was fascinated by its lines. It was the running shoe that you had to have on your feet to impress the others in the playground.

Since that time and thanks to this Torsion, my curiosity and my enthusiasm for sneakers have never stopped growing.

Twenty-five years later, I had the privilege of meeting Jacques. This Alsacien, like me, marvellously embodies the passion that drives me and that his work has partly helped to create.

I was able to discover that Jacques had collaborated on most of the adidas projects that had marked me since my childhood and I was able to understand the process of creating a sneaker and its range.

In addition, thanks to him, I had the privilege of visiting the adidas archives in Herzogenaurach (one of my best sneakers addict memories).

And from there, everything fell into place. It then became clear to me that the sneaker was not only a consumer and performance product but also a historical milestone of our society.

Being able to look at and touch iconic (and historical) models made me aware of the influence of sneakers and Jacques on our time.

For me, Jacques is all about discretion, talent, humility, a keen sense of observation, as well as an irrepressible desire to share and stay connected to our world and its evolution.

Thank you, Jacques, for making me touch the history of sneakers and therefore quite simply History. Our friendship is worth to me all the pairs of sneakers that I will never have... or not!

ALEXANDRE BLUM
*Sneaker collector, podcaster, and
founder of Sneakers Empire association
@nalexblum*

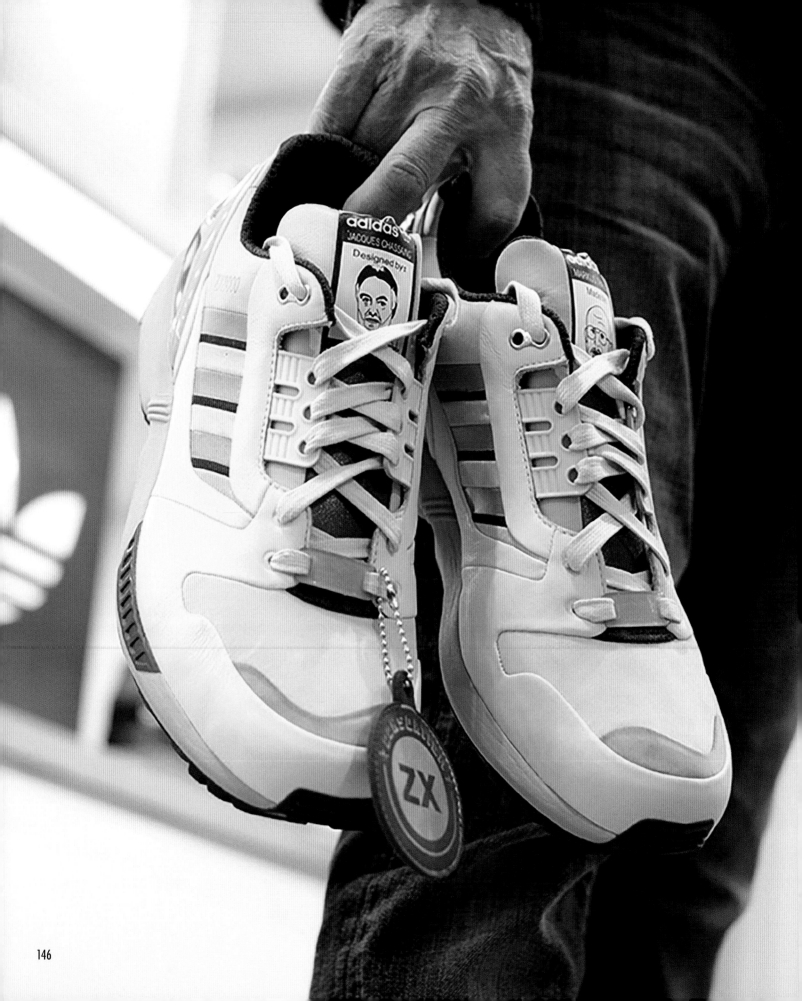

As part of the A-ZX series, Marcus Thaler and I, who worked together on the original ZX series, were asked to come together again to create an updated ZX 8000. The idea was not to change the design, only the construction. Using a "stitch and turn" approach, we tried to smooth out the edges of the original shoe and give it a much sleeker look. It came in a special presentation box that included a deconstructed ZX 8000 that revealed its separate components.

Jacques Chassaing is a very discreet and even sometimes secret person. There are two reasons why it's rather difficult to write about him. First of all, it's not always easy to know what is going on in his mind. Secondly, he stares at you in a way that says "don't betray me!"

So, I thought about this challenge a lot, and I think I found a way. I'll tell you about how I first met Jacques Chassaing. It is quite a funny and, for me, an incredible story. Thankfully another person was with him at that moment, so there is no secret!

The sun was going down on a regular day in September 2018 in Paris. The weather was nice. I was doing a tour of the main sneaker shops to grab content for a sneakers guide. I was in one of the famous Shinzo stores in the Les Halles area when I noticed two people talking together in front of the shoe wall. I noticed them because they were an unusual pair. There was a young man all dressed in adidas, with a big Trefoil track top, and another man, not very tall, much older than the other (white hair), and dressed as a

gentleman farmer in leather shoes, no jean pants, white shirt, plain sweater and a nice dark coat, very elegant. I wondered who they could be for a minute, but went about doing my own things. I left the store to go to another one very close, the other Shinzo store, the one for running. Again, I saw this strange couple talking with a salesman. The one with white hair was speaking in French about adidas technologies.

At that moment, I realized these two people worked for adidas. I myself worked for adidas for nine years, so I knew how to recognize one of our kind. I started listening to the conversation aiming to know more about them, to find out what kind of position they had. All of a sudden, the salesperson asked me if I needed something. I answered that I was very interested in the conversation and I started explaining why, saying I used to work for adidas as a Product Manager for the running category. As we were talking a lot, I suggested we go out on the sidewalk to get away from the loud music of the store. There, the man with the white hair and I talked for an hour about everything, but also about the association I created in Strasbourg to entertain the sneakers community with events and radio shows. He soon told me he was well connected with the adidas archives in the adidas headquarters in Germany, and that he could arrange to invite the members of the association for a special visit. I knew how exclusive these archives were. I was a little doubtful about the reality of this proposal, but I was also trustful

of this guy and very excited! We agreed to stay in touch, and I gave him my business card. It was just when we were about to leave each other that I asked for his name. "Jacques Chassaing. Au revoir." When he said it, I froze! This name rang a bell. I googled it and boom, the picture of his yellow tribute adidas ZX 8000 appeared, and I made the link. I had been talking for an hour with none other than Jacques Chassaing, the father of the ZX that I love so much. It turned out the other person was a young adidas designer, that Jacques was showing the sneaker shops.

I guess you got it. This anecdote outlines perfectly who is Jacques Chassaing. Discreet, as I already mentioned. He is a designer that lives in the field. He loves observing people, consumers, sales people, how they act, what shoe they grab on the wall. He is also very humble, not once did he tell me who he was. He loves to teach, I think it's what he loves most these days. Writing these words also makes me realize just how much he values trust. When you meet him, you may think gaining his trust is like climbing the Himalayas, but this story tells the contrary. You can trust him and he will trust you in return. I will never forget this moment in September 2018. Two months later, he kept his word, and twenty of us made a visit to the adidas archive. Thank you Jacques.

SAMUEL MANTELET
Sneaker connoisseur and
marketing consultant
@sam_mantelet

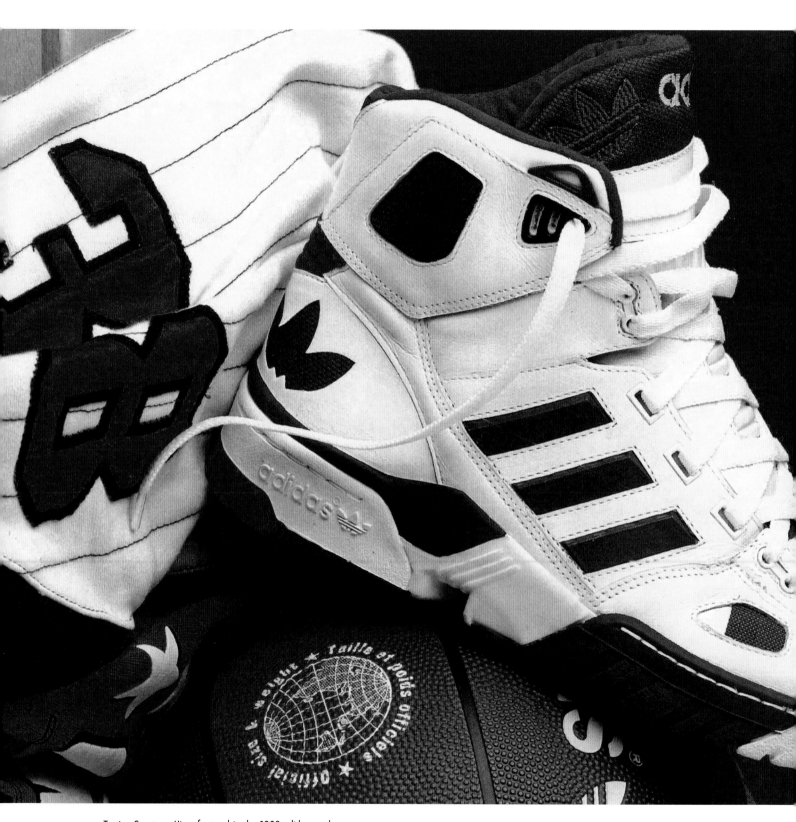

Torsion Spectrum Hi as featured in the 1989 adidas catalog

SPECTRUM ¹⁹⁹⁰

One of the craziest basketball shoes we did. A real beast.

The Spectrum was created around the time there was a kind of "arms race," where all the brands were competing to make the most technical basketball shoe on the market, so it was packed full of new tech and features.

Although it was a basketball shoe, the ZX Thousand running shoes had a big influence on the design of the Spectrum. It was a combination of many of the things we had learned from both running and basketball.

Up to this point, Torsion had only been seen on running shoes, but the year the Spectrum was launched, we rolled out Torsion to a lot more categories and it became the first Torsion-based basketball shoe. From the high end ZX Torsion models, we brought across the idea of having an external heel counter with a mesh window, which on the Spectrum was shaped like a Trefoil. The mesh window idea also made its way on to the cuff of the high-top.

One of the unique features of the Spectrum that would make its way on to later shoes was the combined cuff strapping and tongue that wrapped

around the ankle and foot to improve stability—a development of the "wrapping" ideas that came from the Forum and Conductor.

Another unique feature was the ventilation ports integrated into the upper (adjacent to the Three Stripes branding) and inspired by the Ferrari Testarossa's air vents.

The Monza F1 outsole was made from a compound that was highly resistant to abrasion and, on the Spectrum, was pretty special looking with its multicolored sections, which I'm sure is what inspired the marketing guys to come up with the name of the shoe. Like Torsion, the Soft Cell cushioning capsule was also being rolled out beyond the running range, and the Spectrum was unusual in having Soft Cell in both the heel and the forefoot around the pivot point.

When I look back at the Spectrum now, it looks pretty overloaded. However, as we tried to do with all of our basketball shoes, there is nothing on the shoe that is there just for aesthetics other than the colors. It was all about performance.

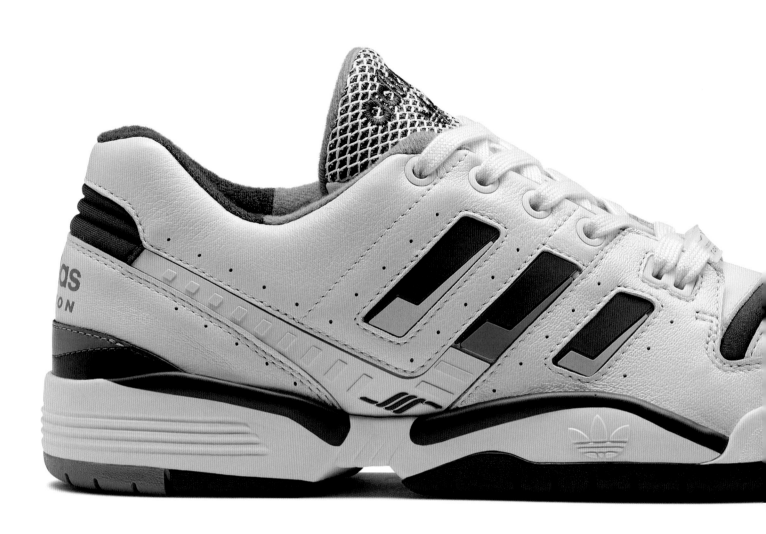

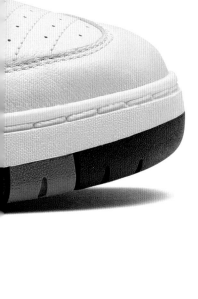

EDBERG COMP *1990*

Although it wasn't the first, the Edberg Competition was among the earliest adidas tennis models to be built around Torsion, and it was designed to say it out loud.

With the Edberg Comp, we wanted to make Torsion the star of the show, and the heart of the design was the arrow, or vector shape, that came from the heel side to the midfoot and acted as a visual pointer to highlight the Torsion groove. Accents on the midsole mold also helped to make it a focal point. However, it wasn't just about showing off Torsion, the vector also had a functional benefit as it also gave the shoe great lateral support.

Because it was a tennis shoe, we couldn't make the Torsion groove as deep as it was on running models. It had to be angled less steeply because of complaints we often received from venue owners, especially the clay tournaments. When the players slid, the shoes would dig into the surface and "rake" it, which, of course, they didn't like, but the shallower Torsion groove helped to alleviate this.

The interior lining was unusual in that we used a different material at the heel than from the rest of the lining. The reason for this is it was more

grippy and so held the wearer's sock and, consequently, the heel better. To show this, we used a different color, hence the lining has a separate color just in the heel area.

Like previous Edberg shoes, the look we chose for the Comp was designed to be eye-catching. The contrast between the deep purples and royal blues with the pastel pinks and peaches became a classic '90s colorway.

Personally, I never really liked the Three Stripes on this shoe. As I've mentioned elsewhere, people often encouraged us to do something different with the Three Stripes, and so we started to get a bit crazy with them at times. If you look at other shoes from around this time we tried to be creative with the stripes by splitting them into different shapes and using funky colors. Shadow stripes or accents were already a step too far for some people, but these were something else. Unsurprisingly, we stopped messing around with them after this.

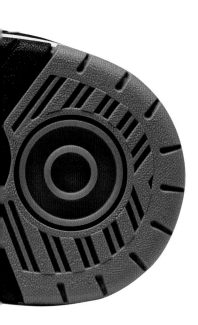

ZX 0000 EVOLUTION

ZX 0000 ^1991^
EVOLUTION

The ZX Torsion shoe that never was. A prototype that was developed to make a point.

This shoe really came about because, in any organization, there are always people who want change purely for change's sake. I've often found that the only way to stop them complaining is to show them that what they want doesn't work, and that's the reason this shoe came about.

Cutting a long story short, some of my colleagues weren't happy about the look of the groove on the Torsion models. "Not sexy enough," they said. So we looked at how we could change the look of the midsole by filling in the Torsion groove and then slicing it, so that it still allowed the flex that makes a shoe a Torsion shoe.

My colleague Otmar Kaiser did a great job with the design, which was in many ways a bridge between the ZX series and Equipment. But when they saw the prototype, even those who had previously complained agreed that the original Torsion groove was still a better look, so it remained just an experiment and sat on a shelf in the archive—that is, until thirty years later, when it was rediscovered and given a limited release as the ZX 0000 Evolution, the missing link between ZX and Equipment.

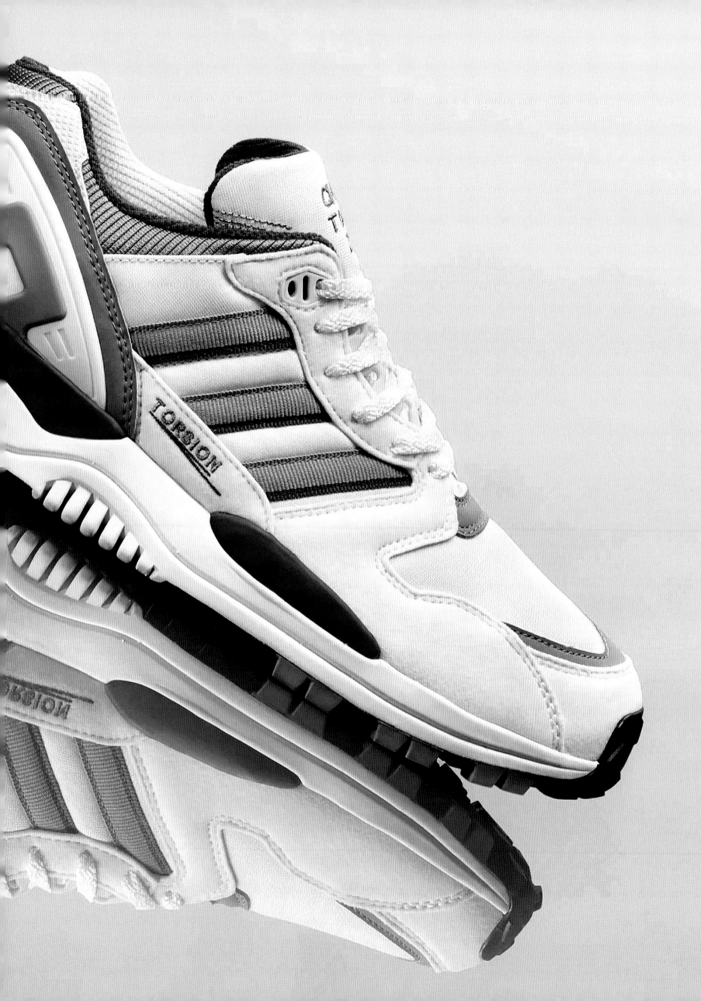

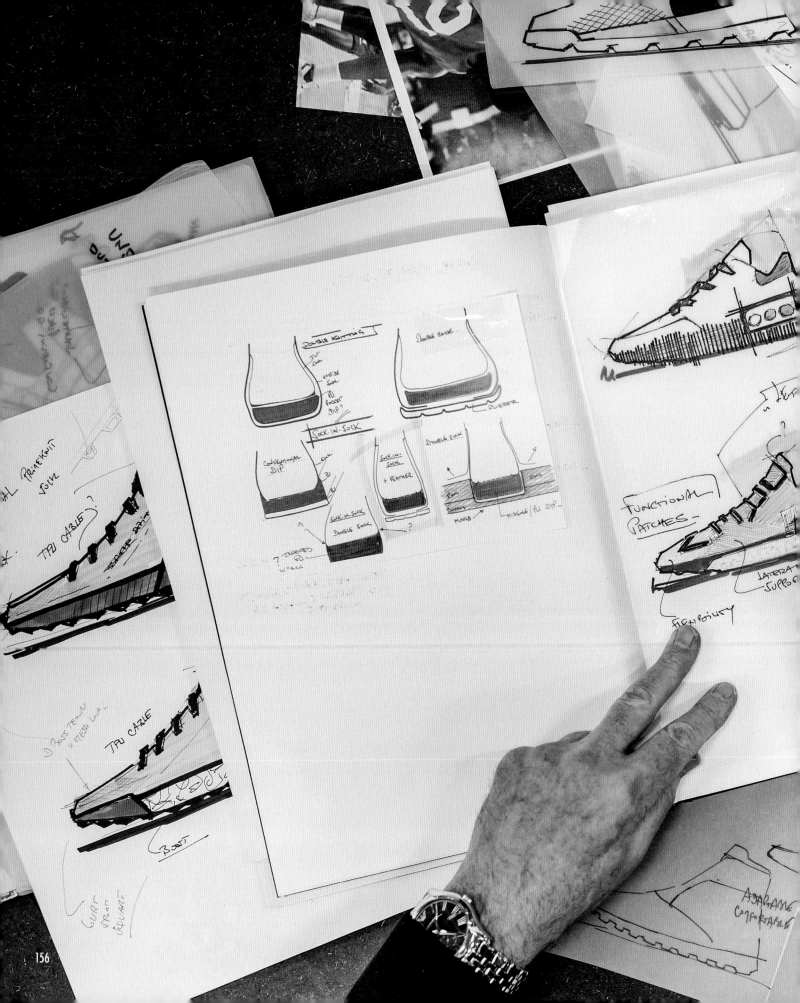

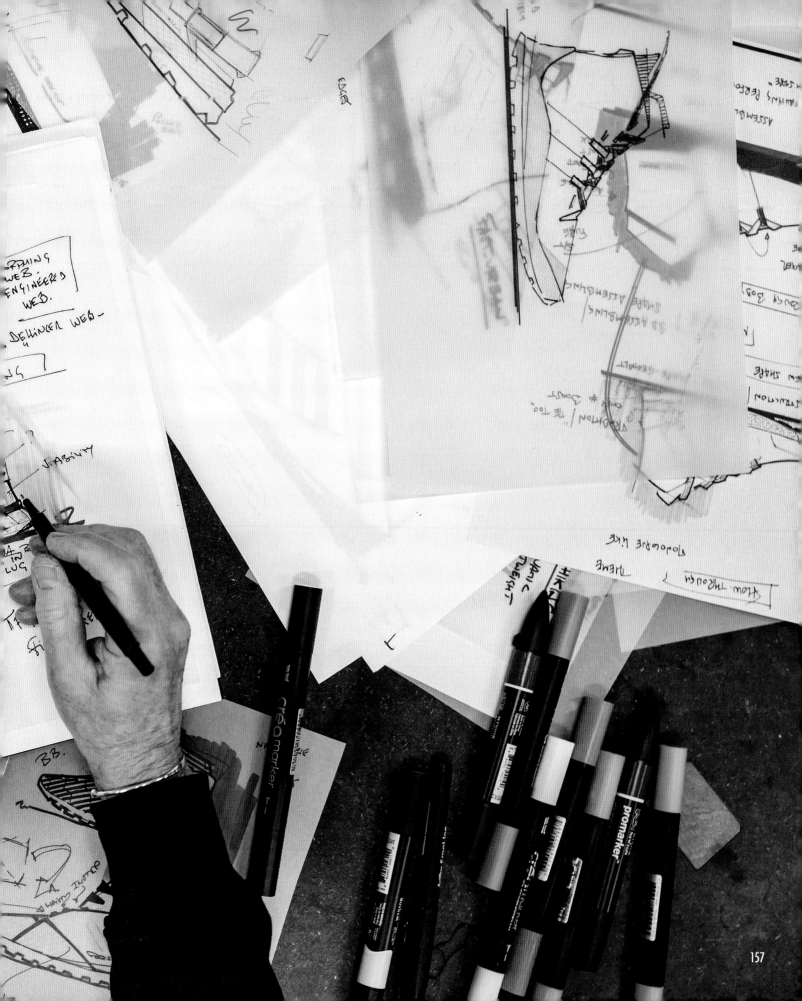

nach Würzburg

EMSKIRCHEN

LANGENZENN

Herzoge

Adolf Dassler Spezial-Sportschuh

urach

ERLANGEN

Bruck

Tennenlohe

Kriegenbrunn

Eltersdorf

Vach

Mannhof

Buch

urgfarrnbach

FÜRTH

NÜRNBERG

abrik **HERZOGENAURACH** am Bahnhof

Rob Strasser, who along with
Peter Moore made Nike No. 1,
but later helped to revive adidas

adidas

THE NIKE GUYS

The passing of Horst Dassler marked the beginning of troubled times for adidas. Rudderless and lacking strong leadership, it took two guys who had once been our adversaries to show us that the path to the future began in our past.

Horst Dassler's death came as a great shock to everyone at adidas. There was not only great sadness but fear after his passing. Like many large organizations, complacency and unwillingness to change meant that adidas hadn't moved with the times or even realized it was under attack from Nike, Reebok and several new and more dynamic competitors. Horst's return to Herzogenaurach was intended to allow us to respond but, sadly, he never got the time to get us back on course.

The other problem was that adidas had always been driven by production, so we never asked the consumer what they wanted. We just kept producing based on an estimate of demand. At Nike, it was different. They developed the concept for the product first, then sold it in to the distributors and retailers and took orders based on production at a later date, according to demand. We had a tough time reacting to that model. The other thing was that Nike and Reebok had totally changed the landscape in terms of what sports

brands were doing in marketing and promotion, whereas at adidas, we lagged behind, believing reputation was the strongest form of marketing.

Desperate to turn things around, Horst's successor as Chairman, René Jäggi, took what appeared to be a crazy step and reached out to two guys who seemed like the unlikeliest of saviors. Rob Strasser and Peter Moore, the architects of Nike's success. The former Marketing and Creative Directors of our rivals, they had left Nike to start their own consultancy, called Sport Inc., and were initially brought on as advisors to help turn the company around.

Coming in as outsiders with an objective viewpoint, the first thing we did was listen to them. One of the things that Rob and Peter said was the perception of adidas at the time was negative, which was tough to hear, but good that we could because some of us were living under the illusion that adidas was still the best in the world. We weren't, and the truth was we had

been passed by both Nike and Reebok and were down in third place.

More importantly, Rob and Peter not only diagnosed the problem, they had a solution. Quite simply, they believed we needed to go back to the founding philosophy of our founder, Adi Dassler. Rob and Peter felt that adidas's greatest strength was in making sportswear that helped athletes and active people to achieve their best performance, but that we had strayed off that path by trying to become a fashion company. It was true that people wearing sportswear as everyday fashion was now the norm, but it was the fact it had been made for athletes and performance that made people want to wear it for fashion.

The needs of the athlete that Adi Dassler had always considered— comfort, stability, and quality—had not changed. So why had we? The path was clear. We needed to put those values back at the heart of everything adidas did.

THUNDER & LIGHTNING

When Rob and Peter came to adidas, there was understandably surprise, even concern, from many, but for me, it was the start of an exciting new era.

For many reasons, the arrival of Rob Strasser and Peter Moore caused ripples throughout adidas, not only because of the irony that they were partly responsible for our current situation, but also because they were both like forces of nature.

At Nike, Rob had been known as "Rolling Thunder," and weighing 400 pounds and having an even larger personality, we could understand why. The first time he came to adidas France, we were completely taken aback by this bearlike American guy wearing a suit and a pair of unlaced marathon trainers. After the meeting, we all looked at each other and thought, "Who is this guy?" But as we began to work with him, we quickly grew to like and appreciate Rob. Although he was originally a lawyer, he was a real marketing guru. He saw in ways others didn't and really understood what motivated people. Although he could have taken the approach that he knew better, and simply dismiss opposition to his ideas, he knew how to fight for them convincingly and how to disagree with others with respect.

Every day was a new adventure to him, and his passion to get adidas back on its feet was infectious. When he was in town, he would come into my office every morning with great gusto and say "Jacques, what are we doing today?" I still remember the first time he came in. He looked around and saw my organized chaos with prototypes and drawings everywhere and he said, "Hey Jacques, I like your shit!"

Compared to Rob, Peter was almost serene but certainly no less passionate or driven. Few people exude creativity like Peter. He has a natural gift for knowing how to create solutions, whether it's a logo, a shoe, or an entire communications strategy that really connects with people in a simple way.

As the guy that cocreated the Jordan brand and designed the Air Jordan 1, I was a little in awe of him, yet he was always very open and willing to listen to my ideas. He would even joke that he was just a one-hit wonder compared to me. I'm not sure if I had designed the Air Jordan 1, I would be so modest! One of the biggest changes that came with Peter was that design was no longer just a function of production or marketing, we became our own department, with Peter as our Creative Director and champion. Over the years I spent with Peter, he also became my friend and mentor, and we remain close today.

With Rob and Peter at the helm, there was unified and defined direction, and their attitude was straightforward. You either do it, or you don't. There was no in-between. I'm reluctant to use the phrase in an adidas context, but it was literally a "Just Do It" attitude. They also had no time for any old traditions or personal rivalries that were going to hold back progress. One of the first times I realized this was while working on one of the first shoes I did under Rob and Peter. I had to work with a colleague who I wasn't getting on with, and we fought over what direction to go in. Rob got so fed up with us he said, "Enough! The two of you come with me!" He put us in a room and said, "When I come back, I want a new shoe!" Well, both of us knew that with Rob, if you weren't going to produce a result, then you might as well hit the road. When he came back after two hours, we had all the drawings ready for him. Thankfully he liked them, because with Rob it was either "Fantastic! That works!" or, "It's shit! Start again!"

It may have upset some people, but that kind of decisiveness was exactly what we needed, and it led to the two key concepts that would get adidas back on its feet again: Equipment and Originals.

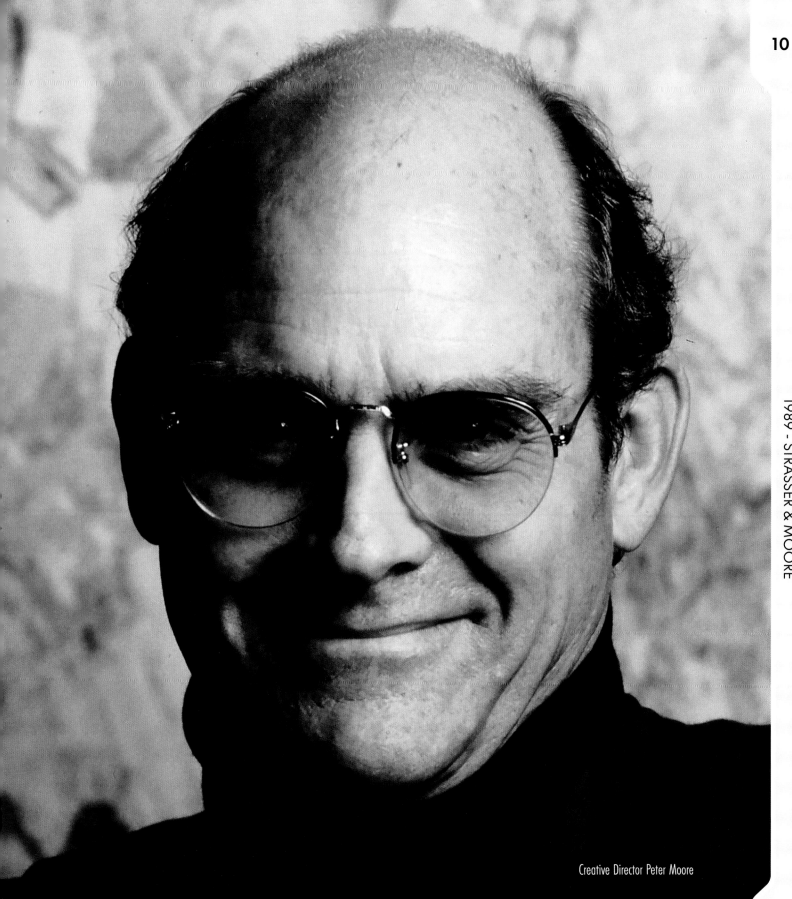

Creative Director Peter Moore

ADIEU FRANCE, HALLO WORLD

Change for adidas meant change for me, but it didn't come without some pain.

One of the questions Rob Strasser and Peter Moore had when they began working with adidas was why we had two separate design departments, one in Germany and another in France. Believing it was totally counterproductive, they initiated a study to assess where the best place to locate a unified adidas design center. It was driven by an external agency, Fuchslocher. Over one year, we visited several locations including Barcelona, Frankfurt, Paris, Milan, and New York. But after a lot of consideration and debate, we decided to remain in Herzogenaurach. Getting back to our founder's principles was core to our future path, so it made the most sense to stay in the place where Adi Dassler had founded the company.

With the decision made to stay in Herzo, I was asked to head up the new design department, which meant moving my team from France to Germany. I don't mind telling you it caused a lot of problems. My French design team couldn't understand why we needed to move, especially when we were doing such great work. After all, it was adidas France shoes that were

some of the best sellers. But the decision was made; we had to move to Germany. Thankfully, most of the team said, "Ok, we'll come with you," but it wasn't long before some, myself included, began to wonder if we'd made the right decision. At first, none of us wanted to move to Germany because our families were in France. So, every Monday morning, we drove four hours to Herzo, stayed in a hotel during the week, and then drove the four hours back to France on Friday evening. Honestly, this kind of living and commuting began to destroy us so, sadly, a lot of the guys from France left. It wasn't long before it was just me and one other person left from the original adidas France design team.

Eventually, I relented, and moving to Herzo was a major change in my life, as I was one of the first French guys to be based there. Being French, I was used to a less formal style of working. In Germany, it was normal for everyone to wear a tie, but I was possibly the first guy who didn't wear one. A lot of the older guys looked at me like I was some kind of a rebel, but I would

The adidas World of Sport headquarters
campus in Herzogenaurach, Germany

always say to them, "Hey! We're a sports brand!" I was also a lot less disciplined in my approach to work compared to my new colleagues. It's not to say that German people don't have fun when they work, of course they do, and at adidas France we had a lot of German people, but in France the attitude was that you should have fun when you work. It wasn't an idea shared by all of my German colleagues.

When I first moved to Germany, I often felt the need to be a kind of ambassador for adidas France. When you look at some of adidas's most popular products like the Stan Smith, Superstar, Rod Laver, and Nastase, they were all made in France, so I wanted adidas France to get the recognition it deserved. However, it wasn't long before the old rivalries were cast aside. Our industry was changing rapidly and adidas was no longer number one, so we needed to work together and forget differences of nationality. From the brand's earliest days, the Dassler family always had an international vision, to the point that in many countries, people had no idea adidas was a German brand, they just thought of it as their brand. Adidas had always belonged to the world. As a team, we were determined to take the company back to it.

ENJOY YOURSELF

I'm convinced that if you're a creator, it's essential to have fun in your work. When you enjoy what you do, you show it in what you make and build an emotional connection with those who buy your creations, making them far more than just products.

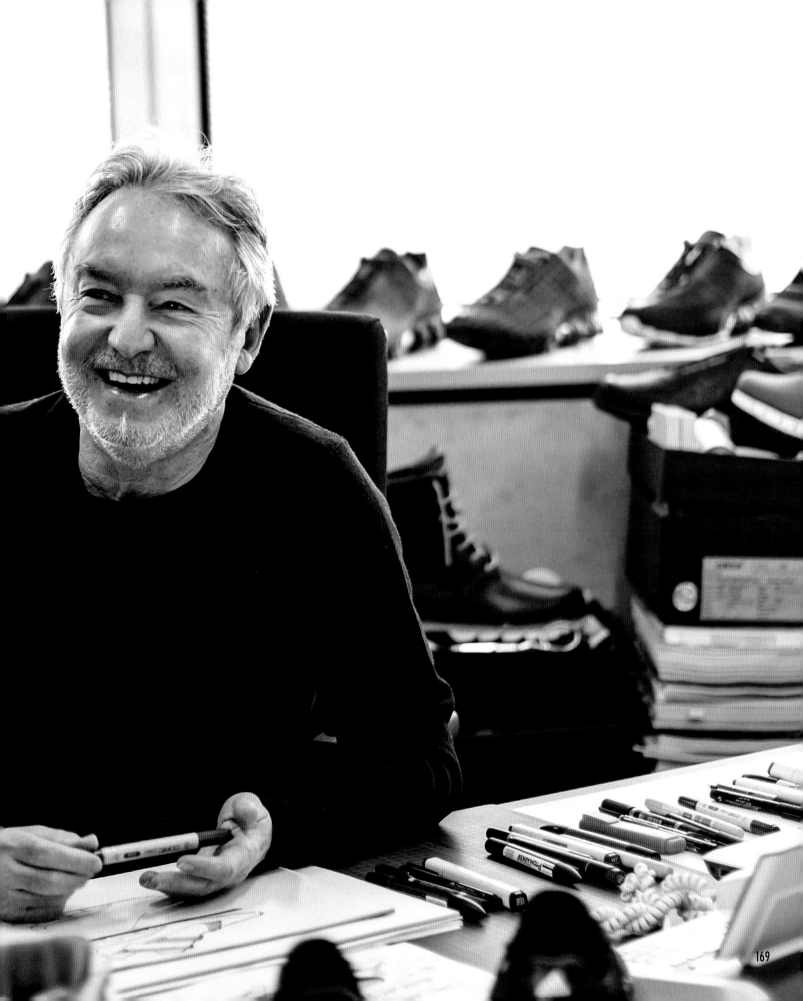

PAUL GAUDIO

My journey with Jacques really began in the early '90s when I was working in product design in the States. Out of the blue, my friend Charles Johnson, who was working for Jacques at the time, sent me a box. Inside was a note saying, "Hey, I'm working at adidas now and living in Germany. We're hiring. You should come over!" I opened the box and it was a pair of Equipment 1991 running shoes, and I remember thinking "Wow, these are cool." I could see it was a real product, not just a shoe, and that they'd really thought about the design. Admittedly, I'd kind of forgotten about adidas because the brand had faded in the States, my memories of it were just Superstars and hip-hop, but these shoes were so impressive, it made me think maybe adidas was somewhere I should consider.

Not long after, I found myself in Germany being interviewed by Jacques and Peter Moore in this slightly strange HQ building, where people wore suits and smoked at their desks. I wasn't sure it was where I wanted to be. From talking to Jacques and Peter, it was clear the shoes Charles had sent were an example of what they wanted to do with the brand. After I attended a global sales meeting full of young, international, energetic, excited people, I saw that this was where the brand was going. I was sold.

When I started working with Jacques, he was more coach and mentor than boss. The thing that still amazes me is the shocking amount of trust he gave to a young designer like me. Both to learn, but also to just do things on my own. He was very much of the school of thought that form follows function, which really resonated with me. He always approached you respectfully and with suggestions or questions that prompted you to rationalize what you were doing. Rather than tell you needed to change this or that, he would pose feedback as a question and say, "Maybe you could try this or have you considered that?" So he left you in control of your own decision. All of his products were so well thought out and so rational and purposeful that he was a great example for a young designer. Rather than standing up and giving big speeches, or telling you how it ought to be, he would just quietly set an example.

When I started with him, he was working on Equipment, which was really pushing the boundaries of not only the brand but also sneaker technology and design. So there was loads of room to explore and to try out new things. As a boss, he was so open and allowed you space to break boundaries and barriers. What also made him a great teacher was that, being classically trained, he could do the whole process start to finish—from making the patterns to stitching to lasting, he knew how to do it all. Yet he was unlike many classically trained guys in that he wasn't resistant to change and learning new processes.

Jacques and Peter Moore were really two birds of a feather, with Peter setting the vision for the brand and Jacques turning it into kick-ass product. As a young designer, I loved the clarity, simplicity and purity of their direction. They were both so ultra-supportive too. Because you were still learning, you might make a mess of something, but they were always so tolerant of your mistakes. The kind of products we were designing meant there was a sense that there was no such thing as too far, which meant it would have been easy to go off the rails, but Jacques was great at keeping part of you grounded by asking, "How does this help the athlete?" In what was a newly evolving world at the time, he was a great rudder.

I came into adidas at a time that was crazy, tumultuous and very political. It would have been easy to get chewed up and spat out, but Jacques and Peter were like an island of calm and stability, they always said, "This is what you need to focus on, don't accept any bull shit from anybody." So it was empowering and inspirational to have them backing me, and it really helped prepare me for anything. But the thing was that it was also huge fun too.

After 9 years with adidas, I went off to start my own design consultancy but later returned to the brand. Although Jacques and I no longer worked directly together, I knew I could always go to him to get his perspective on things. From day one Jacques had always loved helping people and training them on the ways of the brand. When I came back, nothing had changed. Later, when I became Global Creative Director and Jacques was heading up Porsche Design, I could see it was almost a kind of lab, filled with talented young designers to whom he was a great mentor. There are a lot of people out there who in Jacques's position would want to show off how amazing their career has been, but not Jacques. All he has ever wanted to do is share, and that's incredibly inspiring.

PAUL GAUDIO
Former adidas Global Creative Director

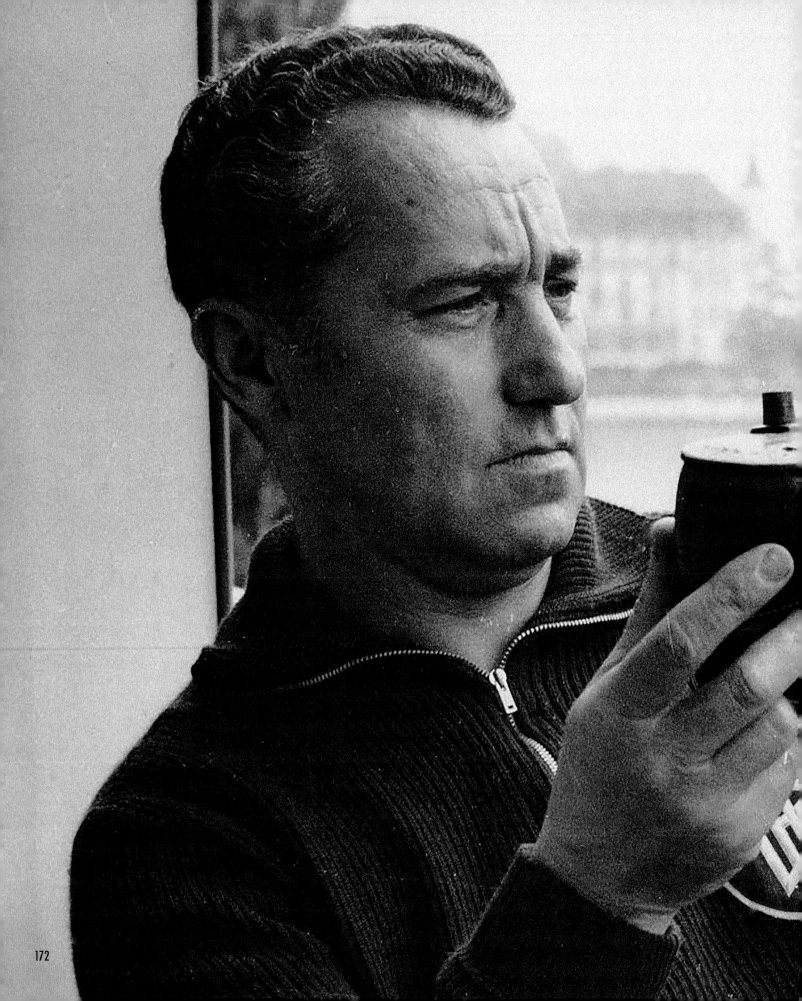

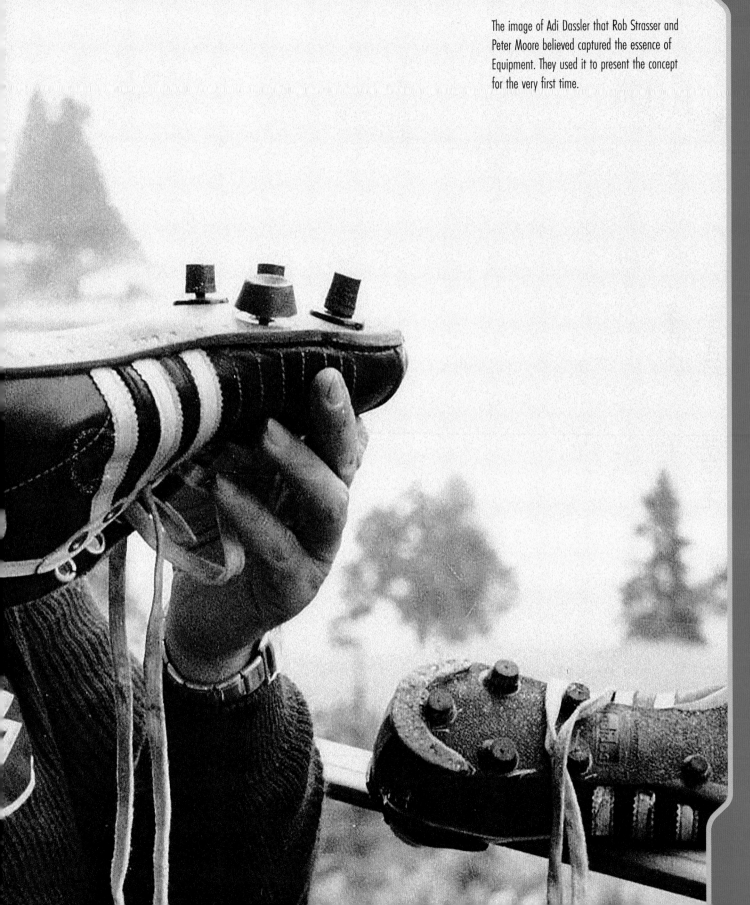

The image of Adi Dassler that Rob Strasser and Peter Moore believed captured the essence of Equipment. They used it to present the concept for the very first time.

1991 - EQUIPMENT

ONLY THE BEST FOR THE ATHLETE

Equipment. More than just a new collection, it was a philosophy—one that we were already familiar with, but one that had been forgotten.

The crazy thing about the Equipment concept was that when Rob and Peter first presented it, we all knew immediately what it was because it had been Adi Dassler's principle from the day he started adidas: "Only the best for the athlete." It was the essence of what the brand was about, but we had just forgotten it. What was even crazier was that it took two guys from Nike to point it out to us.

Rob and Peter believed that, at its core, what adidas was best at was making essential equipment that helped athletes achieve their best. They described Adi Dassler as, "equipment manager for the best athletes in the world." As Peter put it, "Equipment is all you need, nothing more, nothing less." The term itself was also completely unpretentious. You use equipment to do a job, not to look good. The only statement Equipment was intended to make was that you were serious about what you were doing. It meant stripping away any

appeals to fashion and focusing on the essentials. Performance, comfort, and quality would be at the heart of every product, and gimmicks and anything that had no impact on performance would be discarded.

As an idea it felt so right and so fresh, and it really resonated with me because of my admiration for our founder and respect for his values. But it wasn't just about doing what had been done before. Equipment was about taking those values and refreshing them to make them work for today and the future by creating honest products designed to perform.

Along with this new philosophy, the Equipment brand was given a unique look and feel. Peter created a new logo, now often known as the mountain logo, but originally designed to be distinct to Equipment, which was a departure from the traditional Trefoil. Incorporating the Three Stripes in a unique shade of green, it sat at the pinnacle of a new

design language that reflected the brand's new direction and essence.

However, the use of green faced opposition internally—not just because adidas had always been blue (the color of Bavaria) but because it wasn't considered a commercial color. Although common today, in the early '90s, you rarely saw green as part of a brand identity, and wouldn't until the 2000s when brands began adopting it as a way of claiming environmental credentials. However, Peter wanted to use a color that he hoped would become linked to adidas in the same way red was to Coca-Cola. He believed it said everything he wanted Equipment to say: athleticism, freshness, quality, and the outdoors. To me it also represented something else: hope.

Peter being Peter, he didn't take no for an answer, and green is still synonymous with Equipment today.

Opp. above: Peter Moore's original sketch detailing the inspiration for the Equipment logo
Opp. below: Its more technical implementation!

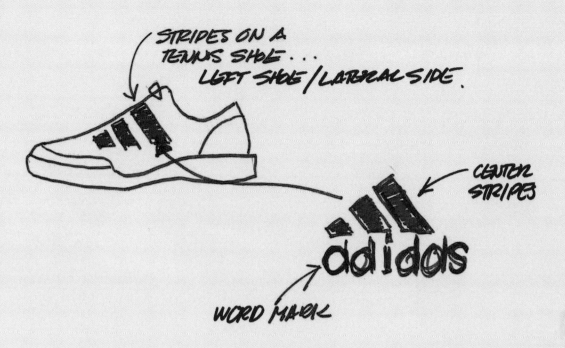

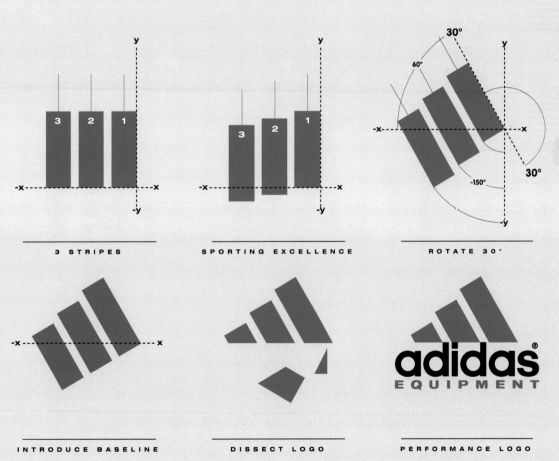

3 STRIPES

SPORTING EXCELLENCE

ROTATE 30°

INTRODUCE BASELINE

DISSECT LOGO

PERFORMANCE LOGO

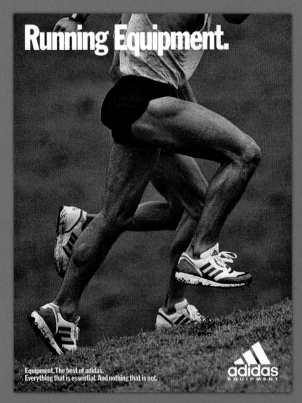

Running Equipment.

Equipment. The best of adidas.
Everything that is essential. And nothing that is not.

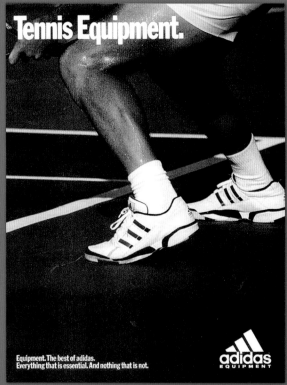

Tennis Equipment.

Equipment. The best of adidas.
Everything that is essential. And nothing that is not.

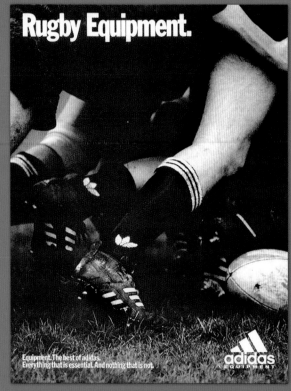

Rugby Equipment.

Equipment. The best of adidas.
Everything that is essential. And nothing that is not.

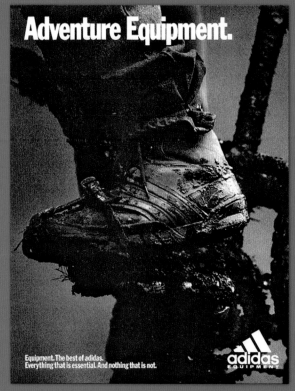

Adventure Equipment.

Equipment. The best of adidas.
Everything that is essential. And nothing that is not.

GOING GREEN

When Rob and Peter asked me to work with them to create the first Equipment range, I was incredibly proud and excited, because I really believed in the idea and felt committed to making it work.

Being able to bring Adi Dassler's philosophy to a modern collection in an uncompromising way was a challenge in which I reveled. Creating the collection required us to take an almost puritanical approach to the design of every shoe. Each one needed to be focused on providing the wearer the essentials of performance and comfort at a reasonable price. And when it came to aesthetics and construction, fashion went out of the window and we followed a strict form-follows-function approach. Anything on the shoe had to be there for performance reasons, not just for decoration.

One of the best examples was the way we used the Three Stripes branding on many of the shoes. Originally, Adi Dassler used the Three Stripes mark on straps applied to the upper to enhance the stability and support of the shoes in the midfoot. We wanted to bring this back wherever it was practical so on several shoes, we applied the Three Stripes branding to part of a midfoot support and eyestay system we called "Riemen," which is German for straps.

The essentialist approach even extended to the look and naming of the shoes. Along with Equipment, green, black, gray, and white were chosen as core colors for their simplicity and strength. The names of the shoes were kept as utilitarian as possible, being named purely by function. For example, the low-cut clay court tennis shoe was known simply as Tennis Clay Court Lo.

Again, following Adi Dassler's philosophy, where existing technologies could enhance performance, we didn't reinvent the wheel and the Torsion and Soft Cell technologies previously used on the ZX range were incorporated in almost every shoe. Similarly, the proven Cushion, Support, and Guidance categories that were the bedrock of the ZX Thousand series were also brought across to the Equipment running models.

The first collection included shoes for a broad spectrum of sports including, running, tennis, basketball, squash, volleyball, football, and golf. A first for the time was a new category we called Adventure. Although adidas had always offered hiking and mountain boots, the category was a new idea at the time, appealing to buyers wanting rugged outdoor wear and featured Adventure high-top, mid, low, and trekking boots.

Equipment became a milestone in adidas history and, for people both inside and outside the company, it marked the turnaround point where we pulled the brand out of its slump and became a player again. Both our products and marketing improved thanks to renewed optimism and a challenger attitude, which is reflected in the advertising of the time, which was far more punchy and edgier than it ever was. There are still those who look back at Equipment as too radical and too much of a departure from classic adidas. I know some collectors even refuse to have the shoes in their collections. The irony is that to the best of our ability we tried to design Equipment as if Adi Dassler himself was doing it.

Although the original look eventually gave way to more colors and styles, the Equipment philosophy continued to influence our approach to design long after the '91 and '93 collections, being absorbed (some would say diluted!) into other ranges, such as Feet You Wear and Predator as EQT.

I started at adidas on January 2, 1987, in Herzo, at the time when Horst Dassler came to Germany to run the whole company and was about to put the first international product management in place, but passed away shortly after I started.

I first met Jacques when he was heading up Design and Development in France. Torsion was the first big global project I was involved with at adidas, and working with Jacques, it really was fantastic to bring the project together with him, Hart Klar, and Peter Rduch. Torsion really changed the running industry—not only because it changed the way people selected and bought their running shoes, but because from a design point of view, it was a radical, almost aggressive approach. Most running shoes before then were white or very plain in color. The earlier ZX series had certainly brought color to the category, but with the ZX Torsion range Jacques, together with Wolfgang Scholz, was creating shoes with colours you just didn't really see on running shoes, like bright and intense blues, yellows, reds, and greens. And it wasn't just on the uppers, because we also used color on the midsoles to indicate what type of runner you are. It was such a successful range that even today in the Originals line, Torsion shoes are a huge factor in terms of business and also style for adidas.

So that was sort of my first big project for the brand, but also working with Jacques, and was really when I started my appreciation for his taste and eye for detail. I really gained an understanding that he was someone who was not just the designer, he was also a developer and really thought about the foot, the performance, and the aesthetics, all at the same time. It was just fascinating to work with him.

I traveled almost every second week to France when Jacques was heading up design there, and it was fascinating to see how he led his team and how he worked with them, and just how much people respected him. They really looked up to him. Then they moved the whole French design and development team to Herzo. They brought them to Germany on Monday morning in a bus, and then brought them back to France on Friday afternoon. It brought the company together, which was a great thing, but I also felt very sorry for the French guys because they were away from their families and their social lives, so it was tough, but Jacques still managed to maintain his level of work and creativity and somehow produced some of his best work at that time.

The other major line that I headed up and worked on with Jacques was Equipment. It was really the idea of Rob Strasser and Peter Moore who brought it to adidas but initially they were consultants, and I was the guy who managed it internally. It was much more than just a range; it was a whole philosophy and had a big impact on the structure of the company.

We started business units with a global responsibility leading the whole business, and we had one for each sport and (once) one for adidas originals and one for Equipment. Initially, Equipment was divisive. There were people who really were excited about the new direction, which was almost a kind of modernization of the old direction of Adi Dassler. But, of course, there were also people who just liked the direction they were taking the brand in the years before, which definitely wasn't homogeneous. It went in all different directions in different countries and regions of the world and stood for different things. What Equipment did was bring it all back together to the core of what the brand stood for, and Jacques almost having that in his DNA, was very excited to be part of that movement.

Although I left adidas in 1998 to become the CEO of Bally, when I started my own consultancy later on and brought adidas and Porsche Design together, Jacques and I were reunited again when he headed up footwear for the Porsche Design Sport collaboration. In many ways, he hadn't changed at all. He still had that same drive and passion for his work that I so admired. Probably even more so!

BERND WAHLER

Equipment.

Multi-sports shoes from the first Equipment collection in 1991

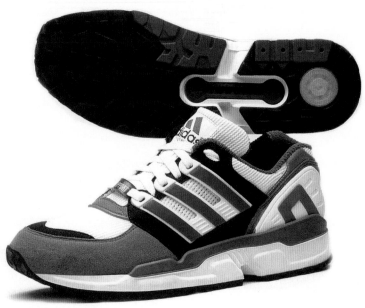

Running Support

Squash Lo

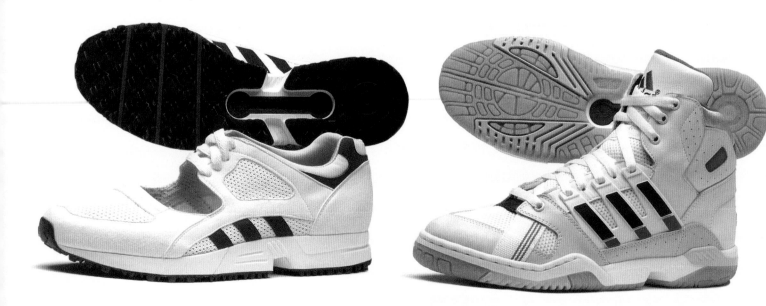

Racing

Volleyball Hi

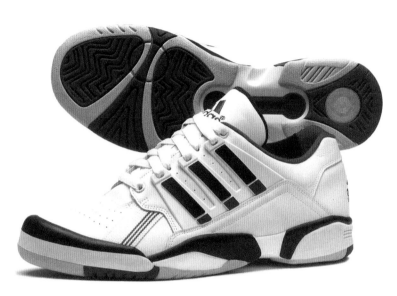

Tennis Clay Court Lo

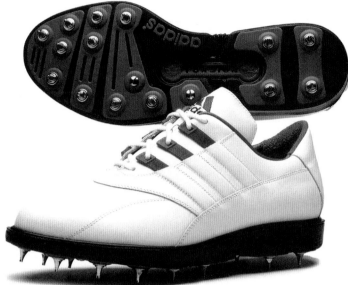

Golf

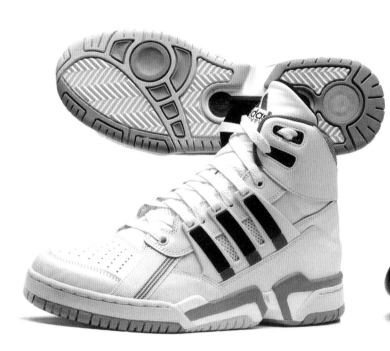

Basketball Hi

Adventure Hi

INA HEUMANN

It seems that I was waiting all my life at adidas for this to happen, and that words are put on paper that describe what I have experienced by talking and listening to Jacques.

Having first joined in 1979, I've worked with many wonderful people during that time and one of them is Jacques. When I think of Jacques, I hear his voice and that wonderful French accent, and I see a gentleman—in the way he dresses, the way he speaks, and the way he treats others with such respect.

The best concept that Jacques and I both worked on was Equipment. It was a unique time and both of us were part of something that had a huge cultural impact on the company. At the time adidas was suffering. The company didn't have a clear vision and strategy and, in terms of product it was all over the place. We created products without any thought of asking if it was right for the brand or not. It's almost unimaginable today but alongside sportswear we were doing business shirts and ties, it was a mess.

However, when Rob Strasser and Peter Moore first came to adidas, things began to change. They came to us and said something we didn't expect. "You need to go back to the roots of Adi Dassler." It sounds crazy today but, at that time, Adi Dassler was in many ways forgotten at adidas. We just didn't think of our founder. We never thought "How would Adi solve this problem?" or looked back at the products that he had created to learn from them. In many respects we had forgotten who we were.

Peter and Rob reminded us that we were a sports brand and we are here to make the athlete better, as simple as that. A lot of people get the impression it was a one-way discussion though, it really wasn't because Peter and Rob also wanted to learn from us and challenge us in a way that we had our own epiphany, realizing ourselves that the answer was already within us. One of the few people who hadn't forgotten it though was Jacques, because he always tried to live up to the values of Adi Dassler.

It wasn't just what Rob and Peter said, it was the way they behaved. At the time adidas was still what you might call a "suit and tie" company. So formal that when we addressed each other we used "Sie" rather than "Du." But when Peter and Rob came, they wore jeans and T-shirts, and formality went out of the window! They talked to anyone and everyone. Rob would just stroll through the building and no matter who you were, he wanted to talk to you. He would ask us, "What's good and what's bad?" You could have a real conversation with him and ask him questions, and although he wouldn't always have an answer, by talking to him you found it yourself.

Rob and Bernd Wahler, who headed up our Business unit Equipment, really knew how to make life fun! There was one time when Rob invited us, at his own cost, to Portland. We took vacation days and went on a five-day trip to Portland and Manzanita where Rob had a house on the beach and even did a trip to Los Angeles. It wasn't just a vacation, it was a once in a lifetime experience and I know even today all these years later if I was to ask any of that team for help, they wouldn't hesitate.

When Rob and Peter first introduced the Equipment concept, there was some hesitation from people, but the simplicity and positivity of the message created a kind of infectious enthusiasm for it. One of the best reflections of this was that the employees wanted to start wearing our own products again. Nowadays it's normal to see adidas people wearing adidas, but it was a first at that time, because we all started wearing Equipment! It was like being part of a start-up. It was so new, so fresh, so optimistic. We were off to change the world and on a mission to get adidas back to being the best sports brand in the world.

So many of the adidas principles and standards that we both were part of bringing back to the brand are still core to the brand today. If there is one person who is the living DNA of adidas it is Jacques. His desire to bring Adi Dassler's values to new generations of designers and to help them grow, without preaching what is right or wrong, and help them develop their own thought process is truly inspiring. It continues to be my pleasure to know and work with him.

I am a bit spoiled when it comes to fit and comfort of an adidas shoe as I know how they felt on my feet when they were introduced. But there was always one guarantee, if Jacques designed a certain shoe, then I could just buy it off the shelves without even trying on, as I knew this shoe would work.

INA HEUMANN
adidas Project Manager, Original Equipment team member

1991 - EQUIPMENT

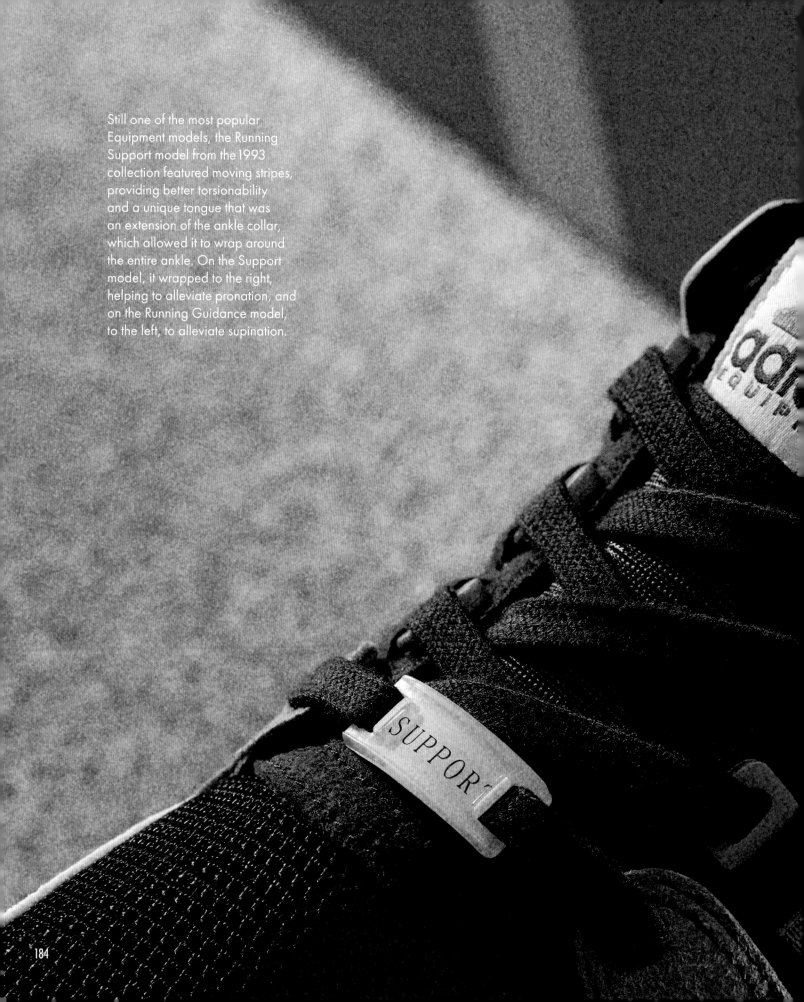

Still one of the most popular Equipment models, the Running Support model from the 1993 collection featured moving stripes, providing better torsionability and a unique tongue that was an extension of the ankle collar, which allowed it to wrap around the entire ankle. On the Support model, it wrapped to the right, helping to alleviate pronation, and on the Running Guidance model, to the left, to alleviate supination.

THOMAS KRÖDEL

Jacques Chassaing was always a very valued colleague for me, and one of the great constants at adidas over the years. First and foremost, as Head of the Design department he set the path and direction for a group of talented young designers. Above all, I admired his work as a designer, which throughout his career was key to the success of the brand.

That's why his designs were always something very special for me. Never predictable or expected, and always with done with a freshness and uniqueness that I have always admired.

I've always respected his feeling for the value of great materials and the way he did everything he could to implement an essence into his creations that was true to his original vision.

Over the years, I've always known Jacques as a very calm, very thoughtful, and focused colleague. He's always been an example for me how you work professionally and with great respect. He always had a lasting influence on the working environment in a large company throughout a long working life, managing to stay positive through all the adversities.

For me, Jacques has been one of the most formative employees who has worked for the adidas brand and company, and that is his legacy for adidas. All the best Jacques.

THOMAS KRÖDEL
Former Vice President Football Operations,
Brand Operations adidas

Opposite: Equipment Running Cushion, one of the shoes Thomas and Jacques worked on together as part of the 1993 Equipment collection

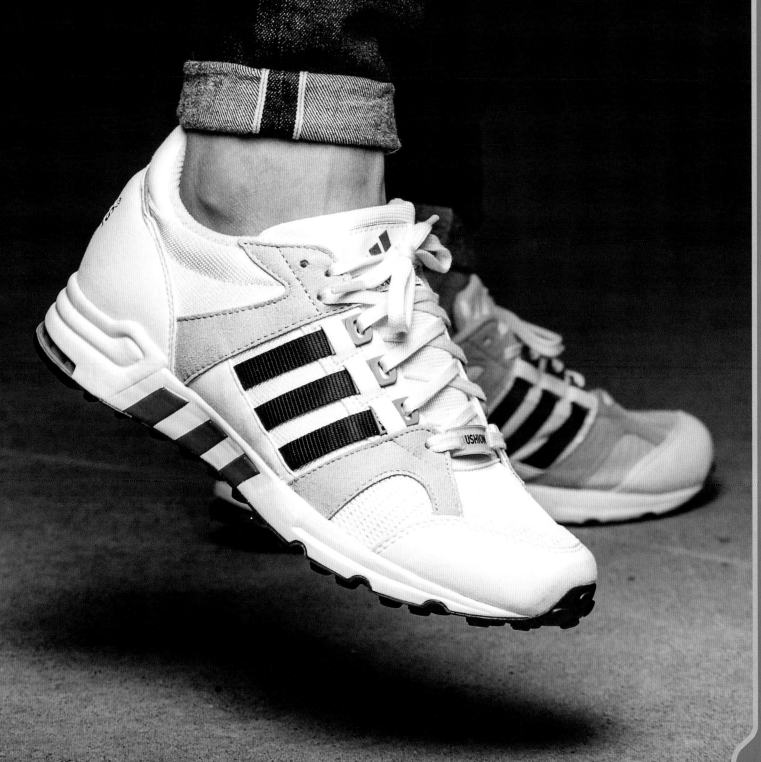

WHERE YOU ARE

Something I used to say when I hired young designers was the first thing you need to do at any brand is understand where you are. Because when you understand the origins of your brand, you not only know where it has been but, more importantly, where you can take it.

1991 Originals launch catalog

THE ORIGIN OF ORIGINALS

Originals today is an entire division of adidas, but it started out as just an idea for a collection. Little did we know the impact it would have.

A key part of Rob Strasser and Peter Moore's plan to reinvigorate adidas was the concept of Originals. The idea came to them during their first visit to Herzogenaurach, when they visited the company archive and saw a treasure trove of shoes. As they looked at the incredible history laid out before them, they realized that these shoes, many created by Adi Dassler himself, had been part of some of the greatest moments in sporting history, and had once been loved and worn by millions. It was time to bring them back.

Called Originals, Rob and Peter's idea was to create a collection of adidas shoes that were once the cutting-edge sports shoes of their time and revamp them into modern street wear classics. The first time they spoke about it was during a meeting they called on Corpus Christi in June. Back then, religious holidays were usually strictly observed, so calling a meeting on one was not exactly popular! But that was Rob and Peter. Rules were there to be broken.

On the table in the meeting room were some real adidas classics that would potentially be the start of the Originals line up. For a shoe to considered an "Original," it was agreed that it had to have sporting origins but be comfortable enough to be street wear. It also had to have been a proven success in the past. Coming from Nike, Rob and Peter's example was the Cortez, a '60s running shoe that was still popular in the '90s.

One of the first things we considered was how we could take classic models and bring the levels of quality and comfort up to modern day standards, while keeping the same construction and shape. When these shoes were originally made, they were great for the time in terms of comfort, but people now had higher expectations. To evolve them into street wear, with many of them we started by looking at the padding of the shoe, especially in tongue and quarter lining and how we could increase it. Depending on the shoe, originally they would have been PVC, but we moved to a spongier or softer materials to increase the feeling of comfort to make the shoe less performance-orientated and more casual wear.

In some cases, we also changed the label on the tongue; for example on the Stan Smith, we went with a simple textile label with the linear adidas text logo. It was key that we didn't make too many changes because it was essential to retain the original character of the shoe.

The differences from the classic shoes were in the colors that we introduced, which were more "fashion friendly," and in the materials, which included softer and smoother leathers, suede, and in some cases, waxed leather.

When the range was launched in for Fall/Winter 1991, the shoes that were part of the debut Originals collection were the Stan Smith, Official, Superstar, Samba, Gripper Hi and Lo, Marathon Trainer, and VIP. To make them distinct, the Originals line was sold in its own style of box in naked cardboard wrapped with black Three Stripes.

Looking back on it now, while we were pretty sure Originals would be a success, we could never have envisioned it would eventually become an entire division.

Debut Originals range featured in the 1992 adidas Japan Originals catalog

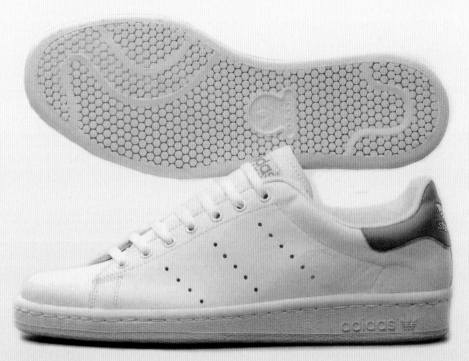

Stan Smith

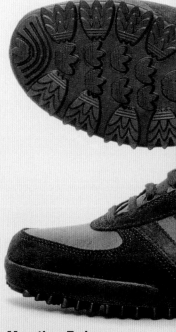

Marathon Trainer

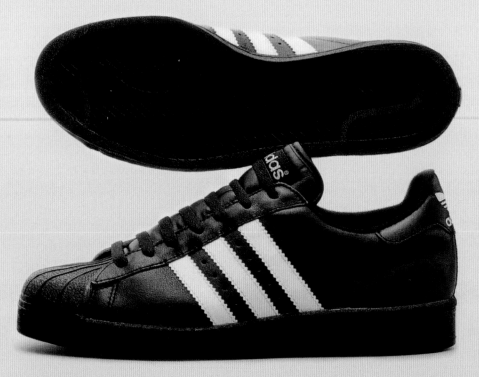

Superstar

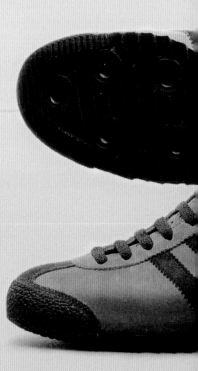

VIP

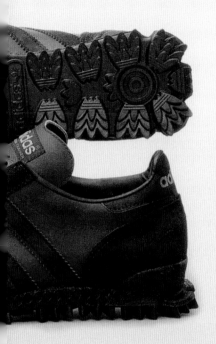

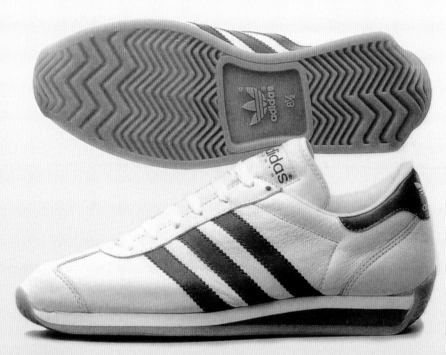

Country

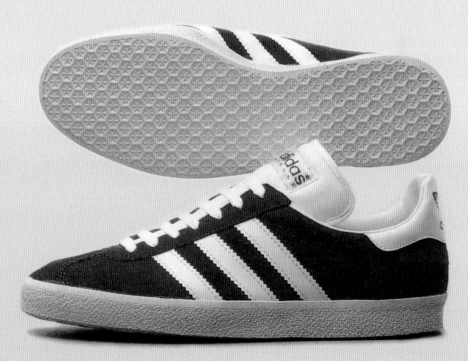

Gazelle

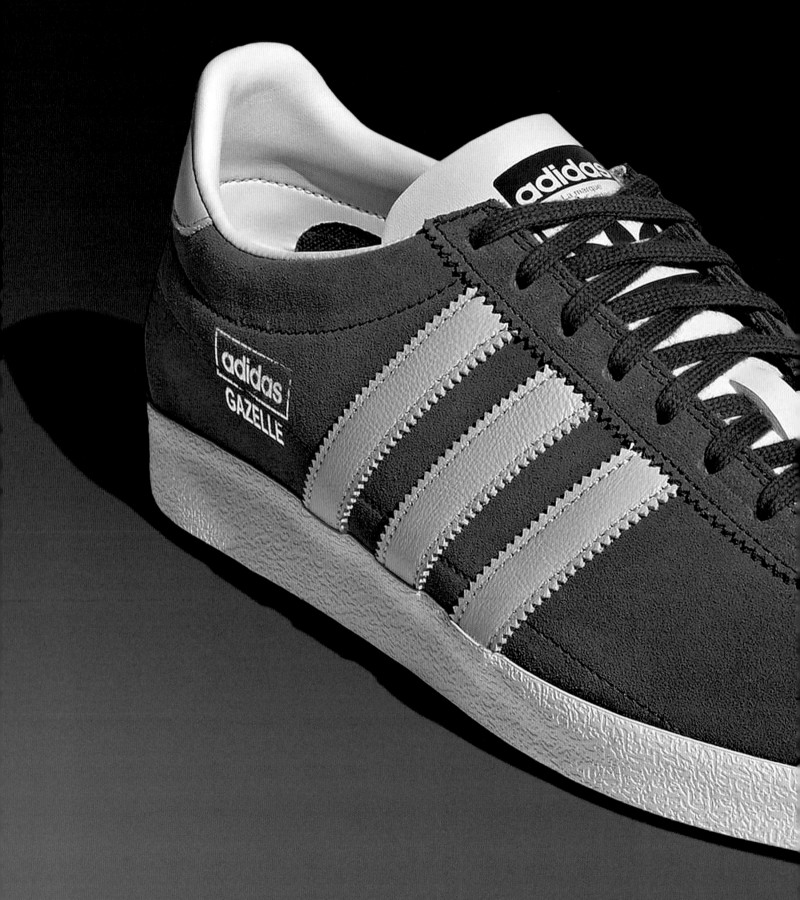

INSPIRATIONS:
GAZELLE *1966*

Although it's considered a fashion shoe now, when it made its debut in the 1960s, the Gazelle was designed as a serious training shoe. What I love about it is that its look says handmade. Although it has changed over the years, it still has that handcrafted look. The other thing I love is how its colors always pop. It was one of the first training shoes to be made using suede, a great material to use when you want intense colors. The brightness of the blue and red it originally came in really caught the eye. Each color had a different outsole—the red for outdoor use and the blue for indoor—but it was later one of the first adidas shoes to come in a wide range of colors, and the outsole was changed to the hexagonal profile it still has now. Although it came in and out of the adidas range during the '70s and '80s, its popularity meant it was one of the shoes we chose to be part of the very first Originals collection.

FASHION

What is fashion? Fashion for me is when I feel good in what I'm wearing, not what everyone else is wearing. Fashion starts here, with you, not out there on someone else.

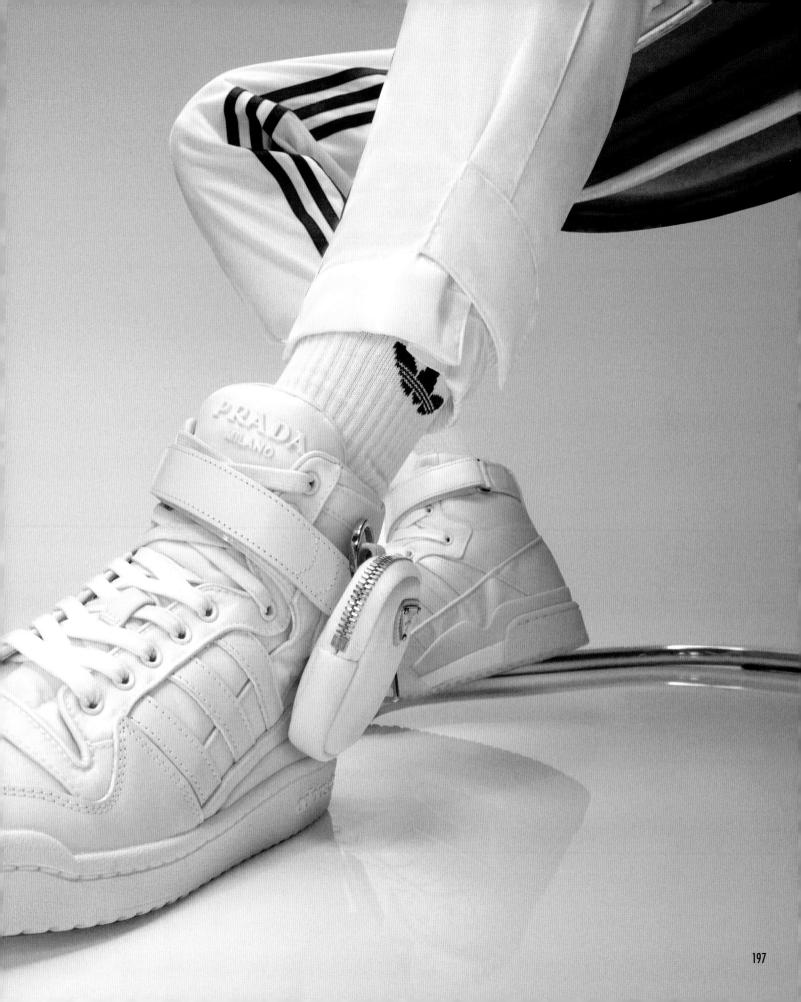

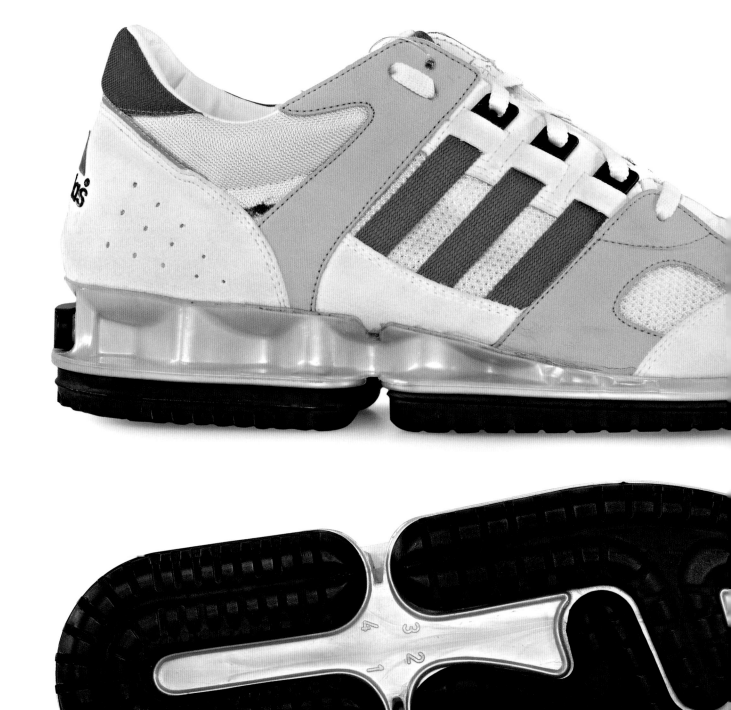

First Tubular Radical Prototype

TUBULAR *1993*

Sometimes an idea comes way before its time.

The concept for Tubular first came at the time of the "Air Wars," when all the brands were creating designs around the idea of inflation. While Reebok and Nike focused on inflatable air bladders that adjusted the fit, we wanted to create a sole-based system that allowed the wearer to fine tune the traction and comfort of the shoe. The inspiration for the system came from car tires. You only have to watch Formula 1 to know the difference that they make to a car's performance. The relationship between grip and inflation is key and can be the difference between winning and losing. We wanted to explore if this could make a difference to athletic performance.

The first prototypes we made were fairly crude and based on regular ZX, Torsion, and Equipment models attached to separately inflated air chambers. The first consumer version we created, if you could call it that, was the Radical, an Equipment upper mated to a hard but flexible Pebax polyamide platform (more commonly used on football boots) that had four air chambers inflated using a valve system in the rear of the heel with an integrated pump. A limited release as a market test received positive feedback and was encouraging enough that we developed the idea into a Tubular range: the Tubular 2 with just two air chambers, the Tubular 4 with four chambers and an inbuilt pump, and a cross-trainer called the XTR.

While these also received great feedback, ultimately, the problem we had with Tubular was not the idea, comfort, or performance, it was that the valve system still needed more development. At the time, the technology just wasn't there to manufacture a 100% reliable system on a large scale, meaning the concept was probably too ahead of its time, rendering Tubular as a kind of successful failure.

However, the idea didn't completely die, but it did have to wait awhile for its resurrection. More than thirty years after it had been shelved, looking for ideas for new products, my colleague Nic Galway pulled the old prototypes out of the archive. Taking the design of the Tubular cushioning system as an inspiration, he and his team developed a tube sole that used dual density EVA rather than air to give an equally comfortable ride. Called the Tubular Runner, its look was inspired by the original prototypes, we created back in 1991, with classic ZX cues subtly integrated into design. It became just the first of a whole range of Tubular shoes, meaning that even though much time had passed, our work had eventually made a difference.

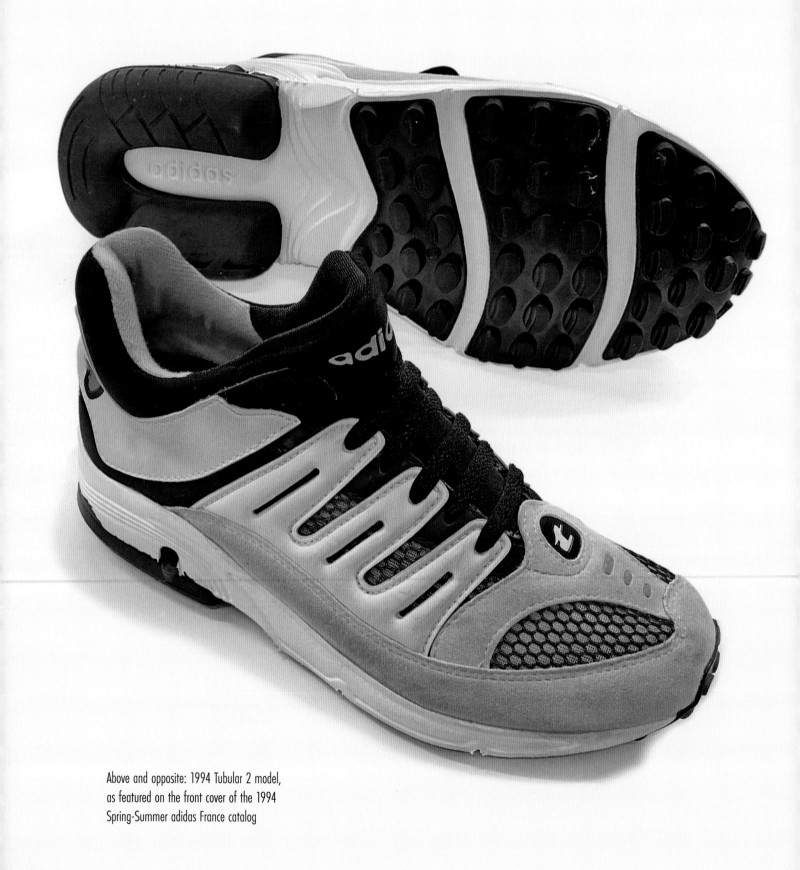

Above and opposite: 1994 Tubular 2 model,
as featured on the front cover of the 1994
Spring-Summer adidas France catalog

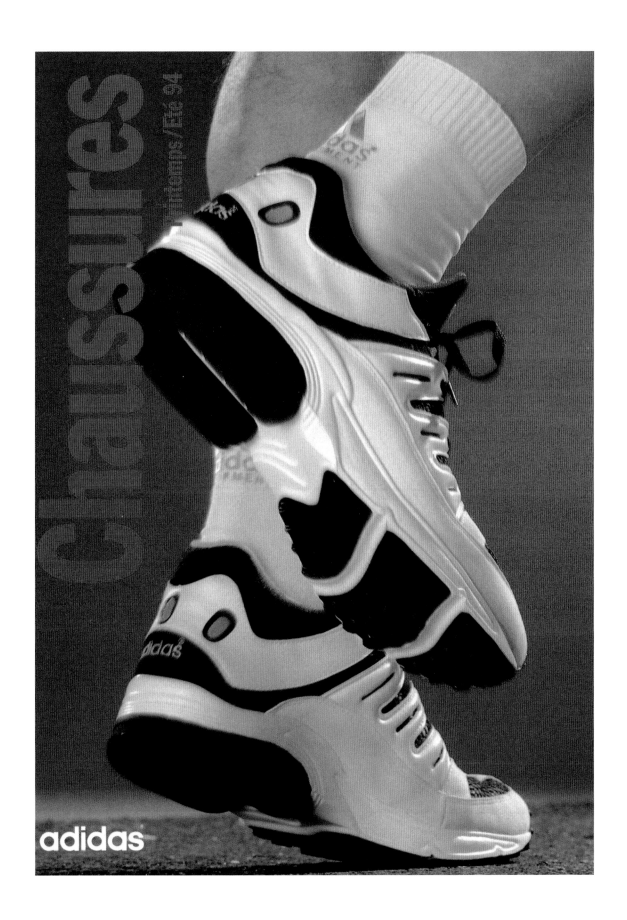

Chaussures Printemps/Été 94

adidas

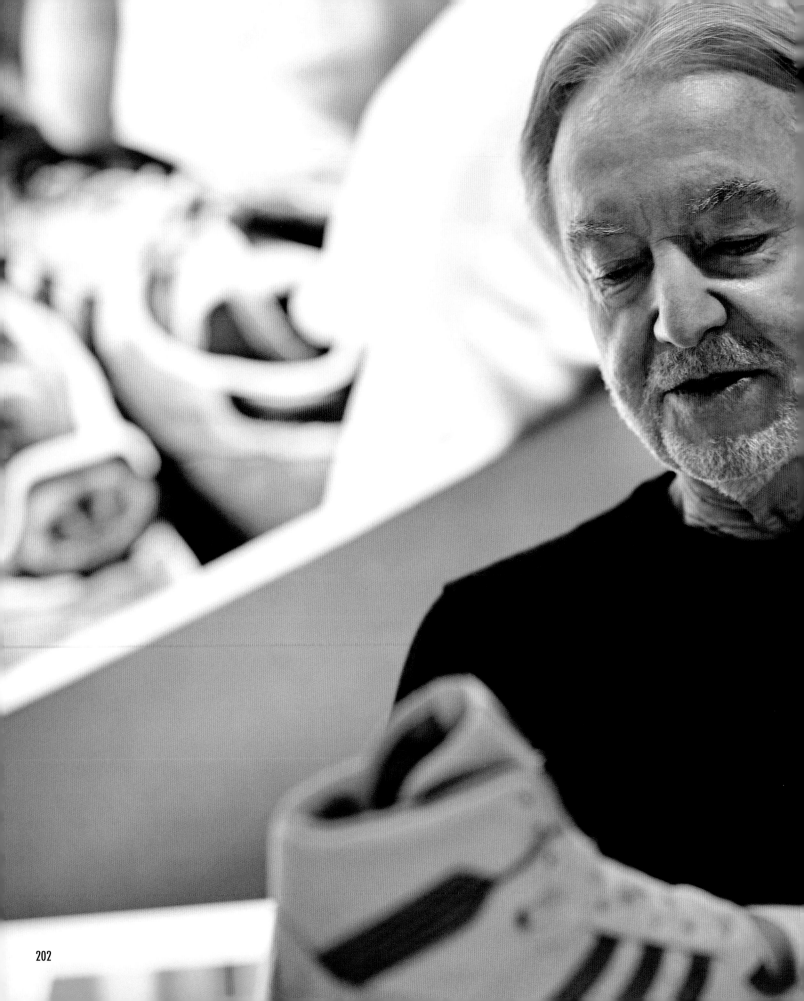

CRITICIZE ME

Something I've learned during my career is that one quality it's essential to have as a creator is humility. The sooner you realize that there are people better at your job than you, the quicker you will learn to reach their level. Almost all creators have egos as tall as the Eiffel Tower. In many ways, it's a requirement of the job, but it means it's often tough for us to listen to criticism. But listen, you must. I'm happy to admit I've done my fair share of shit in my time. It's true. And as much as it hurt to hear it, it was only to my benefit, because it helped me to make not just what I was working on at the time better, but also the next thing.

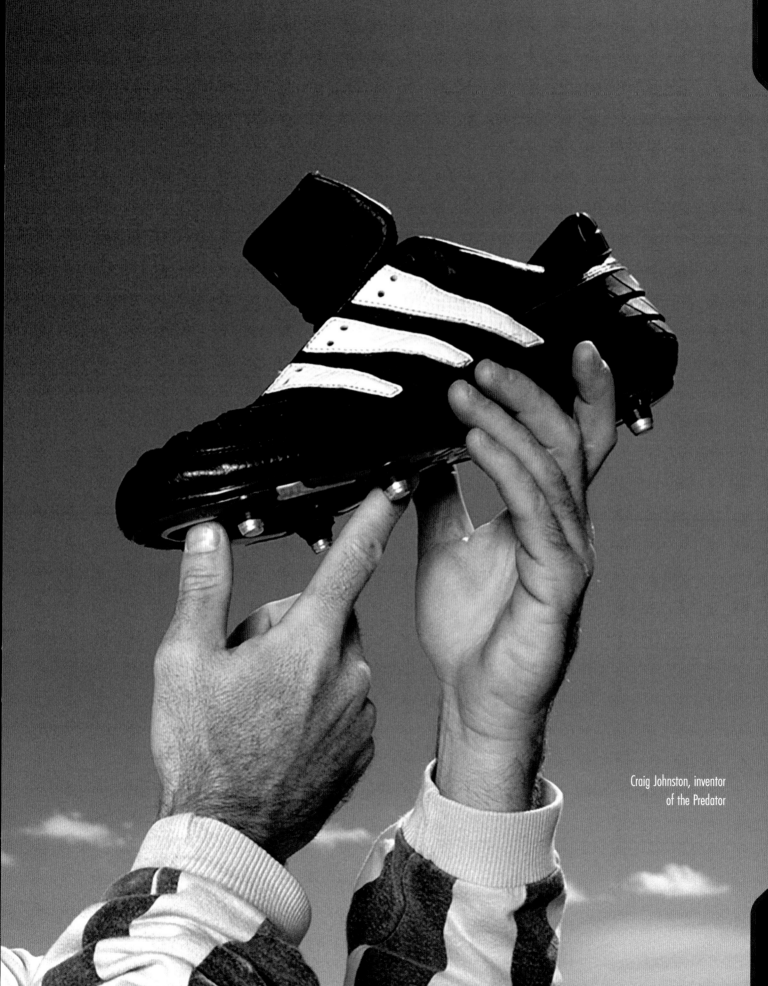

Craig Johnston, inventor
of the Predator

PREDATOR ¹⁹⁹⁴

The Predator was a great shoe to work on because it was such a daring and bold idea, but it would have been nothing without the drive and passion of its creator, Craig Johnston.

When Craig first approached adidas with the idea for a new football boot in 1992, he had already been developing it for several years after retiring from a successful career playing for Liverpool. The first time I met him, he came with a bag full of what looked like a cross between a football boot and a garden shoe, with strips of rubber fins on the forefoot, which he explained helped a player to control the ball better and apply swerve to it.

Initially, there was skepticism from some of my colleagues, but there was something about the design that was very interesting to me. We were always thinking about how we could improve our football boots, especially regarding contact with the ball, and Craig's idea seemed to make sense.

However, as much sense as it made, my colleagues and I weren't football players, and we were keen to get the thoughts of someone who was. Someone in soccer promotions contacted Franz Beckenbauer, a long-time adidas player, and asked him to look at the prototype. During a visit to Herzo, he tried it on but as it was in the office, he couldn't test them properly. He suggested we bring it to him to try at Bayern Munich.

We took some prototypes to the Bayern training ground, which was completely covered in snow, where along with Karl-Heinz Rummenigge and Paul Breitner, he tried them out. I can't remember if it was Rummenigge or maybe Breitner who said, "We don't know exactly what, but there is definitely something going on with these boots." When some of the best players in the world say that about a boot that is still a prototype, it's the best thing you can hear.

There was a lot of excitement about the boot after the Bayern legends tried them. When it was tested by the adidas technical guys, the results showed that there was a definite improvement in power and swerve, so a deal was made with Craig to develop his design further.

Our team, which included Hart Klar, Wolfgang Sholz, and Jimmy Weigl, worked with Craig throughout the project and, admittedly, there were often some tense times. It was partly because of cultural differences, but more because he felt it was his baby. We understood though, and admired his passion and dedication very much. It was more than just a new boot to him and, because of his drive, it became the same for us.

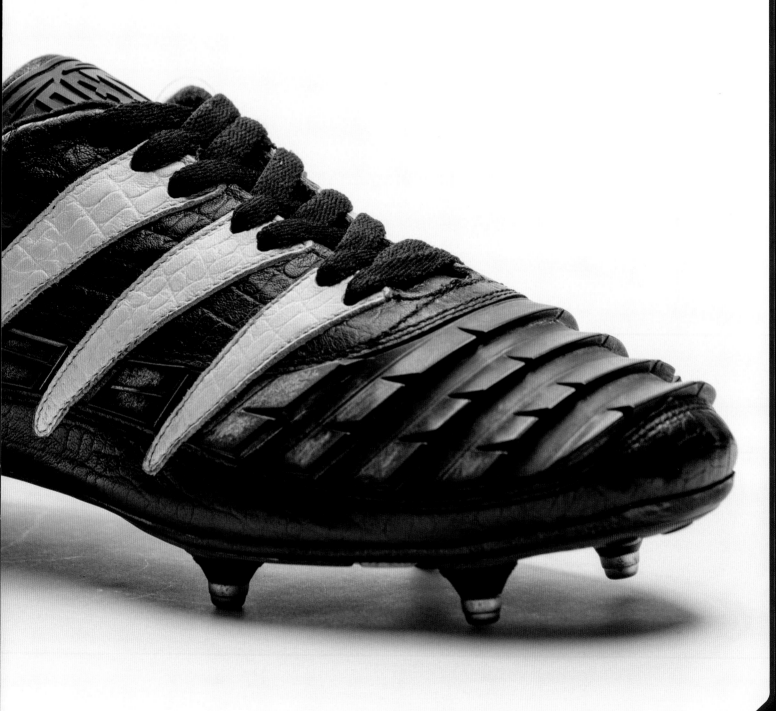

One of the first Predator prototypes with
the fins extending up to the tongue

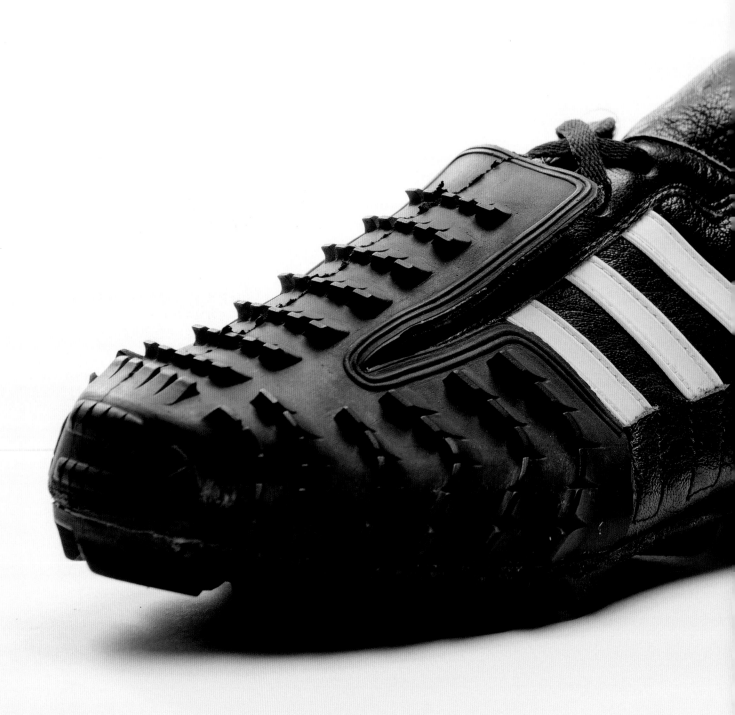

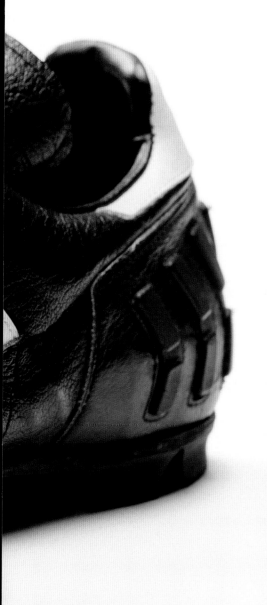

One of the biggest challenges we had was finding the right shape and geometry for the fins. Because they were moved when contact was made with the ball, we had to find the best angles and direction to transfer rebound and power to the ball. I can tell you from all the headaches I had, that's not a simple task! On the first prototypes that we developed, the lacing was covered by a tongue with fins on it, but we found the best solution was to keep them to the forefoot.

Although the shoe is best known for the fin technology, it also had a pioneering outsole based around a multi-angle corrugated metal plate that was specially developed by a sports medicine team who determined the optimum angles of the corrugations.

Like Torsion, we knew if you could show the customer the technology they were more likely to understand it and then buy it, so we created transparent windows that allowed you to see the what was going on. The downside was that being metal, the Flexitech panel added to the weight of the shoe, and to add the window we had to increase the thickness of the overall sole, but it worked well.

With the fins giving the shoe a very animal-like aesthetic, we wanted to complement them by doing something different with the Three Stripes, so we gave them a kind of clawlike look and reptile skin embossing to complete the aggressive style.

The name "Predator" was chosen by Peter Moore and is still the perfect name. He also designed the first logo, which had a suitably menacing look, and went on the tongue of the shoe, molded in 3D like the fins.

As challenging as it was to get right, the first Predator was a great shoe to have been involved with—not just because it was a milestone in the history of the football boot, but especially because it was the realization of Craig Johnston's dream.

Although my involvement with Predator ended after 1998, it was and still is great to see it continuing to evolve and appear on the feet of the world's greatest players.

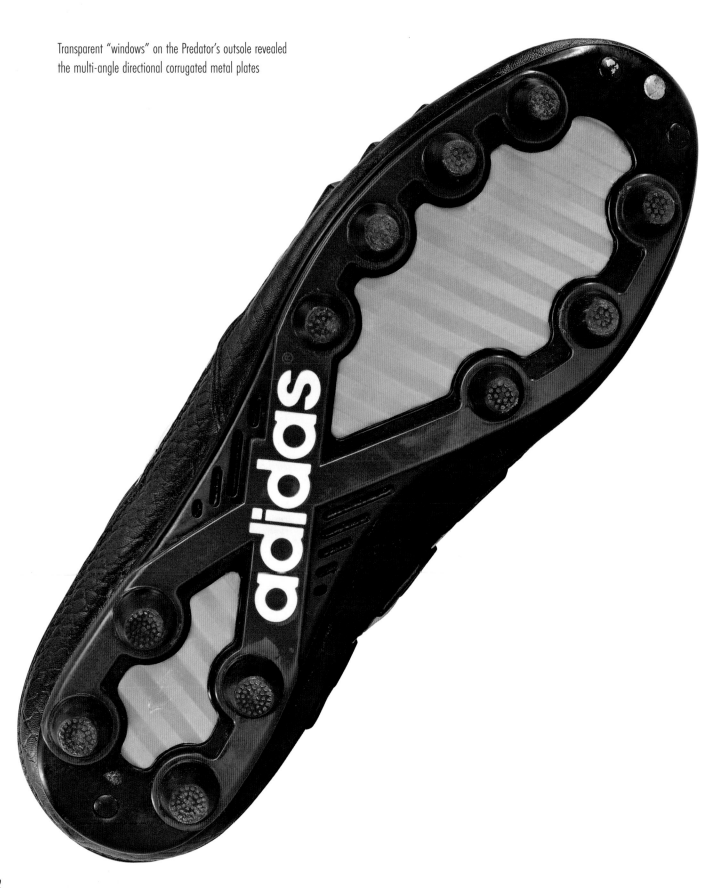

Transparent "windows" on the Predator's outsole revealed
the multi-angle directional corrugated metal plates

1OO% legal.

PREDATOR
by
adidas

O% fair.

PRESSURE
POINT
ELIMINATION

Dieses System revolutioniert das Komfortdenken im Fußball.
P2E ist eine gewellte Platte, die aus einem fortschrittlichen und leichten Mischmaterial hergestellt wird.
Dieses System ist zwischen Laufsohle und Schaft integriert. Sie verläuft von Seite zu Seite, verbindet die einzelnen Stollen und verteilt den entstehenden Druck über die gesamte Sohle. Dadurch wird der auftretende Druck enorm reduziert, speziell bei sehr harten Böden, und bietet somit einen unvergleichlichen Komfort vor allem bei Stollenschuhen!

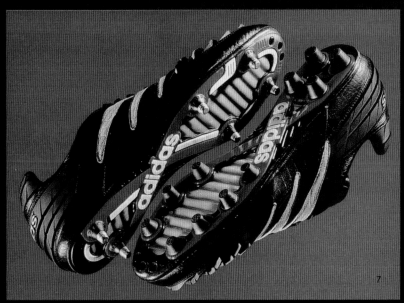

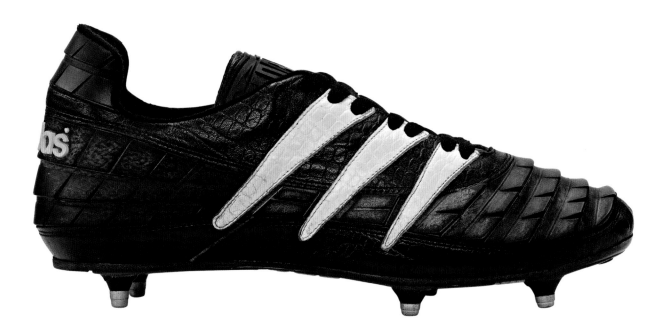

Predator (1994)

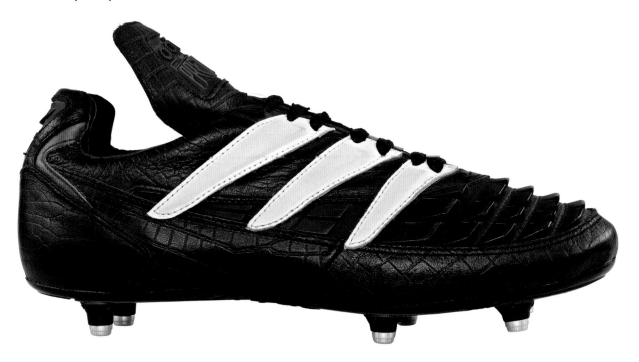

Predator Rapier (1995)

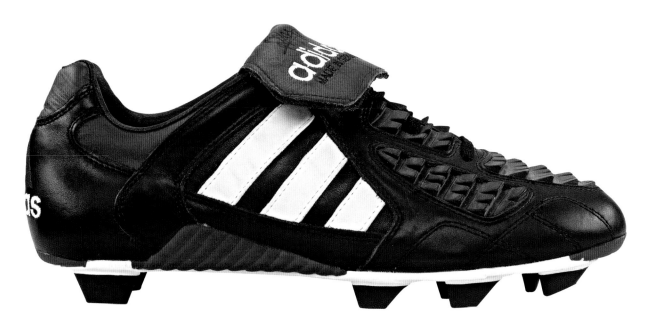

Predator Touch (1996)

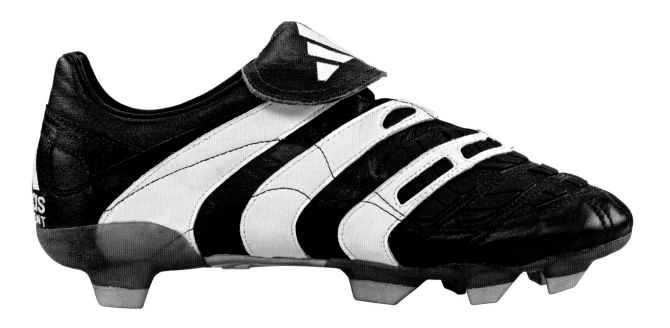

Predator Accelerator (1998)

CREATING A MONSTER

HART KLAR

I worked with Jacques both directly and indirectly on many projects during our time together at adidas, but one of my favorites was as Product Manager of the Predator.

In 1992, former Liverpool striker Craig Johnson approached us to present his concept for a new football shoe. After his career, Craig had coached youth teams in Australia. While coaching, he often noticed poor ball handling and poor strikes. He had the idea to prevent this by improving friction between the foot and the ball. Taking inspiration from goalkeepers gloves, he made some prototype shoes using table tennis rubber on the forefront of a soccer boot and, after testing them in Australia, felt the results were promising.

After the first presentation, Craig was invited to present the concept to a group of adidas managers headed by Rob Strasser, adidas Marketing Director at the time, and including me. Despite many doubts internally, Rob signed Craig as a consultant, based on his concept of creating a football boot with a totally new forefront made out of rubber, and if it was successful, creating a new category of football boots. Rob wanted it to be a special project outside of the normal product design/development procedure. A team was put together, of which I was named Project Manager.

Rob was keen for Craig to be Product Manager of the project so for the first few months, he lived in Herzo during the week, working directly with me and the project team on site. The team consisted of designers, a developer, a material specialist, and a biomechanical engineer from our Swiss research department. Former German national and Stuttgart football player Hansi Müeller was also part of the team.

Based on the results of his test shoes from Australia, Craig worked with our designers to produce new prototypes. As the rubber used in the prototype wasn't totally satisfactory, we worked together with German company specializing in rubber technology for table tennis, who worked very closely with the best German table tennis players, who were number two only to the Chinese. The result of the collaboration was a new rubber mixture. Craig and the designers then came up with the concept of "fins and jets," similar to shark fins, which were used on the prototypes and made with new rubber mixtures. The aim was to improve the control of the ball and the spin of the ball and the accuracy of the shot.

In 1993, field tests followed with top players and amateurs from across Europe. As well as Hansi Müeller, the player we tested most with

was former Stuttgart and Bayern Munich striker Giovane Élber. Others included Mehmet Scholl and Christian Ziege of Bayern, Stuttgart striker Fredi Bobic, Ronald Koeman of Barcelona and Abedi Pele of Marseille. I also remember meeting with Franz Beckenbauer, one of the first to try Craig's prototype.

In addition to field tests, we also needed scientific tests, so an indoor Research Center was opened in Herzogenaurach, headed by our biomechanical engineer. Working with an engineer from Carnegie Mellon University (at least, I think it was!) who specialized in industrial robots, he installed a "shooting robot," that was able to record and measure data from ball kicks.

After testing with different prototypes, the results were documented by slow-motion technology. Craig and the pro players each kicked the ball many hundreds of times, and the results showed a greatly increased swerve compared with a boot with a regular leather toe. Instead of a spin ratio of 5 to 7 rotations/sec, Craig achieved 10 to 12 rotations with the latest prototype. The added spin allowed him to easily bend the ball around test dummies in order to come closer to target. The results also showed that, with the rubber fins on the forefoot, the ball came off the foot faster than with a normal boot.

With these results, the tests continued. We had to ensure the prototype also worked in adverse conditions, for instance, on a rain soaked field. The tests by Hansi Müeller showed that in such conditions the shoe performed equally well. "You have the impression that the shoe bites into the ball," he told us. At the same time, the final rubber mixture was lab tested. Tests revealed that the compound had energy return properties similar to the material used in a Super Ball, meaning that it would regain its shape almost instantaneously, thus transferring energy back to the ball after it had been kicked.

As we prepared for launch, we built a new screw-in and a new molded sole for the boot, which the Soccer business unit had decided to name "Predator." Final tests with top players conclusively showed that the concept worked. Not every player liked the shoe. Despite its distinctive advantages, each player has his own preference how his shoe should feel, and many still preferred the thin leather of a traditional boot. However, when the Predator was introduced at the 1994 World Cup, it was worn by many top players including Jürgen Klinsmann, Karl-Heinz Riedle, Thomas Häßler, Ronald Koeman and Ronald de Boer, who all proved its effectiveness.

The Predator went on to be worn by many great players and has changed a lot over the course of its lifetime, but I like to think a bit of the original DNA that Craig, Jacques, the Predator team, and I all put into it is still there.

HART KLAR
Predator Product Manager

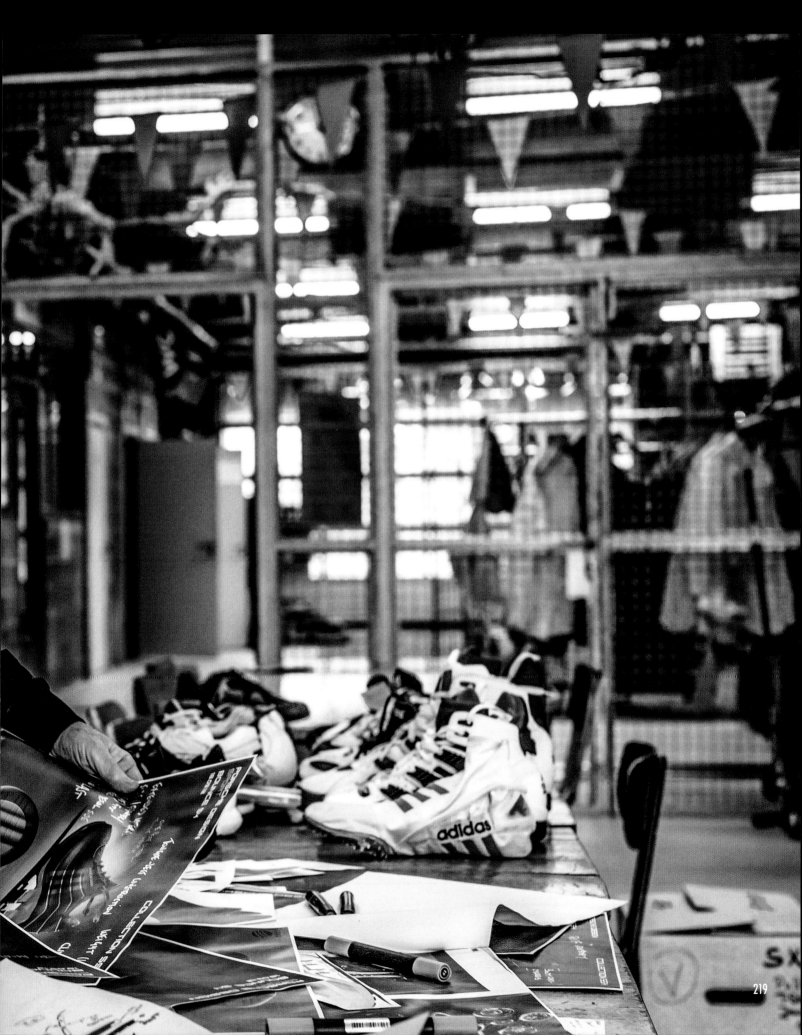

FEET YOU WEAR

Feet You Wear was a radical idea, and I love radical ideas. Although the FYW era at adidas was relatively short, the shoes we made back then are still influencing design today.

I've always believed as a shoe designer that one of the first rules you have to follow is "respect the foot." So when a guy by the name of Frampton Ellis came to us with a shoe concept he called Barefootwear based on a molded sole that mimicked the anatomy of the human foot, I thought it was a great idea.

The idea was based on a sole that replicated the anatomic shape of the foot and the touch points that contact the ground. Ellis had noticed that bare feet were incredibly stable in the angled or rolled positions that sport often requires, but once you put them in a shoe, in the same position, the squared off edges of the sole cause the foot to tip over, leading to ankle roll and loss of balance. The main causes of shoe-related sports injuries. He realized the natural curves of the foot and distribution of pressure across the areas that touch the ground give you much more stability when you are barefoot.

The question was if it could be replicated in a shoe. After further research, Ellis created an engineering prototype that did, and when he had it tested at a biomechanics lab, it produced impressive results. After he approached the guys at adidas in Portland with the idea, we met with him and saw a lot of potential in it. It was unlike any sports shoe ever made up to that time as it was "edgeless," and had such a unique outsole pattern to replicate the human foot. We loved it so much, an agreement was made between adidas and Frampton Ellis to exclusively license the concept.

Peter Moore came up with a new name for the technology: Feet You Wear, which is still a great name today. He also used the very organic look of the outsole to create a logo based on the shapes we called Freddie.

Not wanting to hang around, Stefan Dietrich and I quickly started working in secret to create the very first adidas Feet You Wear shoe.

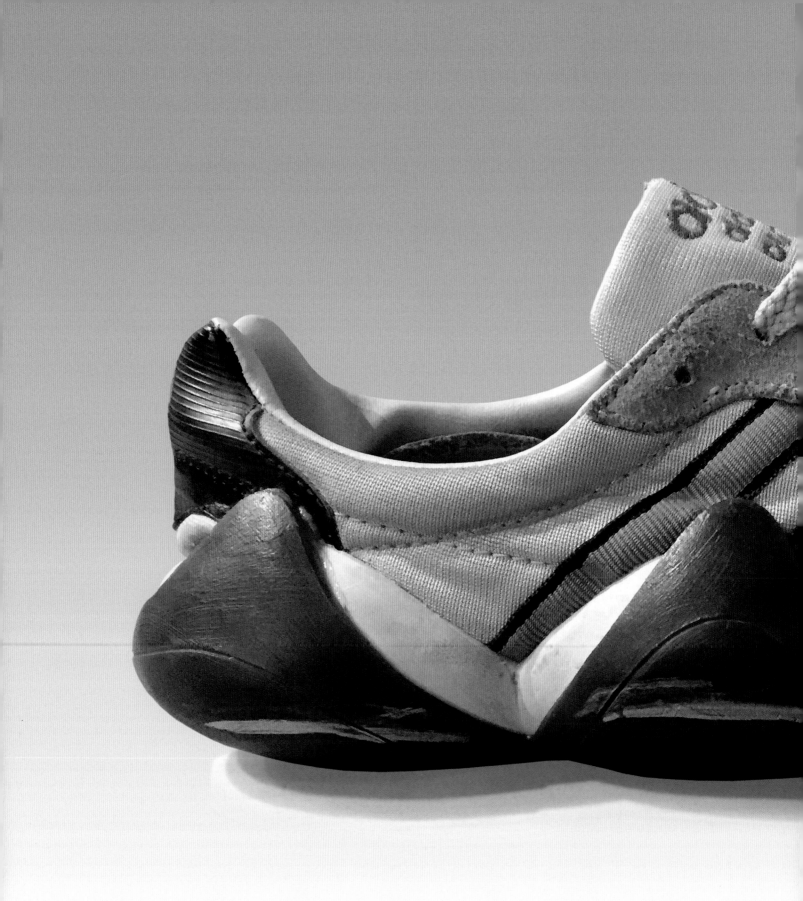

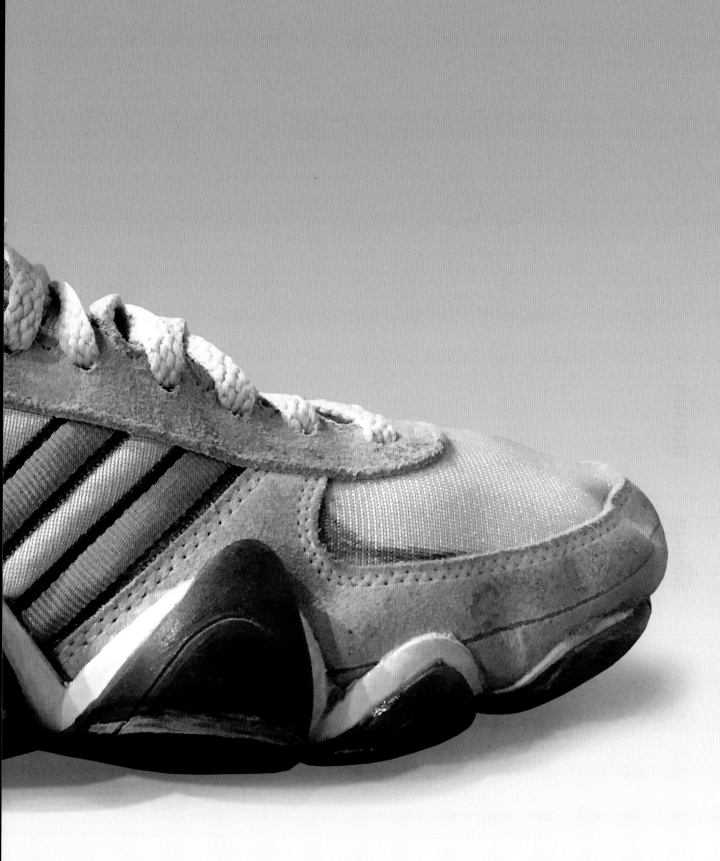

Frampton Ellis's Barefootwear prototype

EQT TENNIS INTEGRAL FYW [1996]

As the very first Feet You Wear shoe, the Tennis Integral had a lot riding on it.

When Stefan Dietrich and I started work on the prototype for the Integral, we kept it so secret that even Peter Moore had no idea we were working on it. The reason being that, usually when you start working on a new technology, it can take years before you have a production prototype due to the number of people and processes that are involved, but with Feet You Wear (FYW), we wanted to create something as soon as we could, so we told almost no one about what we were doing.

Because the Integral was the first shoe based on the FYW concept, we needed to get it right the first time to prove it worked. The biggest challenge we had was finding the best curve geometry on the "bumpers" of the sole. Unlike most shoes, which have an outsole and a midsole, on a FYW shoe, they were merged into one in order to provide the increased stability that comes from replicating the curvature of the foot. But we also had to create something that would sell, so we had to ensure it didn't add too much weight and, of course, was attractive

to the buyer. The final design we came up with gave the shoe a very organic look that, at the time, was very unusual. Because it was a tennis shoe, we used a herringbone grip profile for each of the "islands" on the outsole. These touch points became the inspiration for the Freddie logo.

The sole of the shoe wasn't the only new idea on the Integral, as we applied the Three Stripes branding to support straps, which was reminiscent of how Adi Dassler himself applied the Three Stripes mark to strips of leather used to increase the support of his shoes. The straps on the Integral were integrated with the lacing to give wraparound support to the foot. The Integral also featured a sock-style liner, which was a new idea for adidas at the time.

Looking at this shoe now, part of me wonders what was going on in our heads to come up with such a crazy design. However, looking at sneaker design thirty years later, it's clear that many modern designs have been influenced by the curvy organic designs from the Feet You Wear era.

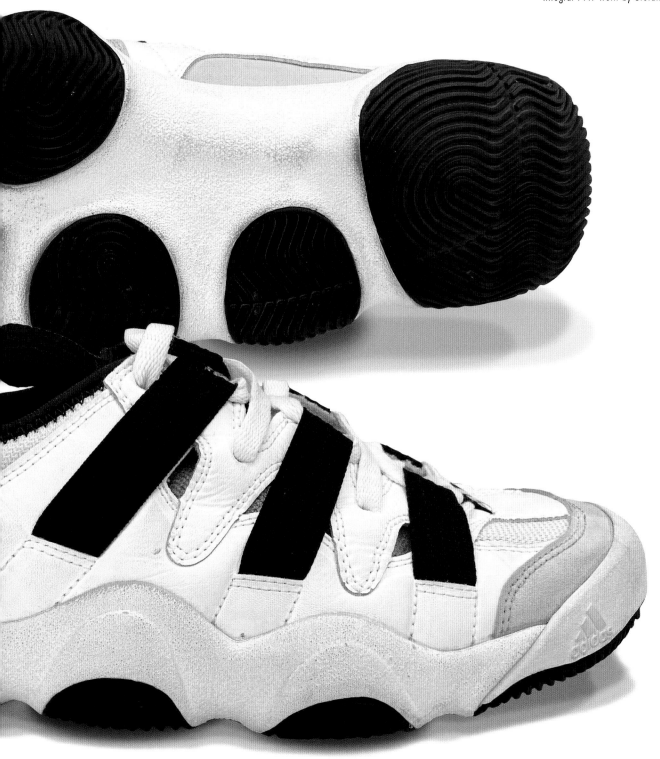

Integral FYW worn by Stefan Edberg

During my time in design at adidas Originals, I was very lucky to have worked with Jacques on three projects—first, when we were asked to create an Originals x Badge of Sport basketball shoe that was modern and utilized Boost but had style cues that were more from an Originals source: BYW (Boost You Wear).

As Jacques had worked on the original Feet You Wear concept with Peter Moore, the design team and I tapped into that relationship and wealth of knowledge and spend some good time listening to Jacques and Peter talk about how the concept was formed, what design steps were taken, and how they developed it from idea to finished product.

I've always been a huge fan of Jacques's work. For me, he is what Tinker Hatfield is to Nike heads. He has created some of the best basketball shoes in the adidas archive, not to mention his ZX work and tons of other silhouettes. I've worked on the reissues of the Rivalry and the Forum, both outputs of Jacques's design portfolio. Working on them, I would check in with Jacques on the progress, share ideas, ask questions, and try to do the best I could to best replicate his original concepts as he first designed them. Reissues come and go, but it's always for me about being millimeter precise. The nuances, even the mistakes—it's all in the minute details that most wouldn't even notice.

I loved to ask Jacques about the good old days at adidas when he was based in France working with Horst Dassler (son of Adi). He'd tell me stories about how the French design team (who were responsible for so much good stuff) would design through the week and then drive from France overnight to Herzo to present on a Monday morning to the German crew at HQ.

Another great story was when Jacques and I were working on the Forum. He told me that he had once flown to New York to speak with a basketball coach who lived in the city and was also an adidas rep. They had a great conversation that led to some tweaks on the design. However there was a moment's snow and ice storm and Jacques got stranded in the airport. The ankle strap that runs around the heel of the Forum was meant to be purposeful on the inside of the collar, that had came out of that airport lounge conversation. However due to budgets that direction never made it to the final design.

When we recreated the Forum and Rivalry, we added some little nods to Jacques and that French design team in the builds, being forever grateful for his original concepts.

As well as being an amazing creative and a huge leader in the time line of adidas, Jacques is a total gentleman, sharp, honest, and humble. I'm very proud to know him as a friend as have him as a big influence on my career.

CHRIS LAW
Sneaker designer, creative director, former adidas Senior Design Director and Crooked Tongues cofounder
@chris_law_

Opposite: Boost You Wear basketball shoe

STAN SMITH *1998*
MILLENNIUM

I was asked so many times to redesign the Stan Smith but always said no. This was the only exception.

You wouldn't believe how many times during my career I was asked to create a new Stan Smith, but my feeling was always that the original shoe should never be changed. The only time I made an exception was in the case of the Stan Smith Millennium, because the idea was to create an evolution of the shoe rather than a replacement.

I worked together with Patrik Nilsson, a fantastic product manager for tennis. The main idea behind the Millennium version was to create a Stan Smith of today that could be used to play tennis and improve upon the comfort of the original. Although the original was designed as a performance tennis shoe, it was no longer recommended for the modern game.

It was very important to keep the shape of the original, which is a very sleek shape and close to the ground, but to increase the comfort. We simply expanded it to keep the profile but gave it more cushioning by giving it a more "buff" sole. On

the upper, we used tumbled leather to make it supple and gave it a subtle Three Stripes visual by embossing them behind the classic three lines of perforations. We took the embossed Stripes effect down onto the molded midsole, which was made with EVA and grooved in the midfoot so that it had a kind of torsionability but without a Torsion bar.

The heel tab of the original Stan Smith was stitched over the rear upper, but here I tried to do something different. I had started to do a lot of shoes with embroidery, not just for decorative reasons but also because it allowed me to join pieces edge to edge. That's why the heel tab of the Millennium has embroidery along its edges.

Although we started with the Stan Smith, we also gave the "Millennium treatment" to the Superstar, Pro Model, and Handball Spezial—again, all with the intention of creating evolved modern-day versions of the classic models.

I first started at adidas in Sweden as Head of Marketing and Sales in 1991, and around that time they started to talk about becoming more of a global brand and having a more international staff at the headquarters. I was one of the people they picked to come to Herzogenaurach as Senior Product Manager for Tennis Footwear, despite the fact that I had never really played tennis and had never set foot in a shoe factory!

When I came to Herzo Jacques was one of the first people I started working closely with and he was tremendous to me and very helpful in that initial period. One of the things that I brought with me was experience in working in sales and marketing. I realized that if you involve the markets in the product development process, and ask them what they need rather than thinking you know it all and just pushing out products without consultation, you'll be more successful. Jacques was key to making this work because we decided that instead of doing lots of shoes, we would do less, but do them better, and I knew that Jacques was the guy who could actually design and develop shoes that would help us do that.

The biggest shoe that Jacques and I worked on together was the Stan Smith Millennium. The inspiration it came when I saw Volkswagen bring out the New Beetle. I said to Jacques, "Why don't we do something similar with one of our most iconic shoes, the Stan Smith?" The classic Stan Smith was of course designed to play tennis in but by then it was a lifestyle shoe and you wouldn't really use it to play tennis anymore, so Jacques and I looked at the classic model and thought about how we could make a Stan Smith that you could actually play tennis in.

Although he used the design of the original shoe as inspiration, his design for the Millennium was really an all-new shoe that had an EVA midsole, much better traction, and was also much more comfy. However, he made sure that the shape and lines of the original Stan

Smith were clearly there. If you look at the moustache on the heel tab for example, it's clearly inspired by the classic shoe yet he brought something fresh and new to it by embroidering the seam. The other thing was that just like the original, you could wear it for any occasion. We wanted Stan Smith himself to be on board with the new shoe so I went to Stan to make sure he was okay with it and he was very enthusiastic about it because he could actually play tennis in his own shoe again.

As well as the Smith Millennium, the Barricade tennis shoe franchise was one that Jacques and I started together and his team designed that proved to be a huge success and spawned multiple generations of shoes. The great thing with Jacques was that he was always open to new ideas and he would always find a better solution than you could dream up in the brief! At that time Jacques was no longer the youngest designer that we had there, but he had absolutely the best touch and understanding of the consumer.

Around that time, the early 2000s, there was a real tendency to overdo shoes but Jacques's approach was always to design shoes with a beautiful simplicity. With just a few lines he was always able to create magic. Other designers were trying to put more and more on shoes but the athletes, they didn't want that, they just wanted to have a shoe that was supportive, with great cushioning and as light as possible, they didn't want to have all the bells and whistles that some of the younger designers wanted to put on them. It's a great tribute to Jacques that so many of the shoes we are seeing now, that everyone from Kanye to Balenciaga are doing, are inspired by the shoes Jacques was doing back then.

In all I had twenty-three amazing years with adidas and the brand is so dear to me. Working with Jacques and the fun and success we had together is a certainly a big part of that, and the best things I can say about him are that his personality is just so great and that his hands really can do magic!

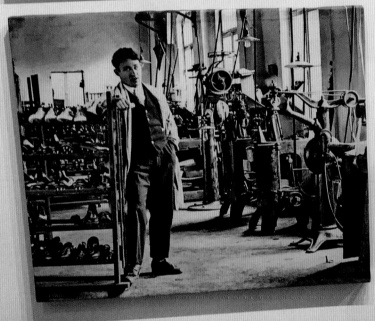

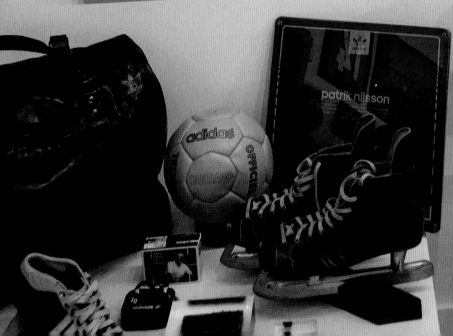

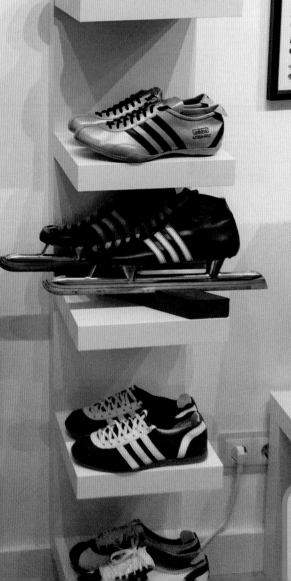

RAISON D'ÊTRE

There were many times when I was asked to create a performance shoe for the street, but my reaction was always "We are adidas. We are sport." And because sport was our raison d'être, I strongly believed that if I was going to create a new tennis shoe, then first and foremost, it should be a fantastic shoe to play tennis. If the wearer also felt it was comfortable enough to be street wear, then great, but only because they decided that. Not us. It's exactly what happened with the Stan Smith. The ones you see here look nothing like the pristine pairs you usually see. That's because they were worn at Wimbledon by Stan Smith himself. To me, it's what a pair of Stan Smiths should look like, because it was originally created to be a performance tennis shoe. Its fashion icon status came about because of its success on court, not the catwalk. As a creator for a sports brand, I tried never to forget it.

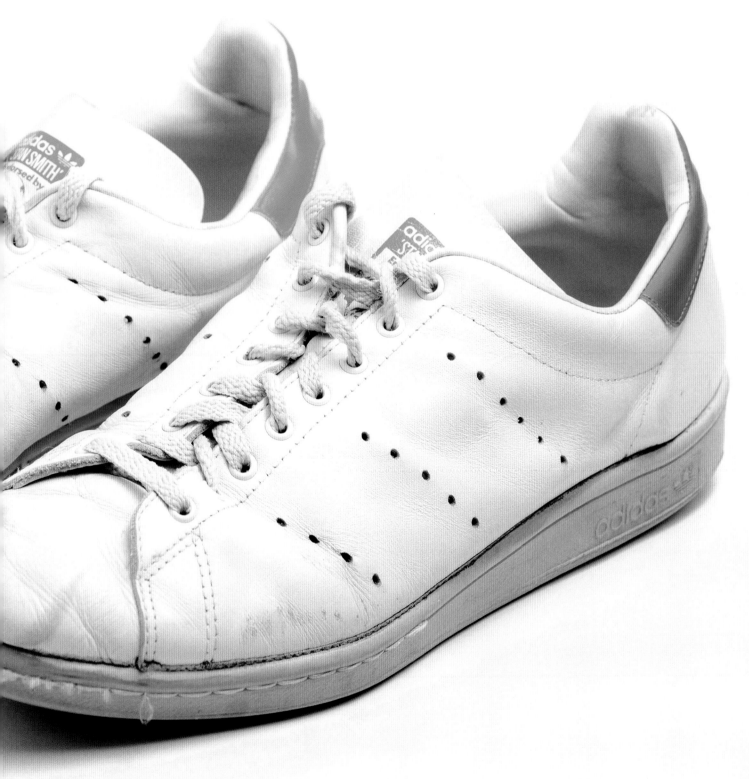

When I first joined adidas in 1988 as Head of Footwear Products, the company was suffering from the death of Horst Dassler and was under pressure from a rapidly growing Nike. Adidas was then still a production-based company that lagged behind when it came to marketing, trying to compete with Nike who was more a marketing company that happened to make sports shoes. Most of the people who worked at adidas then were from a traditional manufacturing background, so they weren't thinking about the importance of the commercial side of the business, but one of the few I encountered who did think about it was Jacques Chassaing.

My first connection with Jacques came when I decided to relaunch some of the classic adidas models like the Stan Smith, Americana, and Gazelle. I have to say most people thought I was totally crazy because they were real classic models representing the old adidas, but I was sure we could have a lot of success by bringing them back. Jacques was the only person who understood what I was trying to do.

This natural understanding between us led us to work together on numerous projects between '88 and '91 when I moved to Japan to build adidas presence in the Far East. At that time, adidas was represented by a distributor, Descente, but because it was an apparel company, it needed to break through in footwear, so it was my role to build a strategy to drive the business through footwear. Despite being two continents away, I was still keen to work with Jacques and together we collaborated on the Japanese market launches and campaigns for Originals, ZX, and Torsion.

The great thing with Jacques was that, despite Japan having a very different relationship with and perception of adidas, he was able to adapt and learn almost instantly. Very quickly, he not only gained an understanding of the market but also its needs in terms of both function and fashion. Almost uniquely, he had

the capability to understand both sides. He wasn't just a designer who wanted to design new. He understood what needed to be done from the marketing standpoint.

Jacques and I had great success with a number of shoes thanks to this, but one of the products I especially remember working on, thanks to his approach, was the Taekwondo shoe.

The market in Japan was moving more from the sport to fashion, and adidas started to become seen as a bit more sexy at the time. People started to look at adidas in a different way. We already had a Taekwondo shoe at that point, but it only sold about 3,000 pairs a year, almost specifically to people doing Taekwondo and some other martial arts. Typically, when Jacques brought his talents to it, that changed!

What Jacques did was fairly simple but highly effective. Taking what was really a kind of slipper with no outsole, he beautifully reshaped it, made it easier to put on, and added a thin EVA sole so that you could wear it on the street, not just indoors. Jacques being Jacques, what others would have labored over was something that just came naturally to him, like an instinct.

When we launched the new shoe, not only did it become a huge success and an iconic product for adidas in Japan and Asia, it found success in the European Latin countries too, something we hadn't really expected. And this is what you always get with Jacques: someone who is a pleasure to work with, someone who is passionate about his work, and someone who somehow always manages to give more than you expect. But above all those qualities, he's a great friend. I love the guy.

CHRISTOPHE BEZU
former SVP & Head of Region,
adidas Asia Pacific

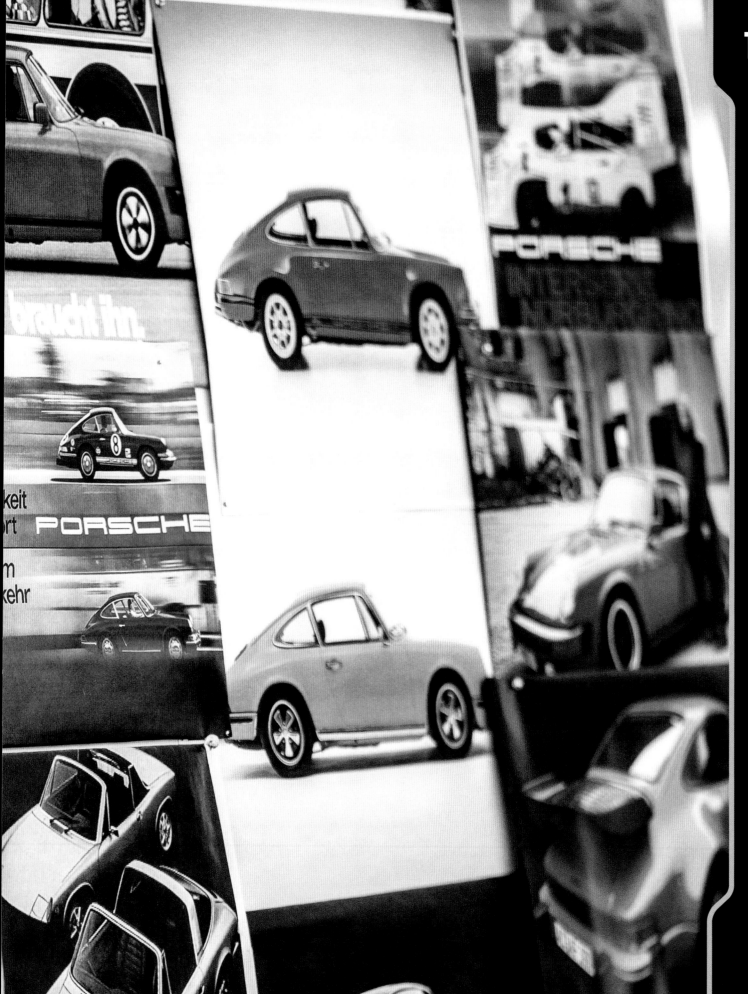

PORSCHE DESIGN SPORT

In 2006, a whole new chapter began for me when I was appointed to lead the footwear design partnership between two of the world's most famous brands.

Trying to uphold the design legacy of one great brand while pushing it toward the future is difficult enough, let alone doing it for two, so when I took on the task of heading up the collaboration between adidas and Porsche Design, some thought I was crazy. But for me, it was exactly what I wanted: a new challenge and new freedom. The idea of leading a small team of hugely talented designers at the intersection of two great brands, and having the freedom to create with my heart and my gut with no one looking over my shoulder, really excited me.

Porsche Design was founded in 1972 by Professor F. A. Porsche, designer of the 911 sports car and grandson of Porsche AG founder Ferdinand Porsche. The idea of Porsche Design was to take the spirit of Porsche beyond automobiles while remaining synonymous with sophisticated functional design and technical innovation.

When I began the role, the first challenge was to find how best to marry the two brands together. Each had an incredible history and a design philosophy born from a

driven founder, and each had its own unique essence and principles. The challenge would be to find the right balance to bring them together in a product range that represented the very best of both. As I quickly discovered, however, it wasn't difficult to find that balance, because both brands shared many of the same values and philosophies due to their heritage being grounded in sport and performance.

One of the complications, however, was that adidas not only had its name on the shoe but also the Three Stripes. The guys at Porsche Design often asked me to put the stripes in different places on a shoe, but I decided right at the beginning it was not something I was willing to do. This is why all the Porsche Design Sport shoes we did had the Three Stripes where Adi Dassler had always placed them: on the instep. However, because it was a collaboration and because we were keen to be a good partner, it was important from the adidas side that we weren't overbearing, so we never did the stripes as prominently as they were on regular adidas inline shoes so as to be respectful

to Porsche Design and to provide separation from mainstream adidas products. So while the stripes were always there, it was never in a bold contrasting color from the upper. It was always used subtly, with the contrast coming from them being embossed, perforated, or molded.

Another key consideration in bringing the brands together was that it was important to understand that Porsche Design was not Porsche AG. Although as an entity it drew upon Porsche's heritage, it had its own vision, which was to bring the design philosophy of its founder to everything from watches to household appliances and, in the case of our collaboration, sportswear.

The synergies between Porsche Design and adidas meant it was a successful partnership from day one, but that's not to say there weren't debates. One area for which there was always a lot of discussion was how we should put two great brands on a shoe harmoniously. I'm happy to admit it was not always easy to find a solution that respected both equally, but we always found one.

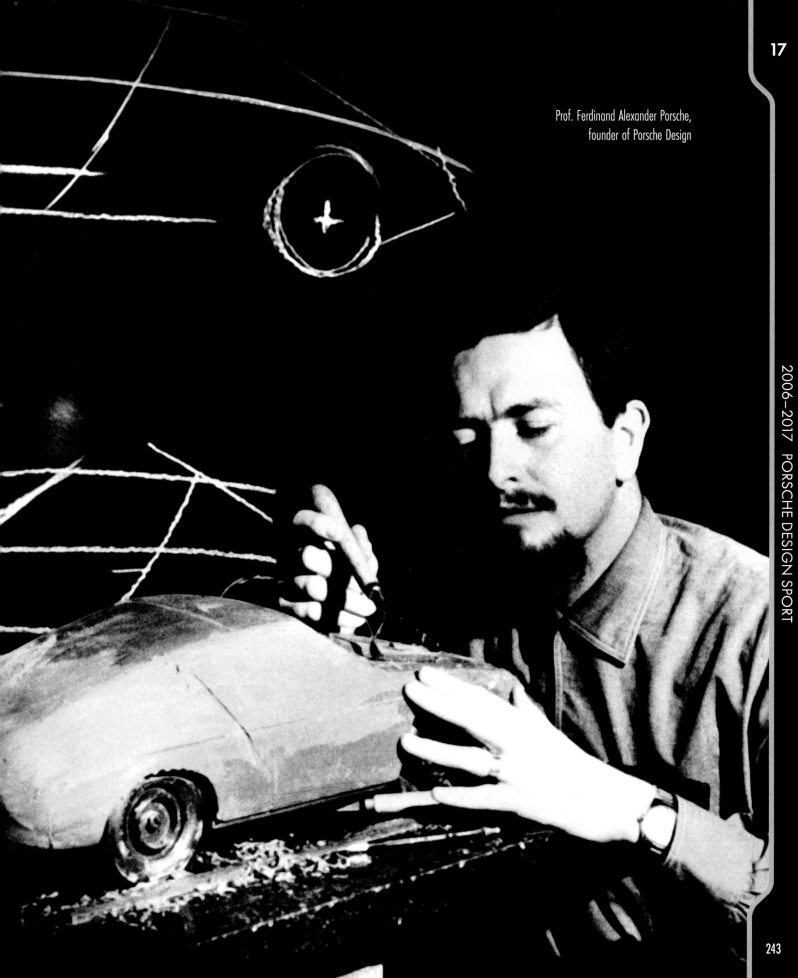

Prof. Ferdinand Alexander Porsche,
founder of Porsche Design

DRIVING P'5600 *2007*

Our intention for the first Porsche Design Sport (PDS) collection was to create a range that brought the brand and its design philosophy to multiple sports and activities, including running, training, tennis, golf, and sailing. However, as much as we wanted PDS to exist beyond its link to automobiles, we understood that the driving category was going to be the natural attraction, so the first product we developed was the P'5600 Driving shoe.

It became the foundation of the first Porsche Design Sport collection and the first statement of our intention to create engineered luxury sportswear. It was also the first example of the design language that would be conveyed across the PDS range.

The shoe was a very sleek asymmetrical mid-cut with a perforated breathable mesh and nubuck upper. Designed for driving, each side had a different tread profile. A more grippy one for the braking foot and one that allowed the foot to slide on the accelerator foot. The outsole also extended up to the bottom of the heel. Its rounded profile allowed better and more comfortable foot pivoting while driving.

The first in what would become a long line of PDS driving shoes, the shoe set a high bar for its successors and the other shoes in the first collection.

Porsche Design Studio in Zell am See, Austria

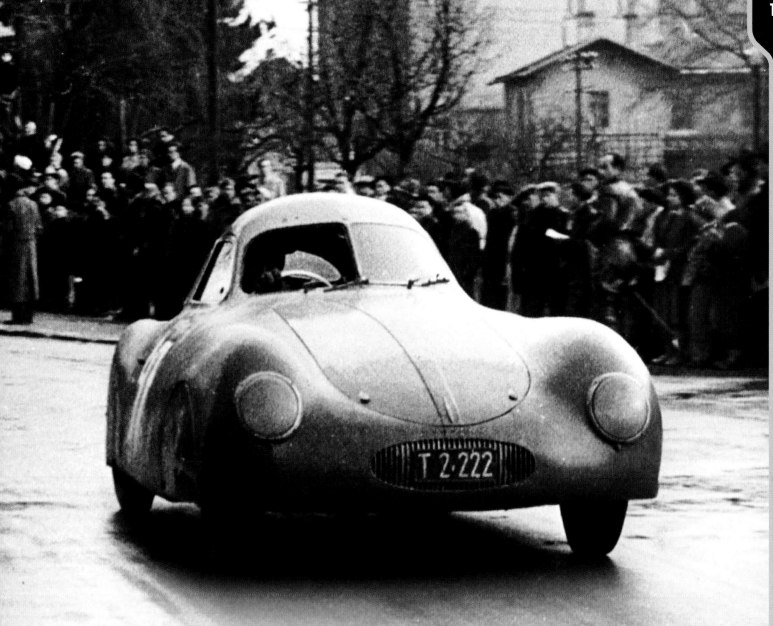

TYP 64

Our inspiration for the first Porsche Design Sport collection was the first car to be considered a Porsche, the Typ 64. Designed to be raced in the 1939 Berlin-Rome race, they were handmade from aluminum and had raindrop-style bodies with very smooth edge-to-edge panels intended to make it near seamless and highly aerodynamic. The car's bodywork influenced the design of several of the shoes in the first collection. It also gave its name to the Typ 64 model that was part of Porsche Design Originals, which was a more accessible range sold through adidas and mainstream retail stores rather than in Porsche Design stores, inspired by famous Porsche models such as the 911, 917, and historic racing circuits. Like its namesake, the Typ 64 shoe (not shown here) was designed to be seamless, with a one-piece vamp with one-piece leather foxing. The rest of the shoe we made using "stitch and turn" sewing to give it a smooth edge-to-edge surface.

WINTER TRAINING BOOT [2011]

The idea of this boot was to take on any kind of weather you could throw at it. It was inspired by Porsche's Ice Force driver training facility in Northern Finland near the Arctic Circle, where drivers can learn to drive in an extreme winter climate, and designed to deal with the same conditions. It had a rubberized upper for weather protection and used advanced materials like Gore-Tex for waterproofing and PrimaLoft for heat insulation.

The spikes of the boot were climate sensitive, hardening or softening depending on the temperature. The upper sat in a wraparound molded cup that provided great stability. It was constructed within a frame that both held the foot in place and performed as the eye stay for the lacing system. Topping it off was a support strap that used a magnetic FIDLOCK system for easy closure.

Porsche's Ice Force Driver
Training Base in Finland

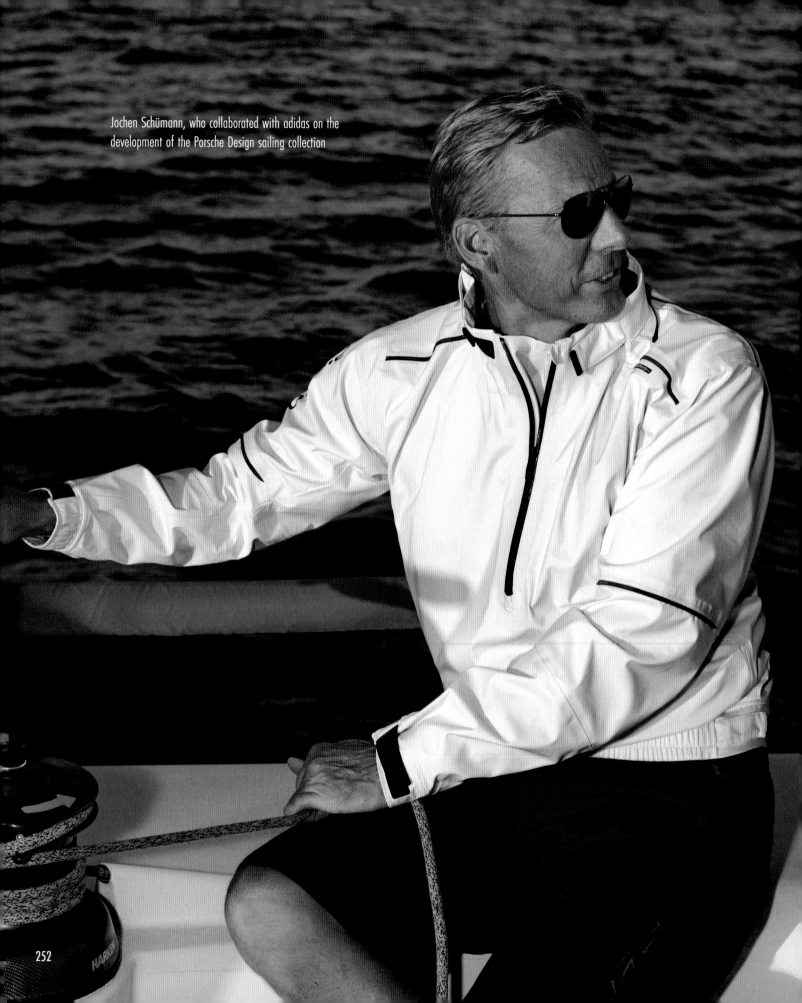

Jochen Schümann, who collaborated with adidas on the development of the Porsche Design sailing collection

WAT BREEZE ²⁰¹²

I really liked this shoe but, for some reason, it was never a big seller. It was a moccasin sailing shoe that was inspired by the hull of boat and had lots of visual design clues from boats and sailing. The design of this and all of our sailing models was the result of spending time with the America's Cup sailing team led by Porsche Design brand ambassador Jochen Schümann, a three-time Olympic gold medalist and two-time America's Cup winner. Being able to speak to team members and observe the dynamics of their

individual roles had a major influence on our thinking. Although the Breeze was designed as more of a leisure shoe, it was equally at home on a boat and was constructed around a molded cup with a 3D outsole and an advanced drainage system. It had no squared-off edges, so it provided stability even when the foot was at a side angle, which is often the case in sailing. From a construction point of view, it was more or less a nightmare. I can remember having to really push my developers on this one, but the end result was worth it.

TUBULAR BOUNCE ²⁰¹²

The original idea for Tubular that we developed thirty years earlier had come way before the technology existed to make it work consistently, but it was an idea that I always liked. Based on car tires, it seemed to have a natural fit with Porsche Design Sport. The Tubular Bounce was based on the concept that Nic Galway had resurrected and developed, but it used tubes constructed from rubber filled with polyurcthane. For me though, this shoe is more memorable as it was a kind of Trojan horse for convincing Porsche Design to let us use more color in the collections.

Before, we had been more or less restricted to black, white, or gray, but I said to the CEO of Porsche Design at the time that whenever I went into one of the Porsche Design stores, the experience was monotone, and that bringing more color to the collection would not only offer the customer more choice, it would bring some color to the stores. For the first time, we were allowed to go crazy and we did the Bounce in blue, lime, and orange, which for Porsche Design was pretty radical. It opened the door to us using more color in future ranges.

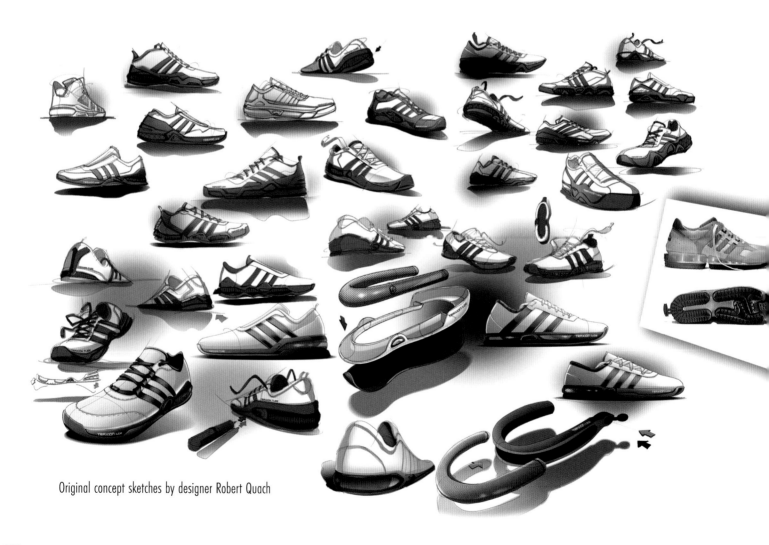

Original concept sketches by designer Robert Quach

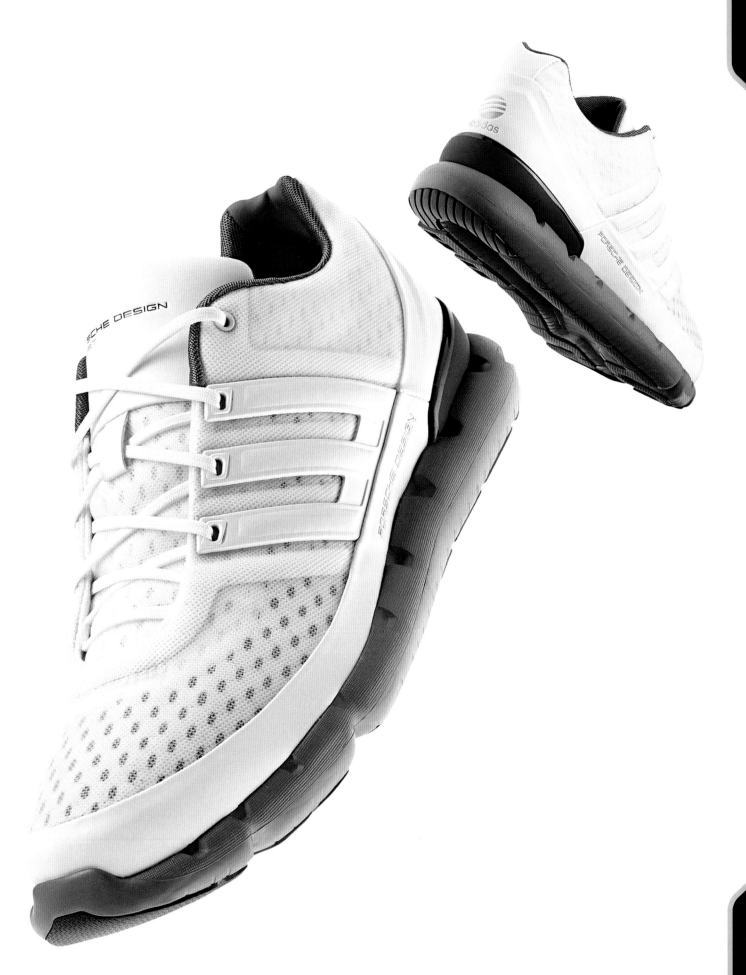

ROBERT QUACH

I first met Jacques when I was twenty-three years old. I was fresh out of uni, clueless about life in general, not to mention the complexities of navigating a corporate environment, and Jacques was, it would be no exaggeration to say, already a legend of the footwear world and looking for an assistant. My interview went amazingly well, so I must admit, at the time I wasn't even surprised when he hired me. Only now, years later, I am starting to comprehend just how lucky I was, and that some people never get the chance to work and learn from somebody of Jacques's caliber. I ended up working with him for seven years, designing footwear for adidas Porsche design and growing from an assistant into Senior Designer. When we stopped working together, it was only because the collaboration between Porsche Design and adidas came to an end, but our personal relationship never has.

I was always fascinated by his creative process and how his mind never stops working. He would make a mood board and put all the images together in order to build a design story, something he is extremely good at. The images he chose were always very impactful and effective. I was also amazed by his hand sketching skills. You don't come across the real old school sketching often these days. It's something that is unfortunately becoming a thing of a past, but it's very inspiring. Seeing Jacques sketch I can imagine is comparable to seeing Dior sketch, that's how good he really is.

On top of that, his ideas are always simple yet timeless. But don't be fooled by the misleading simplicity. It takes a lot of experience and talent to reach the level of being that good. You don't need to overimpress. It's a very subtle way of designing, but it takes a real shokunin to master it. In my career, I'm still trying to achieve this. A good example of his genius would be Porsche Design Bounce S4 shoe, which won a Red Dot Award back in the day. If you look at the shoe, you will notice three horizontal debossed lines running along the shoe that

are there to create a gap between the foot and the shoe itself. It's a very simple detail yet it's impactful visually and has a function, and fits perfectly into the Porsche design philosophy: clean and functional. Although the shoe was released nearly ten years ago, I still see the language created by Jacques used today among very prominent designs such as the Yeezy 1050 Hi-Res boots or adidas parley 4DFWD.

As a person, Jacques has almost an old-fashioned French gentleman's charm that never goes unnoticed. He was always very well liked and even adored by everyone—people of different ages and background. He was the same as a designer: very charming and very respectful. What you also need to know about Jacques is that he is an extremely generous person, always ready to share his knowledge. Sometimes, I would pass by his office to check something with him, and we would end up talking about shoes and design for hours, only to notice at some point that it was dark outside.

What makes him even more rare is that he is also incredibly open-minded. He is always ready for new ideas. He never tried to put me in the box or impose any ideas on me, even though when we just started working together I didn't have any credentials to back me up. Another time, I remember I made a mistake on a shoe and felt devasted. Jacques told me something like "The one who doesn't do mistakes is the one who does nothing." The phrase still resonates with me and keeps pushing me on to take risks and move forward with my work. Only when I started to manage people myself did I realize how good he was and how lucky I was to have him as my boss and mentor.

All I am today as a footwear designer, I owe to Jacques.

ROBERT QUACH
Creative Director, Anta and former adidas,
Porsche Design Sport and Y-3 senior footwear designer

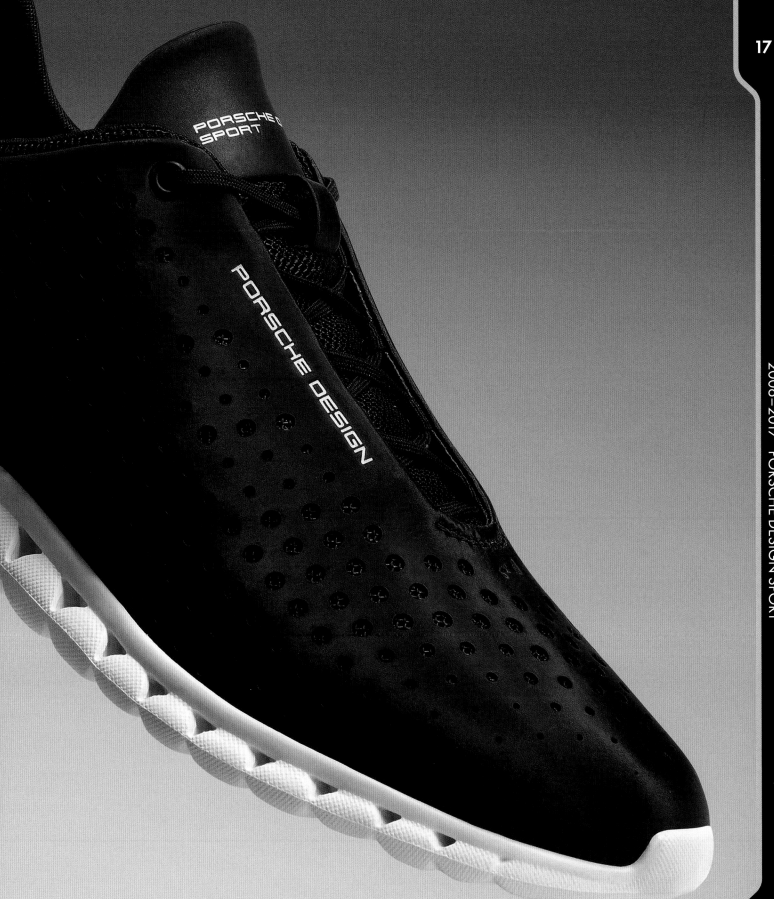

BOUNCE S *2008*
& SERIES

Aside from driving shoes, something we always tried to do with Porsche Design Sport was not to make the collection too car-related, but we found that buyers and potential buyers automatically focused on the fact it was Porsche, so a link to automotive was naturally expected by them.

Understanding that we needed to keep a connection in the range, we decided to develop a running shoe inspired by the suspension systems of Porsche cars. While adidas and other brands had experimented with suspension before, we wanted to create something unique to Porsche Design Sport and began working with the adidas Advanced Design team to develop it.

Once we had a working prototype, it was key to assess if it provided a benefit to performance. Both the adidas and Porsche Design belief was that technology has no value if it is just there for aesthetic purposes. It has to have a benefit to justify its existence. Testing of the prototype showed there was a definite benefit of the system over regular foam

materials, with increased forward propulsion, energy return, shock absorption, and comfort. When the system proved an increase in performance, we pushed ahead with it and took over the technology from the Advanced team.

We gave the upper of the shoe a real track-and-field look with a raised heel that was available in two styles: a more sporty wraparound nylon mesh-based model and another more fashion-oriented version with a perforated full-grain leather upper available in a white, black, and gold.

It was the first running shoe to have a car-inspired suspension system. What was great about this shoe was that, despite being designed as a performance athletic shoe, its suspension made it very comfortable to wear as an everyday shoe.

We were very proud when the Bounce S was honored with awards from Plus X and Red Dot, and was named by *Time Magazine* as one of the fifty best inventions of 2008.

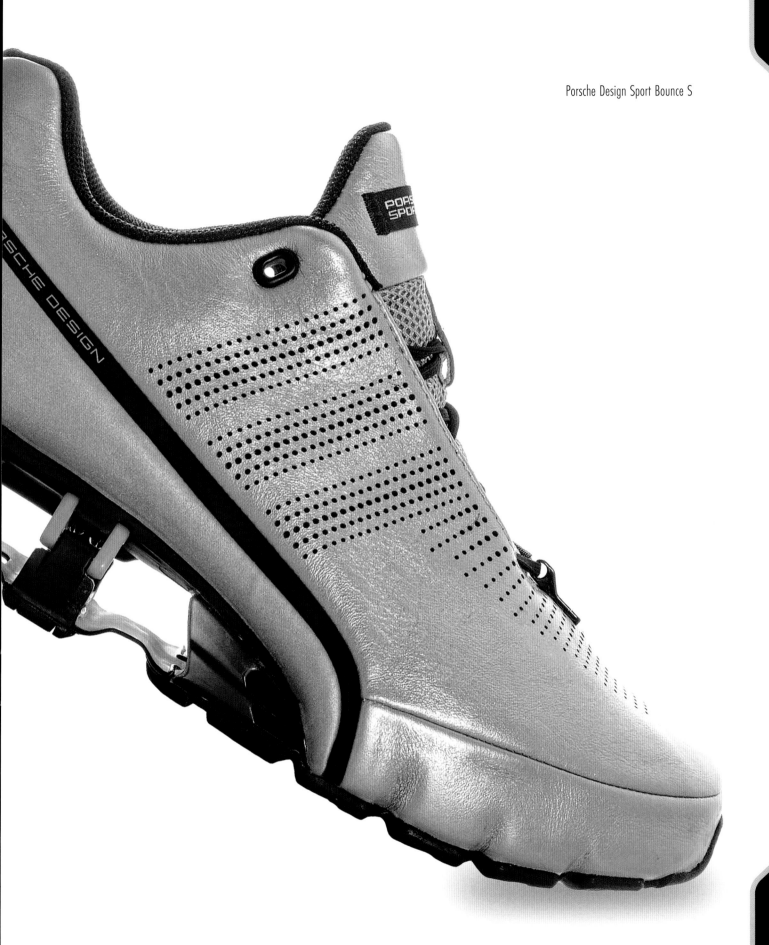

Porsche Design Sport Bounce S

The Bounce S suspension mechanism

When we took over development of the suspension system from the adidas Advanced Design team, it still had an unrefined prototypical look. Working with the Porsche Design Studio in Zell am See, we reworked the look of the unit to give it a look that reflected the Porsche Design aesthetic and design language.

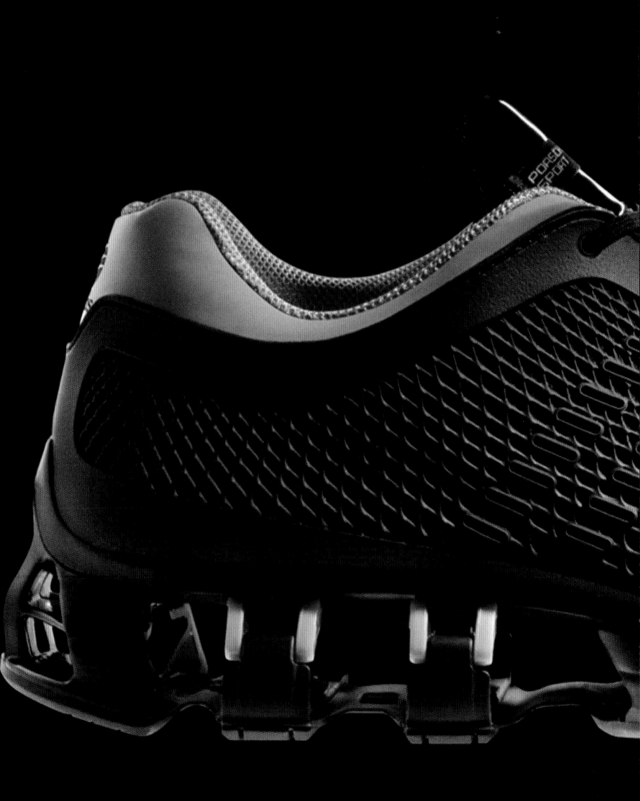

BOUNCE S2 ²⁰¹⁰

On the Bounce S2, we used the same suspension system as the original S model; however, the upper featured a unique Kurim mesh made from TPU that not only gave the shoe a unique look, but made it very flexible and pliable, holding the foot like a second skin. To maintain the contoured look as much as possible, the Three Stripes appeared in the form of ventilation ports in the mesh.

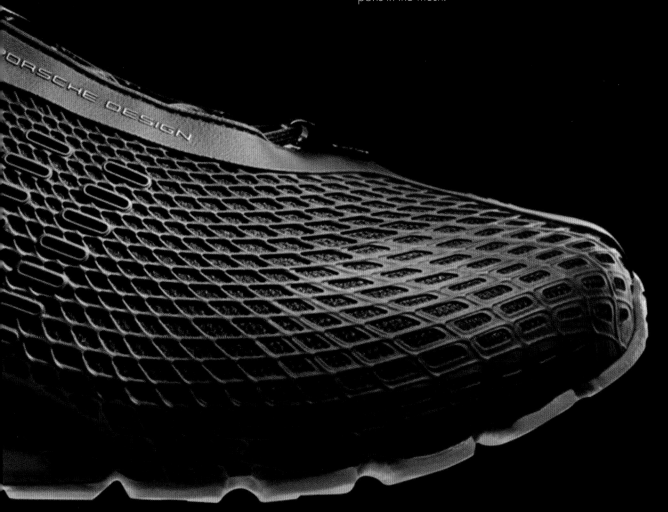

INSPIRATIONS:
EDDIE MERCKX *1978*
COMPETITION

For me, the beauty of this shoe doesn't come just from its aesthetics, but by the degree to which it was designed to meet the needs of the athlete. One of the problems with leather is that it absorbs moisture, which not only causes problems with fit, but also adds weight. In cycling, there has always been an obsession with weight reduction, and the Merckx Competition was designed with this very much in mind. Although leather was still used where reinforcement and stability was needed, much of the upper of the Eddie Merckx Competition was constructed using a lightweight nylon mesh that both cooled the foot and dispersed moisture, either from sweat or rain.

Traditionally, leather was also used on the soles of cycling shoes, but this shoe was one of the first to use a very light material called Rilsan, which was molded to the contours and shape of the foot to give the perfect fit. Very innovative for its time, the shoe was a kind of track-and-field shoe for cycling. Fitting like a glove and incredibly lightweight, it influenced cycling shoe design for a long time to come.

BOUNCE S3 ²⁰¹²

With the Bounce S3, we took the dynamic mesh idea from the S2 up another level with a mesh that used hundreds of individual TPU plates to provide fantastic support and protection to the foot. Like its original predecessor, the S3 was recognized with a Plus X Award, and Porsche Design Sport was named "Most Innovative Brand" in the footwear category for 2012.

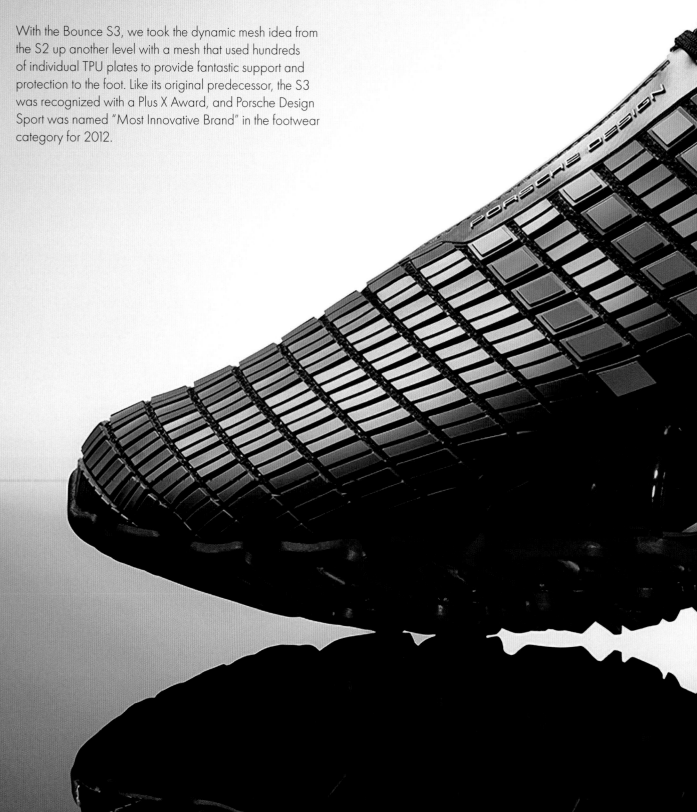

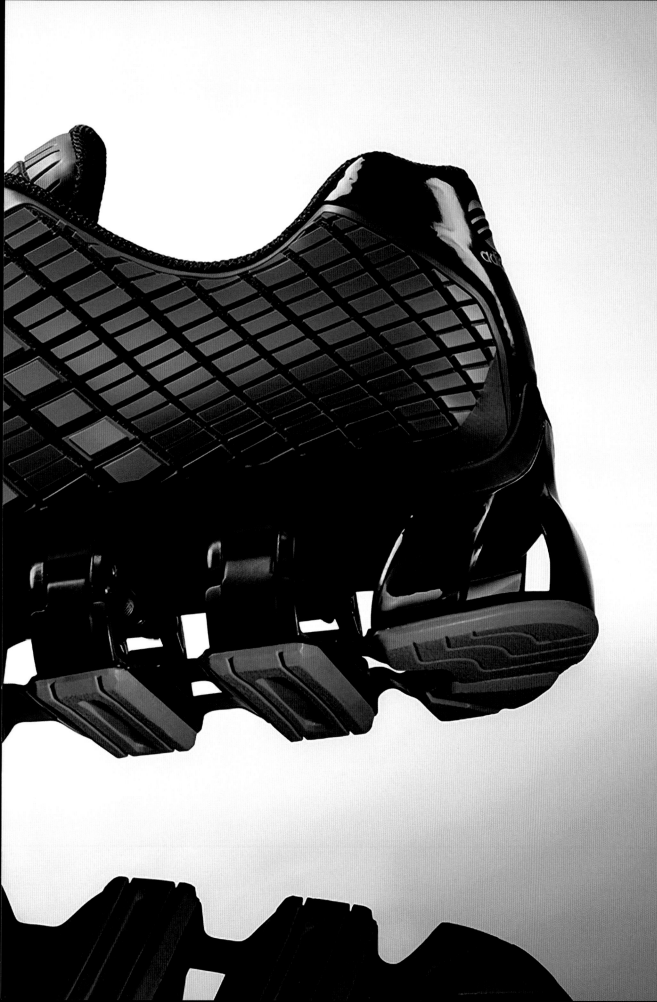

BOUNCE S4 ²⁰¹⁴

Although the original Bounce suspension system was great, it was complicated. For the Bounce S4, we wanted to make it lighter and simpler. Instead of springs, we moved to bell cranks, pivoting cranks that change the direction of input motion. Using two on each side bonded to a carbon fiber platform, it gave the shoe a fantastic technical look. Another advance on the S4 was that the shoe had no heel piece at the rear. This was previously there to prevent the suspension bottoming out, but tests showed that using the bell crank system, we could eliminate it and reduce weight, as well as improve the aesthetics of the shoe. By this stage, we had more of a freehand form Porsche Design and borrowing from adidas's Y-3 range, we developed a sock-based model as well as new "poured mesh" and nylon models, that featured ventilating channels to keep the foot cool.

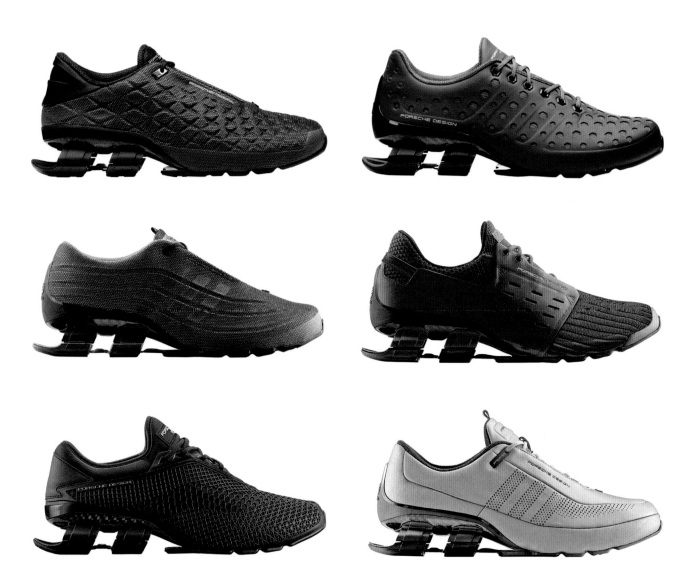

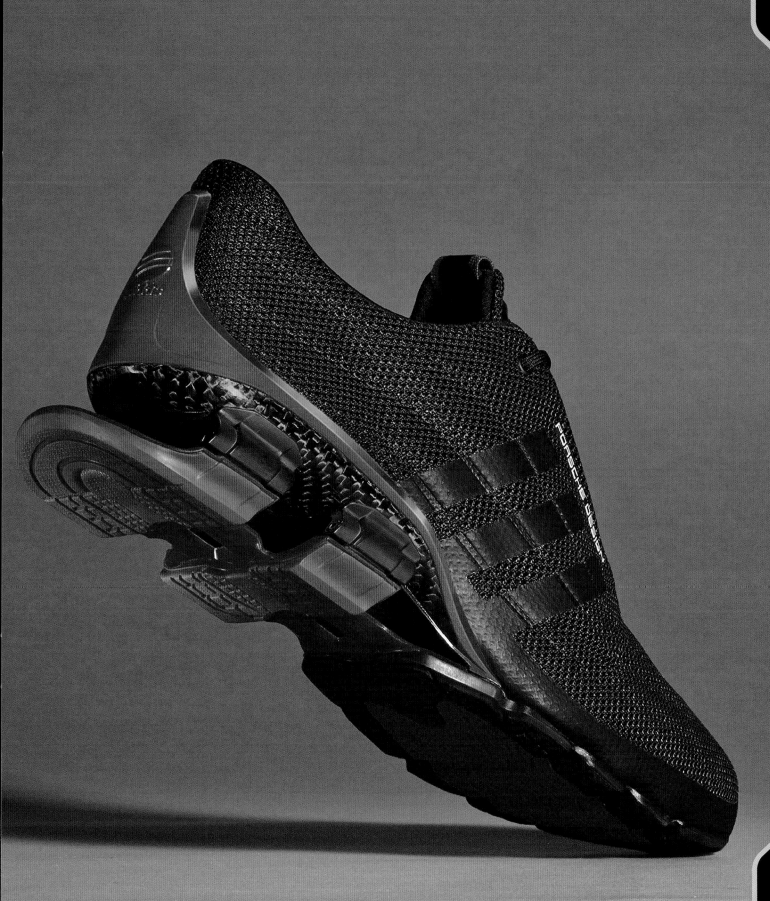

ELSW
FORMOTION 2015

Originally developed for adidas running shoes, Formotion was a heel-based technology that allowed part of the heel of the shoe to pivot—the idea being that it allowed you to have a more natural landing and smoother heel strike. Because it was heel-based, we saw it could also work well for driving shoes.

Working with adidas Advanced Technologies, we did a study that looked into the positioning and motions of your foot when you were driving. We found that your heel has the biggest impact on the position and comfort of your feet when you are driving. The ideal design is to have a rounded heel section. With regular shoes, your foot is resting on an edge, which isn't great for comfort or grip, but with Formotion, it rests on the ball-like heel that has an inbuilt concertina-style mechanism that allows the heel to stay in position while the rest of the foot can pivot as you press the pedals.

The shoe had an almost glovelike feel that molded to the shape of the foot for a great fit and was one of those great examples where technology and sport came together to create a product that improved an everyday function.

INSPIRATIONS:
MICROPACER *1984*

The Micropacer was a shoe that was way ahead of its time. It allowed wearers to track their times, average speed, total distance, and even calories burned with a built-in pedometer, a world first for a running shoe.

As was the case with Porsche Design Sport, integrating technology into a shoe without making it seem like a gimmick isn't easy. What I loved about the Micropacer is that they did this perfectly because it still looked pretty much like a regular shoe. Soon after it made its debut, our competitors also tried to bring computerization into their running shoes, and they came up with some really clunky designs. None of them achieved what the designers of the Micropacer did. They managed to integrate the technology very harmoniously without it affecting the dynamics of a running shoe, and made it look futuristic without turning it into a science fiction showpiece.

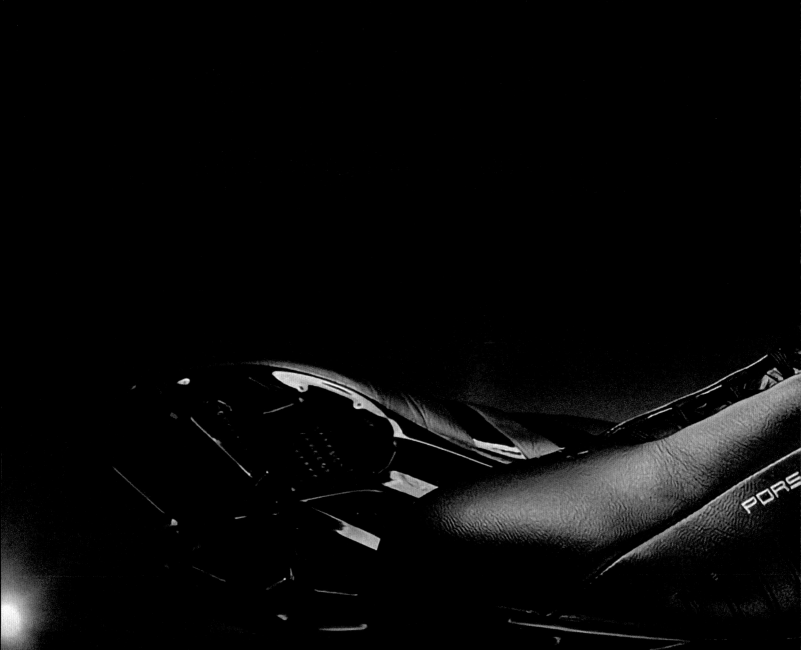

PDS x FOOTBALL *2016*

This was a milestone shoe for me, because it was the last one I did at adidas. Although I didn't think about it at the time, looking back, it was very apt that the design of this boot was inspired by possibly my favorite adidas shoe of all: the Copa Mundial. Like the Copa, it had a very simple and purposeful look with a smooth one-piece vamp. It was also made from kangaroo leather to give the wearer fantastic ball feel and control. The sole plate was an existing proven design and came from Leo Messi's signature boot, the MESSI 15.1.

The Three Stripes only appeared on the medial side of the shoe because I did a study looking at different images of players and found that when you looked at images or television footage, the Three Stripes were far more noticeable on the medial side of the players foot than the lateral. With the kangaroo leather having a matte finish, we gave the Stripes a glossy finish so that they were more visible, but still in a subtle way.

There was a lot of debate about this shoe because people were asking why Porsche Design was doing a football boot. But to me, there was no difference between doing a football boot and doing a golf shoe or a hiking boot. It still reflected the principle of bringing the philosophy of Porsche Design to different sports.

INSPIRATIONS:

COPA MUNDIAL ¹⁹⁸²

If you close your eyes and try to picture a soccer boot, you will probably see the Copa Mundial. To my mind, it is the best soccer boot that adidas, and possibly anyone, has ever created because no boot feels more natural on the foot.

Made from kangaroo leather, it has an upper that is very strong but also incredibly thin—less than 1 mm thick. That means it feels more like a glove than a boot and allows the wearer to really feel the ball, which means that it's your foot controlling the ball, not the boot. The beauty of its design and its effectiveness as a piece of sporting equipment means that the original Copa Mundial is still sold by adidas today and remains one of the world's best-selling soccer boots. It's the perfect example of a great design that, despite changes in the game for which it was designed, remains a great design decades after it was created.

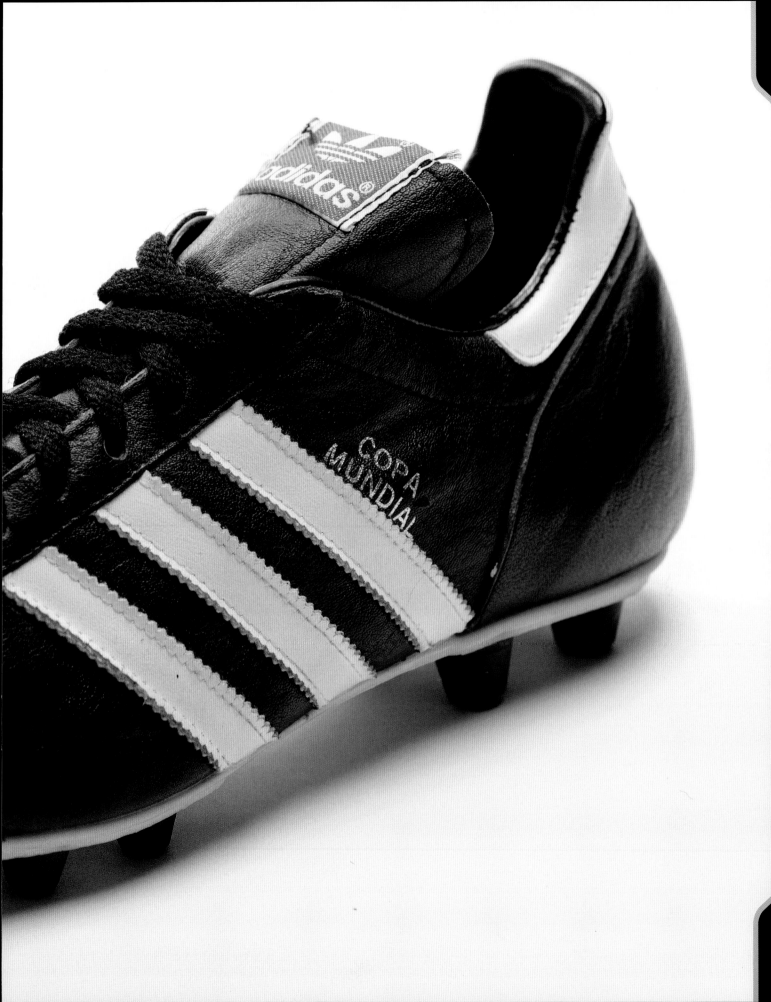

PASSING THE BATON

When I began my career at Bata, I was drilled to believe that it was the duty of creators to pass on their knowledge and experience.

I found spending time at the Bata School teaching young designers everything from shoemaking theory to practical skills to be a very rewarding and fulfilling experience. So much so that when I began to build a team of my own at adidas France, although we had no formal school in the style of Bata, I tried to be a mentor as well as a boss, passing on what I had learned from those who taught me, and from my own experiences.

Our idea at adidas was whenever possible to take designers straight from school and shape them according to the values of the brand. Being a creator is as much about what you do with your head as it is with your hands. When you're creating for a brand, as a young designer, it's essential that you learn and understand its essence and values in order to instill them in what you are creating. When I joined adidas, I was fortunate to work with colleagues who lived the brand every day and set an example of what it stood for. So it's something I tried to do throughout my career when working with young designers.

After retiring from adidas, I've tried to keep doing this. Running workshops for young designers over four days, I would spend the first day in the adidas archives looking at track and field shoes because this was how Adi Dassler started. I would start by taking out the oldest shoes that, for me, were the most representative of Adi Dassler's principles and then make a selection that would take the students through the history of running. One thing I would do in the workshop was leave shoes in their boxes and put them in a corner of the room, then ask the students to take the shoes out themselves. This wasn't me being lazy! Seeing the way you take shoes out of the box shows me if you have respect for them. For me, a shoe isn't just an object. It's part of you because it becomes an extension of your body. It's also because it's the physical representation of the work and thoughts of the person who made that shoe. If the student didn't show respect for the shoes, I knew I had more work to do.

As I've discovered, you can't just talk at people and expect them to take it all in. It's as much about learning where a young designer is coming from, being an example, and putting them in a position where they can teach themselves. It gives me a lot of satisfaction that some of my former designers have gone on to have fantastic careers—even those who went to rival brands!

Jacques attending a student presentation at CREAPOLE design school in Paris as part of the jury panel

LOVA RATSIMANDRESY

I first met Jacques at adidas during my internship in 2007 in Germany. His desk was not far from mine, and one day while I was walking in the office, he stood in front of me and said, "You are French! I saw your car number plate when you parked!" At that moment, I had no idea who he was. This is how it all started.

However, I noticed his door was never closed, and I had regular chats with him until my internship was over. I left Germany, but we kept in touch until I managed to come back for a designer role in Herzogenaurach two years later.

Although I have never worked alongside Jacques as a colleague, I discovered him as a person, and it took me years to realize who he really was and what he had achieved. The truth is that he is very humble, respectful, discreet, and never shows off about his success. I believe this is why he is so respected and recognized both inside and outside of adidas, in the footwear industry and by consumers and fans.

Today, I feel people want to know who is behind many adidas classic models that are still massively popular, so they want to know more about the creator.

What amazes me is the adaptation of his design language throughout decades. When I take a Forum, an EQT Running Guidance 93, and a Porsche Design Bounce S3. These shoes are from three different eras, but it's crazy to realize they come from the same person. His way of adapting the design language through time is unique and inspires me in my journey as a designer.

Today, Jacques is one of the only people who has a historical link with many adidas original shoes, and that's precious. I am always discovering and learning from him. He is an inexhaustible resource.

I'm so happy that people are valuing his work and, more and more, are looking for his legacy. It's the best acknowledgment he can receive and I have witnessed it growing since he retired from adidas. To me, it has even more value now than when Jacques was working for the brand. I feel very lucky our paths crossed, and I'm very thankful that we keep on sharing. Merci, Jacques!

LOVA RATSIMANDRESY
adidas footwear designer, graffiti artist
@ biele.bylova

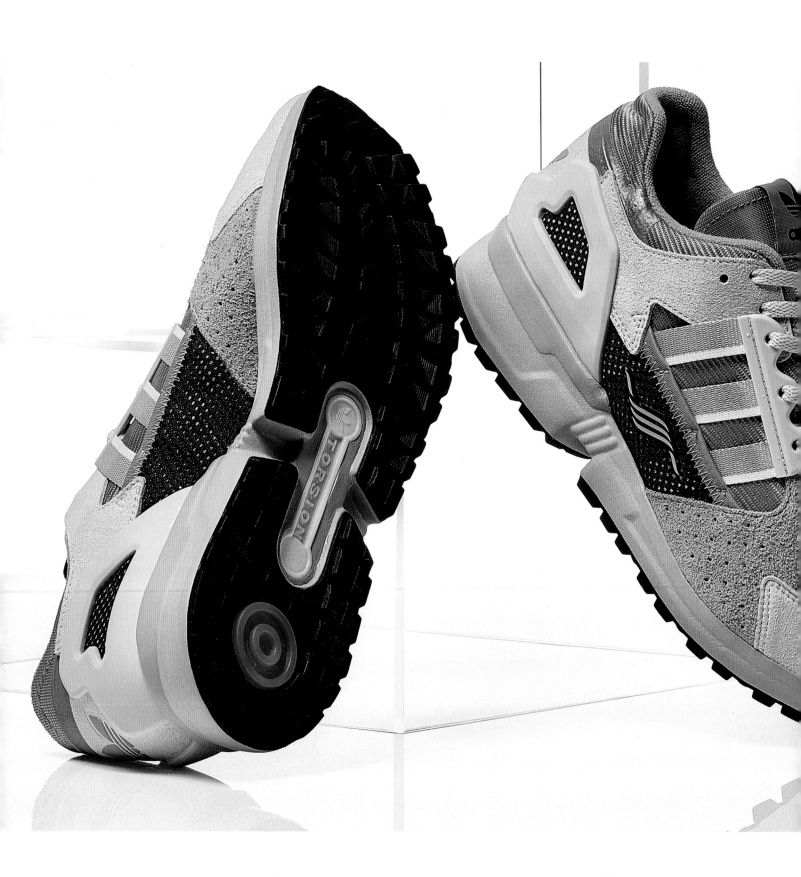

ZX 10000C *2019*

People sometimes ask me, "What would you do if you made a ZX shoe today?" The ZX 10000 is the answer.

The idea behind this shoe was that originally, we finished the ZX series with the ZX 9020, but we wanted to explore the idea of what would have happened if we made a ZX 10000?

Aurélien Longo from design, Charles Lovett from materials, George Griffin from product marketing, and I decided to jump into an imaginary time machine and go back to 1989 to create the next shoe in the ZX lineage. To remain respectful of the time and the ZX legacy, we set ourselves the challenge of only using materials and construction processes that were available at the time. It meant using techniques like stitching rather than bonding and EVA rather than modern TPU, to create a shoe that would be a worthy successor and feel authentic to the era.

One consideration for the design of the ZX 10000 was that not only would it be the last ZX, it would be a kind of bridge to the shoes that came after it. With this in mind, we brought a concept to it seen on later Torsion shoes but not on the ZX series, which was the idea of

increasing the torsionability of the shoe by allowing the upper to rotate as well as the sole. By using floating straps to create a free-moving connection to the ghillie eye stays, it improved the ability of the upper to twist. This gave the ZX 10000 a connection as a kind of missing link to the Equipment shoes that were the successors of ZX.

One of the most satisfying things about this shoe was that, while we set out to create a period piece that was true to the legacy of ZX, almost without intention, the final product still felt like a shoe that belonged to today. Another thing I loved about working on the shoe was that it was such a lot of fun. As I've said, I believe you need to have fun when you work because it makes what you produce better, which was definitely the case with the ZX 10000. Between Aurélien, Charles, George, and me there was tremendous respect and no desire from anyone to be more important than the rest, which allowed all of us to bring equally important contributions.

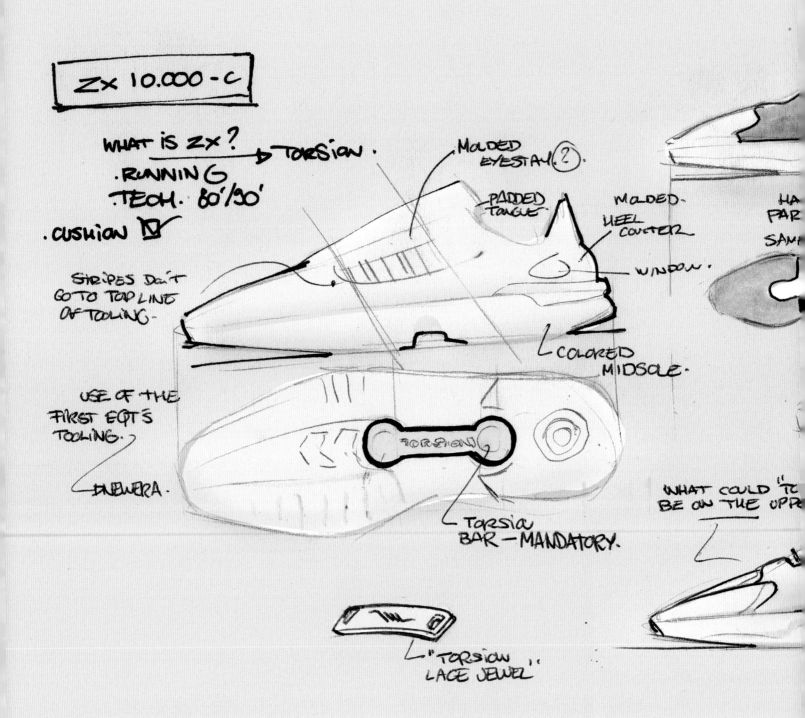

ZX 10.000-C

WHAT IS ZX? →TORSION.
.RUNNING
.TECH. 80'/90'
.CUSHION IV

STRIPES don't
GO TO TOP LINE
OF TOOLING.

USE OF THE
FIRST EQT'S
TOOLING.

→NEW ERA.

MOLDED
EYESTAY (2).

PADDED
TONGUE

MOLDED.
HEEL
COUNTER

WINDOW.

COLORED
MIDSOLE.

TORSION

Torsion
BAR — MANDATORY.

"TORSION"
LACE JEWEL

WHAT COULD "
BE ON THE UPP

HA
PAR
SAM

ZX 10000C development sketches
by designer Aurélien Longo

288

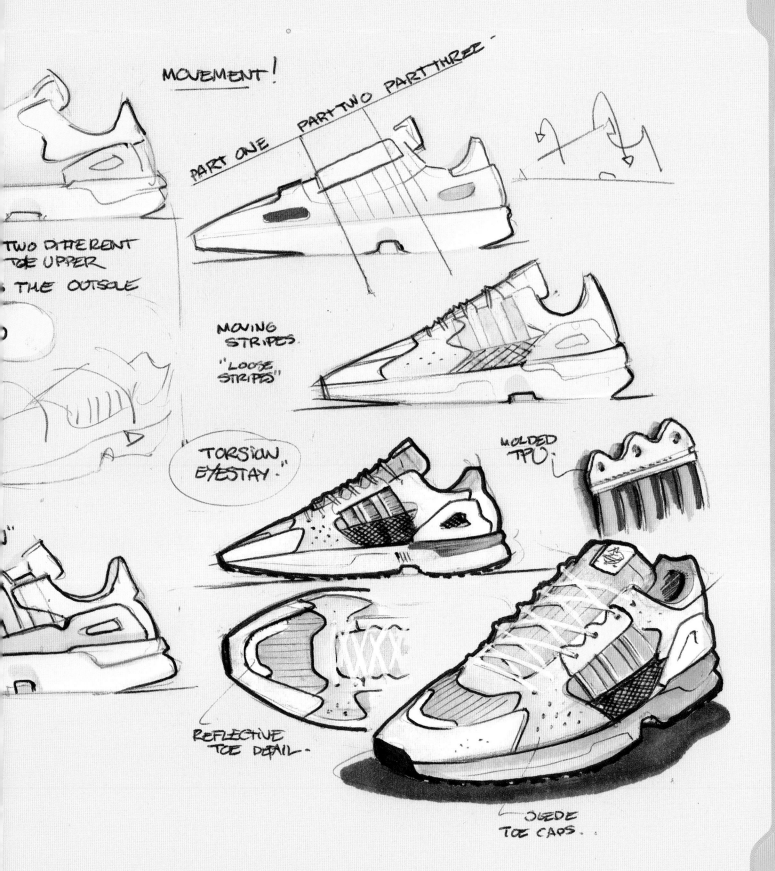

MOVEMENT!

PART ONE PART TWO PART THREE

TWO DIFFERENT
TOE UPPER
THE OUTSOLE

MOVING
STRIPES
"LOOSE
STRIPES"

TORSION
EYESTAY

MOLDED
TPU

REFLECTIVE
TOE DETAIL

SUEDE
TOE CAPS

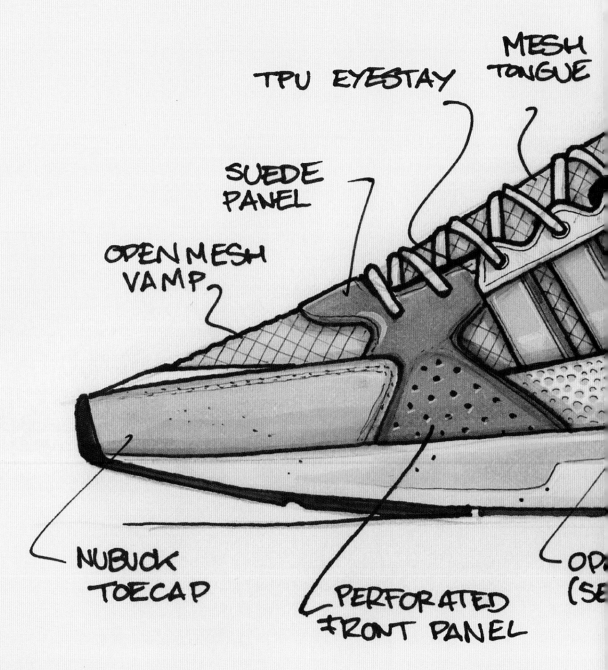

MESH TONGUE

TPU EYESTAY

SUEDE PANEL

OPEN MESH VAMP

NUBUCK TOECAP

PERFORATED FRONT PANEL

OP (SE

Construction materials sketch
by designer Aurélien Longo

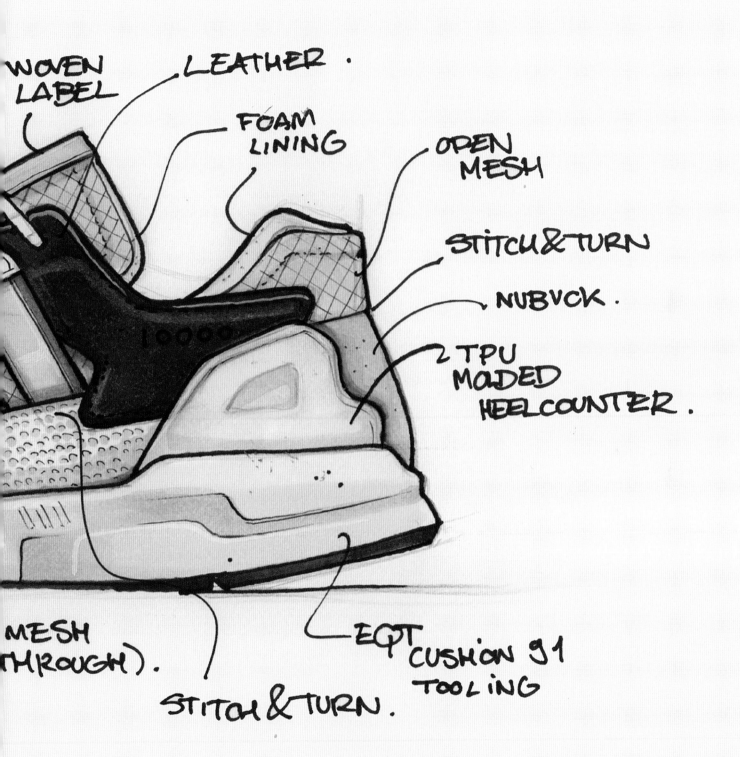

WOVEN LABEL

LEATHER .

FOAM LINING

OPEN MESH

STITCH & TURN

NUBUCK .

TPU MOLDED HEELCOUNTER .

MESH (THROUGH) .

STITCH & TURN .

EQT CUSHION 91 TOOLING

AURÉLIEN LONGO

The best thing that can happen to you when you start your dream job of footwear designer at adidas is to get to meet the people who contributed to make the brand so inspiring to you over the years. When I first met Jacques back in 2011, I did not know who he was at the time, but I knew most of the shoes he designed for the Three Stripes. I remember being fascinated by how humble he was, always willing to help and support the new generation of designers and make them grow. Me and my friends used to sit in his office and talk about design with him for hours.

Over the years, I have been lucky to work on few projects with Jacques, and the adidas ZX 10000C is probably the one I am the proudest of, for all the learnings and challenges that it came with. In 2018, when the idea came to create the very last piece of the original ZX Thousand series designed by Jacques in the eighties, it was important to have him as part of the design-team, so he could share with us all the little stories behind each shoe—all the very important details that built on the legacy of ZX shoes over the years. This was probably the best thing that happened to this project, and I still feel so grateful I was there at that time and was able to design this ZX 10000C together with him.

I met many very inspiring people in my career, but Jacques is certainly the one that taught me the most about the brand. In fact, we keep on building on the legacy of one creator's vision: Adi Dassler. Each project and each product we create should respectfully pay tribute to this heritage as well as contribute to make a better future through sport.

AURÉLIEN LONGO
Design Director, adidas Y-3 x Yohji Yamamoto
@aurélienlongo_perso

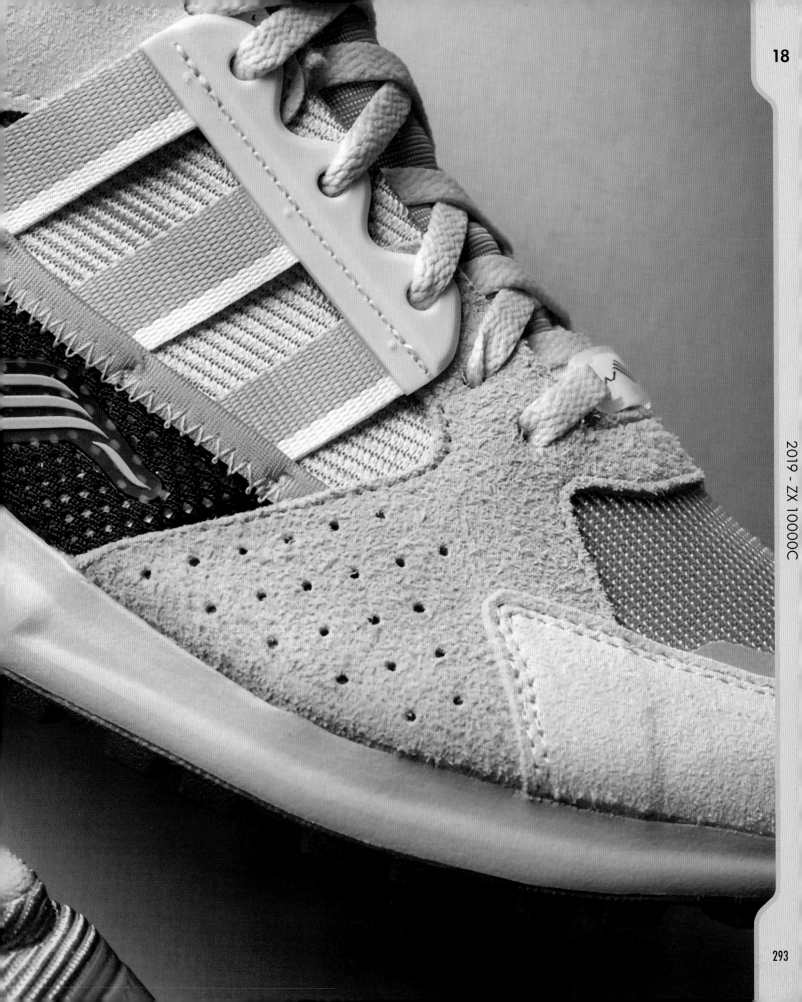

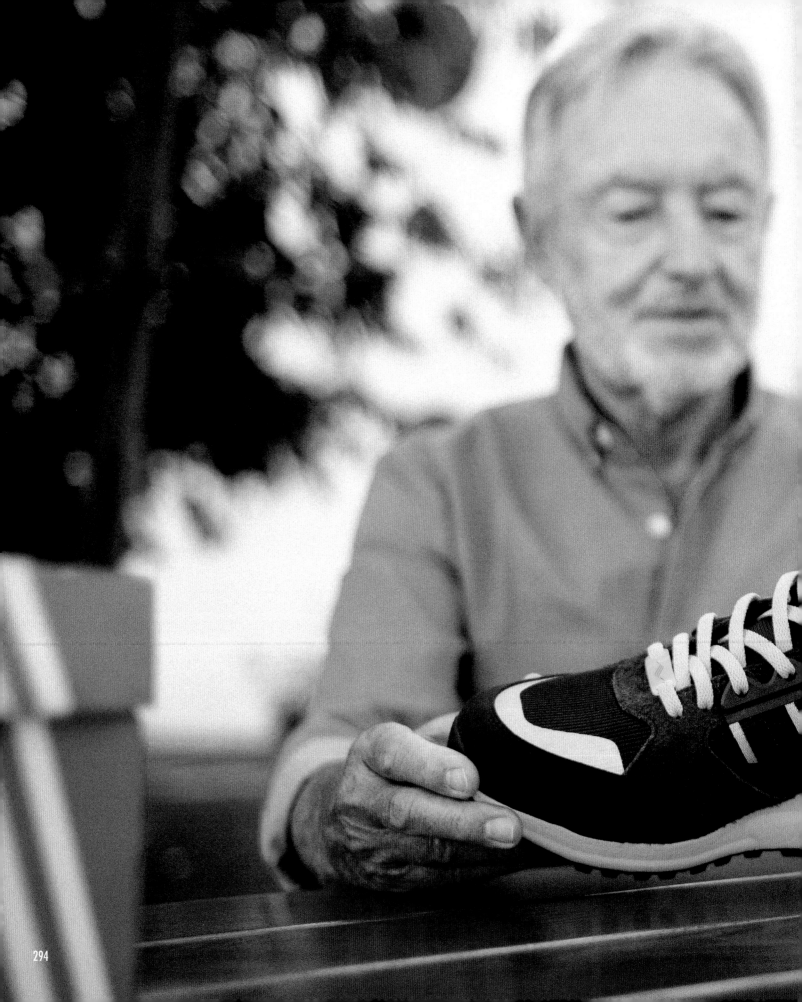

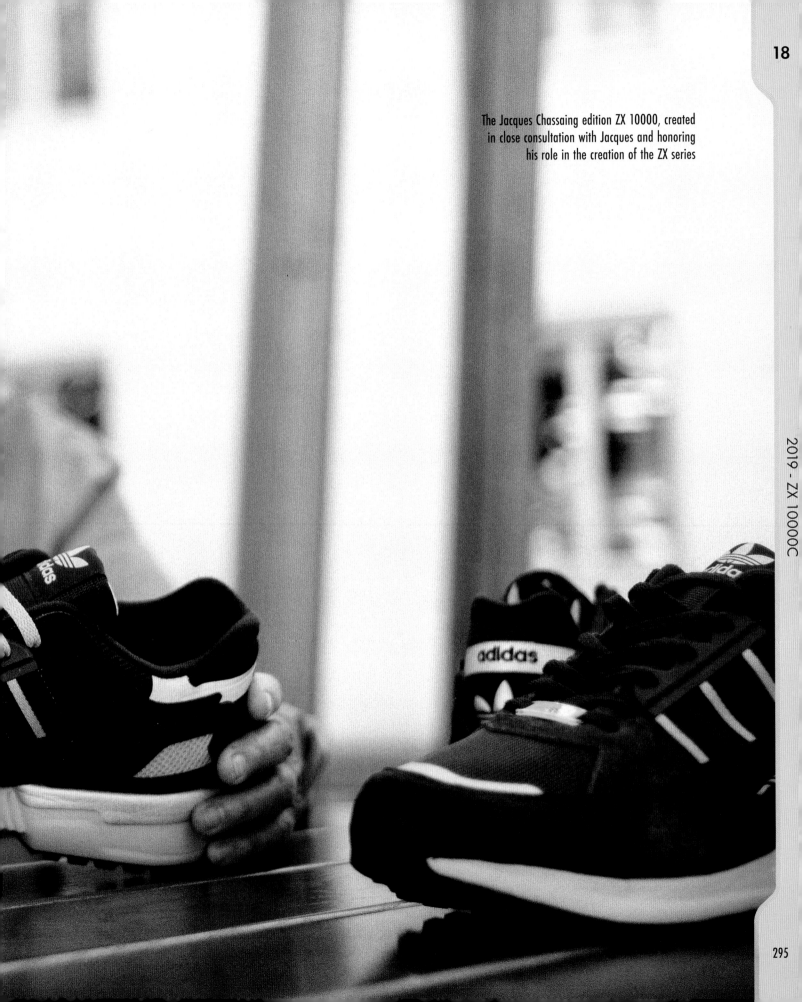

The Jacques Chassaing edition ZX 10000, created in close consultation with Jacques and honoring his role in the creation of the ZX series

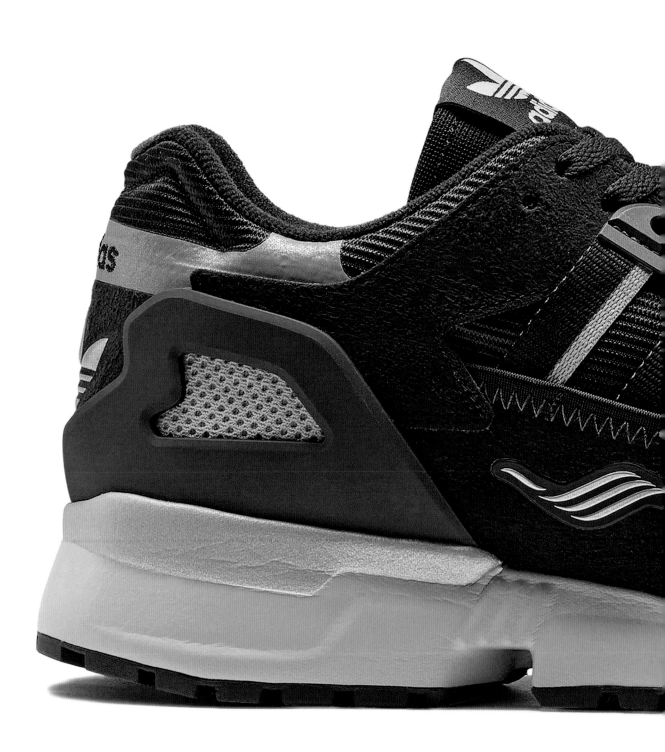

ZX 10000 Jacques Chassaing Edition

JASON COLES

I'm not sure when I first heard the name Jacques Chassaing. I feel like I've always known it, but when I was going through my rebirth as a born-again sneakerhead researching Golden Kicks, I started hearing it a lot. It was spoken by adidas fans with the reverence usually reserved for designers like Dior, St. Laurent, or Ferragamo. As I delved into adidas history, this Chassaing guy was everywhere. I'd ask people, who did the Forum? "Chassaing." The ZX 500? "Chassaing." The Edberg? "Chassaing." How about the Predator? You guessed it. Chassaing. It dawned on me that the guy was responsible for almost every great adidas shoe since the '80s and was behind many of sneaker culture's most loved kicks. So, who was he?

I asked friends at adidas if they knew him or of him. Their responses were like those a devout Catholic gives if you ask what they think of the Pope. The outpourings of fondness, affection, and love were universal. So not only was this Chassaing fellow very talented, he was also clearly a proper dude. I needed to get to know him.

A few emails via mutual friends later, and I was on the phone to him. Once my fan boy gush was over, he was finally able to get a word in. "Ok, that's nice. But there's one thing I want to say to you. What you wrote in the Stan Smith book, it's bullshit," Jacques said. There was stunned silence from my end. "Stan Smith had nothing to do with the Stan Smith Millennium. He never once told me he wanted a new shoe." Continued stunned silence from my end. "Err, ok Jacques. But that's what Stan told me," I hesitantly replied. "No, never happened!" he responded.

Eventually, we got past the Smith thing, and I eventually plucked up the courage to ask if he'd ever thought about doing a book. Jacques being Jacques, he thought I was crazy. But after he got to know me a little bit, much to my joy, he finally relented and so began the collaboration that led to the creation of this book.

The five days Jacques and I spent doing nothing more than talking in his hometown of Strasbourg and in the adidas archive in Herzogenaurach were simply mind-blowing. Learning about his passion for his work, the stories behind the shoes, and discovering just what a great guy he is to know was an experience I will never forget.

Before I let you go, I want to tell the story of an experience I had with Jacques that seems to sum up perfectly how important he is to so many people. During our time together in Herzogenaurach on a very frosty and foggy morning, Jacques and I left our hotel to head over to adidas. As we walked through the thick fog, out of nowhere a man appeared, walking his dog. He glanced over at us quickly then and immediately did a double take as he realized it was Jacques. He stopped in his tracks and pointed down at his shoes. They were a pair of very wet and muddy Forums. "See those?" he said, and gave Jacques a big thumbs up. We laughed, and the guy gave us a big smile before disappearing back into the fog with a chuckle. I looked over at Jacques and said, "You just made that guy's day." He looked back at me and said, "Not as much as he made mine."

JASON COLES
Writer, producer, sneaker historian
@madebyjase

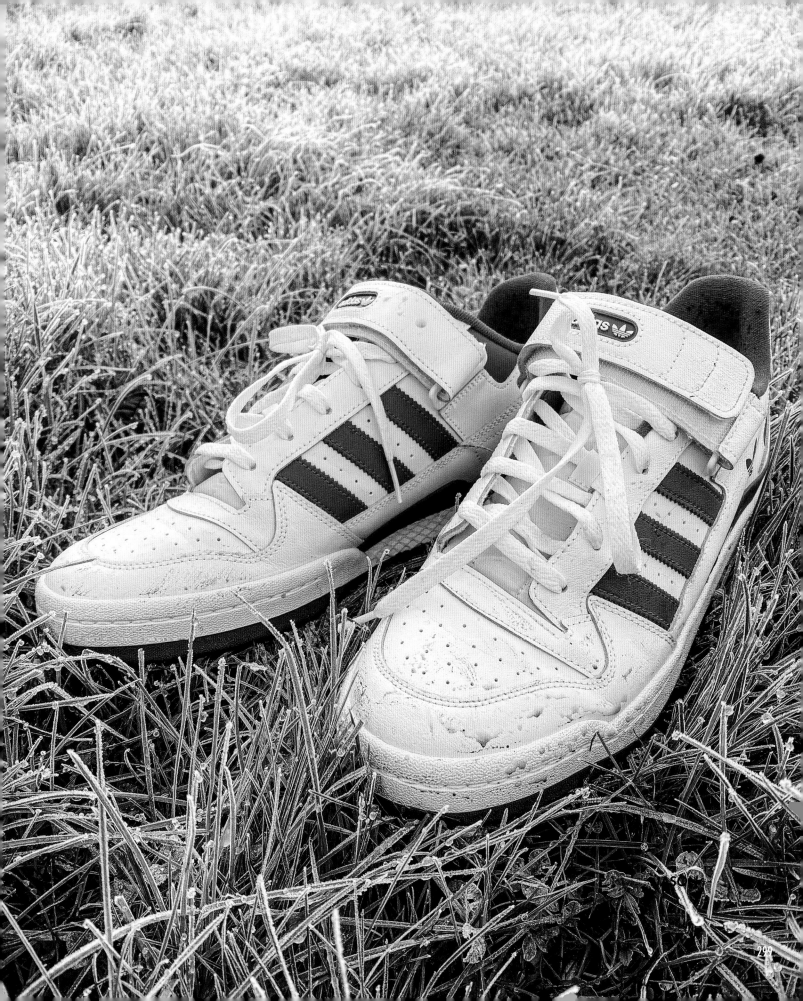

IT HAS NO END

A creator's journey never ends; it only gets more interesting.

When I finally decided the time had come to retire from adidas after thirty-six years, there was no question in my mind it was the right decision. The only questions I had were, "Did I do a good job?" and "Did I pass the torch on to the next generation?" Only others can be the judge of that.

I also had no doubts about my decision to retire because the truth is it would be impossible for me to really "leave" adidas. I think if you've worked for this brand for just one year, or thirty-six, there is something about adidas that never leaves you. I may not be there every day now, but adidas is, and will always be, a part of me.

Any commercial organization exists to make money, of course, but I believe that from the day it was founded, adidas has always existed for a more noble purpose: to make only the best for the athlete. Sure, at times, we didn't always live up to our founder's vision. Not because we stopped believing in it, but because we either lost sight of it or didn't try as hard as our competitors. Some people think that

the word "athlete" is an exclusive word—that it means only a person who competes at elite levels—but Adi Dassler believed an athlete was anyone who pursued performance in whatever activity they did. Like Adi, I've always believed that form follows function, and I'm convinced it was the products we created that exemplified his philosophy most closely that resonated the most with people.

Creators today face many more challenges than my friends, colleagues, and I did. It's no longer enough just to create. We must create responsibly and sensitively, respecting each other and our environment. These are challenges not to be daunted by; they should be relished and welcomed. I envy the next generation of creators in their journey to find game-changing solutions to the problems we all need to overcome to create only the best in only the best way. Just as we did, I feel sure you will find that a part of the answer to the future lies in the origins of your brand and in yourself.

Another part of that answer can be found in those around you. I'm so fortunate to have worked with many brilliant and inspiring people with whom we all shared the belief that whenever better was possible, good was not enough. I'm even more fortunate that I still count many of them as my friends. Without them and my family, I would have achieved nothing. I've learned that creativity is always best when it comes from shared endeavor.

Even though I'm supposed to have "retired," I've never stopped creating. That's because I haven't stopped learning or taking risks. I believe as long as you're willing to do those two things, whatever age you are, you will be your most creative. At the beginning of this book, I said that even before I came to adidas, I was taught to never take no for an answer—not from myself or from others. It's probably the best thing I ever learned and the best advice I can give to you, because as I've discovered, and I hope you will too, nothing is impossible.

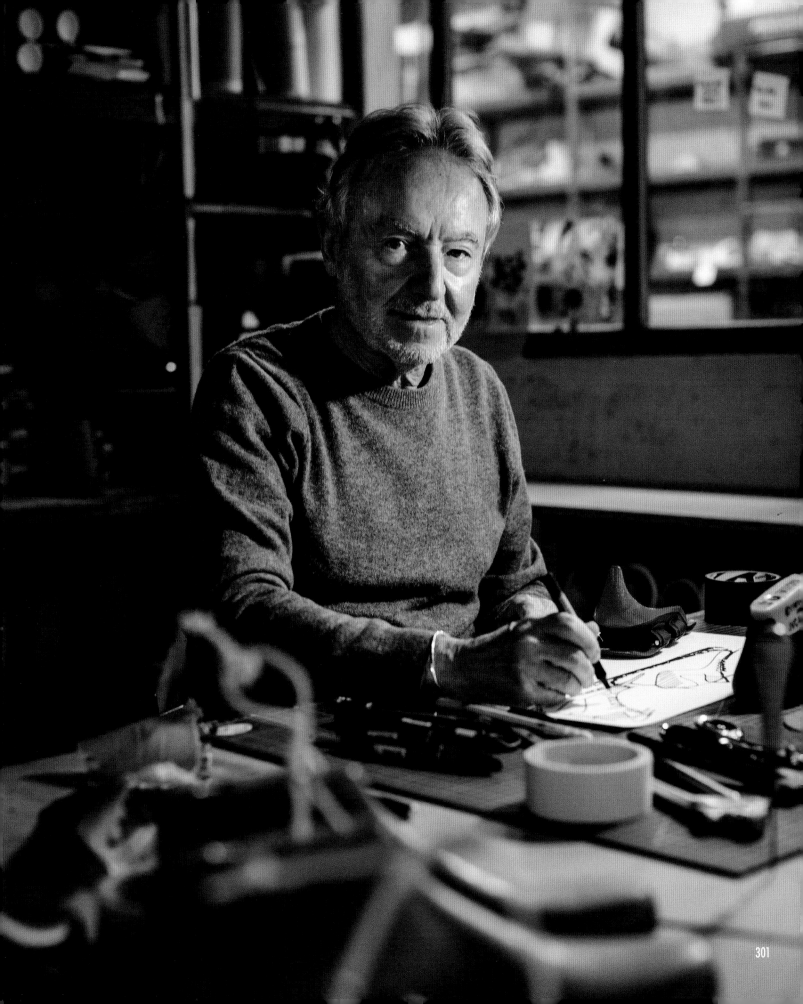

ACKNOWLEDGMENTS

Our warmest regards and gratitude to all those who contributed to the creation of this book (in alphabetical order):

Family
Patricia Thomann-Chassaing
The Coles Family

Rizzoli
Charles Miers
Anthony Petrillose

adidas AG
Gary Aspden
Susen Friedrich
Adrian Leek
Aurélien Longo
Maya Rodal
Ludovic Schuler
Patricia Stoeckel
Sarah Talbot
Christof Wolpert

Bata
Rosemarie Bata

Contributors
Ernie Beckmann
Christophe Bezu
Alexandre Blum
Paul Gaudio
Ina Heumann
Kish Kash
Hart Klar
Quote Kokscht
Thomas Krödel
Robert La Lime
Chris Law
Samuel Mantelet
Robert McCarten
Patrik Nilsson
Robert Quach
Lova Ratsimandresy
Julia Schoierer
Bernd Wahler

Photography
Christian Habermeier
Sebastian Jäger
John Ly
Vincent Muller

Extra special thanks to
Jacques's adidas France Creation Team

Daniel Bauer and the Blizzard Forum team (Eyuep Alkan, Maximilian Bente, Marc Hare, Charles Lovett, and Christian Otto)

Nic Galway, adidas Originals Global Head of Design, for helping an old friend

Ina Heumann, Project Manager, adidas AG, for her immense enthusiasm and support

Peter Moore, for showing the way

Charles-Julien Nivert and Les Ateliers Éclairés for allowing us to use the Makerspace

Laurent Roussiaux, Ludovic Harnist, and Eric Lam at Impact Premium Strasbourg, for allowing us to take over the store!

Jan Runau, Chief Corporate Communications Officer, adidas AG and the adidas Comms team for always keeping the doors open to us

Sandra Trapp, Senior Manager History Management at the adidas Archive, for her assistance in the research of this book and outstanding contribution

Collectors Ernie Beckmann, Tim Carr, Robert McCarten, and Julia Schoierer for allowing us to use images of shoes from their collections

All those many people at adidas, Bata, and elsewhere not named but deserving to have their place in this book too

IMAGE CREDITS

Sébastien Adam: 150

adidas AG: 16, 18, 20–21, 26, 28–29, 30–31, 32, 33, 52–53, 60–61, 64–65, 66–67, 68–69, 71, 78–79, 84, 88–89, 92–93, 96–97, 101–102, 106–107, 115, 116–117, 119, 120–121, 124–125, 126–127, 128–129, 130–131, 132–133, 136–137, 139, 140–141, 142–143, 144–145, 154–155, 156–157, 160–161, 165, 166–167, 168–169, 170–171, 174–175, 177, 178, 181, 182–183, 185, 186–187, 189, 195–196, 196–197, 198–199, 200–201, 203, 208–209, 214, 215, 216, 217, 226–227, 228, 229, 241, 246, 254, 255, 257, 259, 262–263, 264–265, 266–267, 270–271, 272, 27, 276–277 278–279, 280–281, 288–289, 296–297

adidas AG/Studio Waldeck: 76–77, 200–210, 216 (lower), 217(upper)

adidas Archive: 13 (Abb.1_I–2011_f), 20–21 (DC–2), 26 (DC–2325), 32 (DC–10391), 36 (F–7998b_BP1_0405), 52–53 (DC–2459), 64 (DC–10380), 69 (F–5937), 76–77 (F–1053), 78–79 (DC–2348), 88–89 (DC–2581), 96 (DC–232), 106–107 (DC–2141), 119 (Abb.21_I–2777_t), 134 (DC–2387), 142–143 (DC–2887), 152 (DC–239), 160–161 (DC–9503), 165 (Abb.21_I–5902_f), 166 (I–5267_f_1977), 174 (I–1911_f), 182–183 (DC–1086), 195–196 (DC–3999), 200–201 (F–6201_BP1_0185), 202–203 (F–6201_BP6_0199), 204 (F–6201_BP6_0199), 214 (F–7058a_BP6_0311), 215 (DC–1232), 216 (F–1108_BP1_0381, F–5106_BP1_0427), 217 (F–969a_BP1_0385, F–932_BP3_0247), 228 (DC–153)

Steve Bonini: 165

Bata Brands SA. District Archives of Zlin, Czech Republic: 10–11, 12

Ernst-Heinrich Beckmann: 105, 108–109

Andrew D. Bernstein/NBAE/Getty Images: 112

Alexandre Blum: 147

Timothy Carr: 14

Jason Coles: 24–25, 40–41, 43, 80–81, 136–137, 173, 192, 202, 206–207, 219, 222–223, 230–231

CREAPOLE Paris: 284–285

Ina Heumann: 7

Livia Kappler: 63

Kawasaki Heavy Industries Ltd: 70

Kosivu/Adobe Stock: 224–225

Heinz Kluetmeier/*Sports Illustrated*/Getty Images): 34

James Leynse/Corbis via Getty Images: 38–39

John Ly: 86–87, 98–99, 210–211, 212–213, 234–235, 238–239, 282–283

Aurélien Longo: 290–291, 292–293, 295

Samuel Mantalet: 151

Robert McCarten: 54–55, 56–57, 58–59, 72

Michael Ochs Archives/Getty Images: 85

Peter Moore: 177 (upper)

Vincent Muller: 1, 8, 44, 48–49, 108–109, 148, 149, 151, 158–159, 220–221, 248, 250–251, 253, 260–261, 274–275, 299

Patrik Nilsson: 237

Porsche AG: 242–243, 245, 247, 249, 252

Steve Powell/Getty Images: 74–75

Robert Quach: 256

Lova Ratsimandresy: 287

Detlef Schneider: 302

Julia Schoierer: 111, 114

Daniel Sommer: 180

Sotheby's Holdings, Inc: 102–103

Bob Thomas Sports Photography/Getty Images: 94–95

Bernd Wahler: 162

Studio Waldeck: 22–23, 122–123, 190–191, 204–205

Gary Watson/Nathan Damour: 91

2p2play: 82–83

DISCLAIMER

The views and opinions expressed by the authors and third-party contributors to this book are their own and are not necessarily shared by adidas AG or Rizzoli Publications International.

The people, brands, products, and events mentioned in this book are discussed and featured in a purely editorial and historical context.

In respect of the athletes and personalities Michael Jordan, Ivan Lendl, Ilie Nastase, Steffi Graf, Rod Laver, Stefan Edberg, Patrick Ewing, Stan Smith, Run-DMC, Bill Dellinger, and any other athletes, celebrities, or persons of note discussed in this book, no existing relationship with or endorsement of adidas AG or this book and its authors is implied.

First published in the United States of America in 2022 by
Rizzoli International Publications, Inc.
300 Park Avenue South
New York, NY 10010
www.rizzoliusa.com

Copyright © 2022 by Jacques Chassaing and Jason Coles

Written by Jacques Chassaing and Jason Coles
Art Direction by Peter Moore
Design by Jason Coles
Cover Photography by John Ly

Publisher: Charles Miers
Associate Publisher: Anthony Petrillose
Managing Editor: Lynn Scrabis
Editor: Gisela Aguilar
Production Manager: Maria Pia Gramaglia
Design Coordinator: Olivia Russin

Distributed in the U.S. Trade by Random House, New York.

Printed in China

2022 2023 2024 2025 2026 / 10 9 8 7 6 5 4 3 2 1

ISBN: 978-0-8478-7265-7
Library of Congress Control Number: 2022902437

Visit us online:
Facebook.com/RizzoliNewYork
Twitter: @Rizzoli_Books
Instagram.com/RizzoliBooks
Pinterest.com/RizzoliBooks
YouTube.com/user/RizzoliNY
Issuu.com/Rizzoli

Jacques Chassaing: Instagram.com/@jacqueschassaing
Jason Coles: Instagram.com/@madebyjase